MALEVICH

KAZIMIR
MALEVICH

CHARLOTTE DOUGLAS

THAMES AND HUDSON

Editor: Phyllis Freeman
Designer: Ellen Nygaard Ford
Photo Research: Uta Hoffmann

Frontispiece:
Kazimir Malevich. c. 1925.
Stedelijk Museum, Amsterdam

First published in Great Britain in 1994
by Thames and Hudson Ltd, London

Text copyright © 1994 Charlotte Douglas
Illustrations copyright © 1994 by Harry N. Abrams, Inc.

British Library Cataloguing-in-Publication Data

A catalogue record for this book is available from the British
Library

ISBN 0–500–08060–7

Printed and bound in Japan

CONTENTS

Kazimir Malevich was a brilliant and complex artist. A major representative of the twentieth-century avant-garde, an acclaimed pioneer of abstraction, and one of the fathers of international modernism, he nevertheless remains a puzzling figure in the history of modern art. Because he was the victim of Soviet repression, the simple facts of his biography have been slow to emerge, and his life has been mythologized in both the West and the East. To the ordinary viewer, Malevich's alternations in painting style seem abrupt and inexplicable—the sudden appearance of his geometric Suprematism in 1915, and his equally sudden return to figurative work in the 1920s, most especially so. But when such stylistic discontinuities are considered within their cultural and sociopolitical environment, a remarkable coherence in the artist's conceptual and artistic aims becomes evident. Throughout Malevich's lifetime his themes and philosophy, experiments, and even artistic subjects, display a consistency that reflects the artist's own sturdy, determined, and unwavering character.

Malevich has been called a utopian, but if he is, he is certainly not utopian in the usual sense. Although he was passionately interested in what he called Suprematist design, and considered its abstract forms a signal of human psychic evolution, he had much too practical a nature to have subscribed to visions of a perfect life on earth. Even in the expansive days of the November Revolution, when he dreamed of changing the look of the world, he remained a Symbolist, and an artist who thought in cosmic terms. In the rich variety of his work he was always concerned with a world different from the visible one, the world "out there," that stood behind and beyond the life of ordinary existence. His art was the means of its attainment.

Malevich's early experiences were formative for his art. Born in the thriving agricultural region of Ukraine, the artist retained for the rest of his life his early visions of colorfully dressed peasants walking along the village streets, or laboring under an open sky in the wide fields. In much of his art he was to elevate these deeply implanted memories of provincial life into archetypal visions of the world at large, and the burdensome nature of human existence.

Kazimir Severinovich Malevich was born in the city of Kiev in 1878, one of nine children. His parents, Severin and Liudviga Malevich, were Ukrainian Poles. They were not wealthy, but their means were sufficient to provide for family needs. The artist's father supported his family as an administrator in sugar refineries, and Malevich spent the first twenty years of his life in a succession of rural factory towns. At fifteen he graduated from a local agricultural school, but he declined to follow his father into the sugar refineries. By his early teens he had discovered art, encountered his first artists (rare strangers who had come to the village from Saint Petersburg to decorate a church), and begun to teach

himself to paint, choosing views of the peasantry and the surrounding countryside as his principal subjects. When Malevich looked back, it seemed to him that from an early age he had been unswerving about his choice of career, as well as about what he wished to paint.

> All my life the peasantry attracted me strongly. I resolved that I would never live and work in the factories. I would never study. I thought that the peasants lived well, that they had everything, that they didn't need any factories or any book learning. They made everything themselves, including paint. . . .
>
> Peasants always seemed to me clean and wonderfully dressed. . . . I remember weddings at which the bride and her attendants seemed a kind of brightly patterned people in costumes of bright woolen fabric with ribbons woven into their braids and headdresses, and morocco boots with bronze toes and iron heel taps and designs around the tops. The groom and his attendants wore gray sheepskin hats and blue pants—or rather loose trousers gathered at the ankles, into which had gone no fewer than sixteen *arshins* [more than twelve yards] of material—and white embroidered shirts with wide red woolen cummerbunds.
>
> The bride and her attendants went through all the streets of the village singing and bowing low three times to everyone they met.
>
> Now this is the background against which the feeling for art and things artistic developed in me.[1]

Years later, when Malevich described the transcendent ecstasy of a future life, calling it "colorous existence," it was precisely this early joyful experience of Ukrainian peasant life that he had in mind.

The artist credited his parents, especially his mother, with his love for creativity. Although his father eventually opposed his son's choice of career, he spent time drawing with him when he was young. His mother taught him to embroider and crochet. Handwork was to prove an important part of Suprematism, Malevich's historic abstract style; throughout his life (Malevich died before his mother) the artist sought and valued his mother's opinion of his work.

In Kiev, Malevich came to know and admire Nikolai Pimonenko, an established Ukrainian painter who taught at the Kiev Art School. Pimonenko was an aca-

demic genre painter, seemingly without much to offer a young artist of Malevich's modernist inclinations, but his subjects, drawn from rural life—villagers at work, haying scenes, and full-length portraits of peasants—later became Malevich's own.

Quite soon after Malevich began to attend classes at the Kiev school, his studies were cut short by the family's move to the provincial town of Kursk, where his father went to work for the railroad. The younger Malevich also found employment there as a draftsman. Soon he married Kazimira Zgleits, the sister of the wife of one of his brothers and a future doctor, and started a family.

The railroad administration centered in Kursk brought together many energetic young men from around the country, and in Kursk the young painter was fortunate to find people who shared his interest in art. Among his close friends at the time were Lev Kvachevsky, an enthusiastic young painter who had studied at the Imperial Academy of Art in Saint Petersburg, and a young accountant for the railroad, Valentin Loboda. Together with other workers, they organized Kursk's only art group, set up a common studio, conducted drawing sessions, and exhibited their work. But Malevich eventually outgrew such provincial exercises, and in 1904 he rode the train to Moscow in search of formal instruction in art.

He found it at the well-known studio school of Fedor Rerberg. Rerberg specialized in preparing students to take the exacting entrance examinations of the Moscow School of Painting, Sculpture, and Architecture, a premier art school that, more than the Imperial Academy in Saint Petersburg, was responsive to Western and domestic contemporary trends. It was this prestigious institution that was Malevich's ultimate goal. The most immediate result of his first visit to the city, however, was a swift demonstration of his organizational ability, a skill that would affect the course of his art and serve him well in the development of his career. Malevich's trip to Moscow in 1904, and his introduction to artists there, apparently brought about his first documented exhibition, "Moscow and Out-of-Town Artists," held in Kursk in 1905. His friends Kvachevsky and Loboda took part in this show, as did Rerberg himself. The presence of the prominent Moscow painter Konstantin Iuon lent it cachet. By encouraging his new acquaintances to show their work in Kursk, Malevich and his group were able to familiarize themselves with what was being done in the big city, and to present their own art at home in a larger, more cosmopolitan context.

But Malevich's promotional activities in the art world were of no help to his academic studies. Three times in three years, in 1905, 1906, and 1907, he attempted unsuccessfully to pass the entrance examinations of the Moscow School of Painting, Sculpture, and Architecture. Later he was to claim that he had in fact been a student there, but no documentary proof of his attendance has yet been found. Instead, from 1905 until about 1910, the aspiring artist worked at Rerberg's studio.

Rerberg was well traveled and knowledgeable about Western European art. Although he himself was partial to Impressionism, he did not insist upon it for his students. He did instill a "rational" approach to art, however, and offered a thorough grounding in the technical aspects of color and composition. He was interested in psychology and physiology, and urged his students to express feelings and sensations systematically. While Malevich was in attendance at his studio, Rerberg published books on the chemical and visual properties of various brands of oil paint and a text for a course in art history. He was one of the organizers of the Moscow Artists' Society, which sponsored the half-yearly salons in which Malevich got his start. It is notable that in addition to painting and sculpture, this organization emphasized design and the applied arts, and in its exhibitions it included furniture, rugs, and textiles.

Malevich clearly profited from his time with Rerberg, in actuality his only real teacher, although instead of Impressionism, the young artist gravitated to the styles of a late Symbolism, Art Nouveau, and Post-Impressionism. In Kursk in 1905 he exhibited *Witch*, *Madwoman*, *Dusk at the Cemetery*—titles that indicate that by then at least, he was pursuing a brooding Symbolist genre comparable to that of Octave Moreau and Odilon Redon, and exemplified in Russia by the outstanding Symbolism of Mikhail Vrubel.

Until about 1907, when he moved his mother and family to Moscow, Malevich returned to Kursk in the summers. In 1909 he divorced his wife and remarried, this time to Sofiia Mikhailovna Rafalovich, a children's writer and the daughter of a psychiatrist. Living with other artists in a communal residence and desperately in need of money to support himself and his family, as well as his studies at Rerberg's, the young artist took on commercial art jobs to help earn a living; he also designed frescoes for a church interior. In 1909 Malevich drew for publication portraits and scenes from the Moscow Art Theater's production of Leonid Andreev's scandalous play *Anathema* (fig. 1). Eight of these litho-graphs were published by the Art Theater in an elegant album of portraits and scenes from the play.[2]

Malevich, while attracted to Symbolism, did not always take the Symbolist inclination to the sacrilegious and the macabre entirely seriously. He also indulged in a humorous and naughty eroticism, the prelude to the outright effort to shock that became the hallmark of many of the Russian Cubo-Futurists (fig. 2).

The equivalent in Russia to Paris's "salon" exhibitions were the large Moscow Artists' Society's twice-yearly shows; Malevich first contributed to them in 1907, while he was at Rerberg's. Other members of the emerging avant-garde could also be seen in the 1907 exhibition—David Burliuk, Natalia Goncharova, Mikhail Larionov, Aleksandr Shevchenko, Aleksei Morgunov—as well as more established artists, such as Vasily Kandinsky. Goncharova and Larionov were energetic participants on the Moscow art scene, and soon included Malevich in their plans and exhibitions. David Burliuk became a principal organizer of another wing of the avant-garde, which included his two brothers—Vladimir, a painter, and Nikolai, a poet—and Vladimir Mayakovsky, the renowned Russian poet "discovered" by David. The primary theorists of the group were the young poets Velimir Khlebnikov and Aleksei Kruchenykh. Their ideas about the nature of the new art were, in time, to prove crucial to the development of Suprematism.

Malevich and other fledgling avant-garde artists, notably Goncharova and Larionov, began to shift to a Post-Impressionist style of painting about 1909. There is ample evidence in his work that by this time Malevich was thoroughly familiar with modern Western painting. In Russia in 1908 and 1909 Western European artists, especially Vincent van Gogh and the Nabis, such as Maurice Denis and Pierre Bonnard, were considered the "new Symbolists," and their work was taken up as a response to issues raised by Russian Symbolism. Russian artists emphasized the Post-Impressionists' investigation of emotional and spiritual states through subjective deformation, and the work of art as an equivalent of sensation. Artistic developments in the West were followed eagerly, and relevant publications were translated into Russian almost as soon as they appeared. *Zolotoe runo* (The Golden Fleece), a lavish journal of art and literature, propagated Symbolist, Post-Impressionist, and Fauvist ideas; it published Matisse's "Notes of a Painter," and Denis's article "From Gauguin and Van Gogh to Classicism." The journal also sponsored exhibitions, and in Moscow in 1908 and 1909, Gauguin, Van Gogh, Bonnard, Georges Braque,

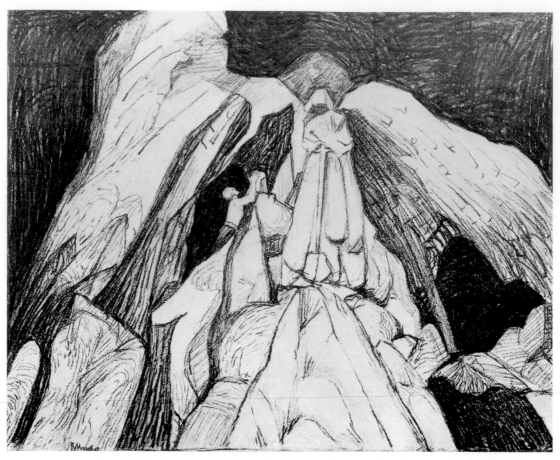

Fig. 1. After the stage set of the play *Anathema*, by Leonid Andreev. 1909.
From an album published by the Moscow Art Theater. Collection Lev Nussberg

Georges Rouault, André Derain, and Denis appeared under its auspices at elaborate "salon" exhibitions.

There were other sources of Western European art available to Malevich. His teacher Fedor Rerberg was an avid student of Impressionism and Post-Impressionism. In 1908 and again in 1909 he published his own translation into Russian of a substantial survey of these trends.[3] Another international salon exhibition was organized by the sculptor Vladimir Izdebsky; it opened in Odessa in December 1909, and traveled from there to Kiev, Saint Petersburg, and Riga. An enormous exhibition of some eight hundred works of art, it included work by Braque, Kees van Dongen, Henri Matisse, Albert Gleizes, Jean Metzinger, and Henri Le Fauconnier, as well as the "Munich Russians"—Kandinsky, Aleksei Jawlensky, Marianna Werefkin, and Vladimir Bechtejeff. By the time it reached Saint Petersburg in April 1910, Goncharova, Larionov, and the Burliuks had succeeded in having their work added to the show, but there is no indication that Malevich had been equally adroit. Also important for the Russian avant-garde was the large exhibition sponsored in Saint Petersburg by the journal *Apollon* (Apollo) and the French Institute,

"One Hundred Years of French Painting (1812–1912)." Among the almost one thousand works of art displayed could be seen Moreau, Pierre Puvis de Chavannes, Redon, and Denis, and also Edouard Manet, Camille Pissarro, Claude Monet, Albert Marquet, Henri-Edmond Cross, and Paul Signac.

A more continuous resource for the new Western art was the magnificent collection of Sergei Shchukin. The son of an immensely wealthy textile manufacturer, and from the 1890s himself the director of two textile factories, Shchukin was a passionate collector of the newest art in Paris. On trips there in the 1890s he bought Monet, Pissarro, and Pierre-Auguste Renoir, and in the early years of the new century, Paul Cézanne, Van Gogh, and Paul Gauguin. In 1904, at a time when the painter was still quite unknown, Shchukin bought his first Matisse canvases, and he commissioned Matisse's large panels *Music* and *The Dance* to decorate his Moscow mansion. By 1911, when Matisse traveled to Russia to visit him, Shchukin had acquired twenty-one of the French artist's works. Shchukin began his collection of Picassos in 1909 with *Lady with a Fan*, and by 1913 owned thirty-five of his paintings. Gauguin was also

brilliantly and copiously represented in Shchukin's collections. Wide and intense Russian interest in this artist was probably further stimulated by Gauguin's retrospective exhibition in Paris in 1906—which Larionov attended together with Shchukin—and by the issue of *Zolotoe runo* published in January 1909, which featured ten pages of reproductions of Gauguin's sculpture and wood reliefs, drawn mostly from the well-known collection of Gustave Fayet in Paris.

Sergei Shchukin was not the only collector of contemporary French work; his brother Petr also bought modern paintings, and the brothers Ivan and Mikhail Morozov, also textile magnates, were avid collectors.

Sergei Shchukin's importance for Malevich and his friends, and for the course of Russian modernism generally, however, was not only owing to his collection itself, but to the fact that it was semipublic; beginning in 1909 Shchukin made a practice of opening his home to artists so they could view the paintings and,

of course, sketch from them. At Shchukin's the artists of Moscow found a large, clear, direct window on contemporary Paris.

The effect of Malevich's exposure to the new art was electrifying. In the three years between 1909 and 1912 he went from being an unremarkable provincial painter to producing some of the major works of art of this century. In that time he assimilated the modern corpus, mastering it entirely, and he began to take his own direction in full consciousness of his powers. Other young Russian painters—the Burliuks, Goncharova, Larionov, Aleksandra Exter—early thought of themselves as contributing members of the European modernist movement, and Malevich fully shared this outlook. They, however, were able to travel abroad, to visit studios, and attend exhibitions—at one time Exter even had her own studio in Paris—but Malevich, constantly in need of money, could not even think of traveling farther than Kursk or Petersburg. His familiarity

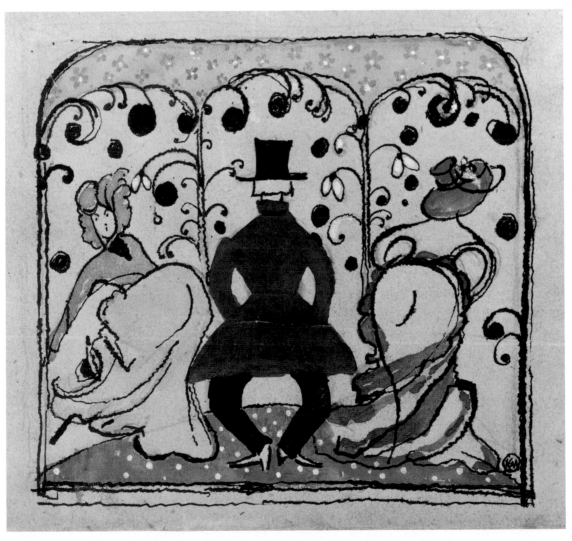

Fig. 2. *Erotic Motif.* c. 1908. Watercolor, india ink, and
pencil on gray paper, 6 × 7⅝″ (15.2 × 19.4 cm). Collection Lev Nussberg

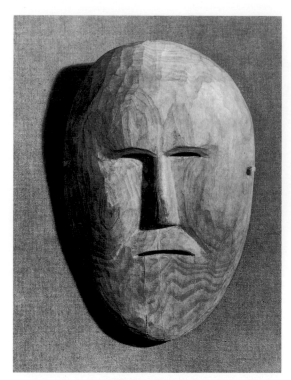

Fig. 3. Siberian mask. Koriak tribe, northeastern Siberia. Early twentieth century. H: 10⅝" (27 cm). Museum of Ethnography, Saint Petersburg

with contemporary Western painting was derived from a diligent perusal of books and journals, other people's lantern slides, traveling exhibitions, and Russian collections.

Malevich's periodic contributions to the comprehensive Moscow Artists' Society exhibitions came to a halt when the first "Jack of Diamonds" exhibition was organized in 1910 by Goncharova, Larionov, and several others. The unconventional name of the exhibition, the first in a series of unusual and antiaesthetic exhibition names in Russia, derived from Larionov's interest in popular folk art, and in hand-colored playing cards particularly. The "Jack of Diamonds" (in Russian literally the "Knave with Bells," an image that Larionov associated with the figure of the artist) served once more to place the Russian modernists in an international context. Among the two hundred fifty works displayed were paintings by the Munich Russians—Kandinsky, Bechtejeff, Jawlensky, Werefkin, and Gabriele Münter—and French Symbolists and Fauves—Gleizes, Moreau, and Le Fauconnier. In this company in December 1910, Malevich, probably at the invitation of Goncharova and Larionov, abandoned the relative anonymity of the heterogeneous Moscow Artists' Society, and made his debut with the emerging avant-garde. The three works that he sent to the exhibition were vigorous and color-saturated, derived from Gauguin and the Fauves, and far from the brooding Symbolism and Art Nouveau amusements of recent years.

The art of the prewar Russian avant-garde assimilated, and in turn reinforced, a Slavic cultural revival that was taking place throughout all of Eastern Europe. In the early years of the century the appealing notion of a unique Russian past and a cultural heritage that was fundamentally different from the West's was compounded of an intricate matrix of neonationalism, Russian Orthodoxy, Muslim nomadic cultures, and pre-Christian nature beliefs. This mythologized "Russia" functioned as did the notion of exotic tribal and Eastern cultures in Western European art. The crafts and artifacts of the Eurasian plain were understood to be naïve, irrational, and intuitive, and were set in counterdistinction to logic, rationalism, and artifice—characteristics perceived in "civilized" and "Western" art.

One of the most far-reaching and important episodes in the development of Russian Neo-Primitivism, however, came from the West: the intense encounter of the avant-garde with the work of Gauguin, Matisse, and Picasso. Neo-Primitivism was born in the flash of recognition that occurred when Malevich and Goncharova confronted first the work of Gauguin and Matisse, and slightly later the proto-Cubism of Picasso.

The artistic process that began with Gauguin and Matisse was not so much a matter of borrowing as it was of Malevich's boundless capacity for understanding and assimilation. He retained vivid impressions of Russian rural life, and could not help but be attracted by the colorful views of Brittany and the projections of a simple cultural harmony that Gauguin offered in his Breton and Polynesian scenes. The effect of works such as Matisse's 1909 *Nymph and Satyr* in the Shchukin collection can be felt in Malevich's rhythmic sketches and gouaches of spare peasant figures and in his oil painting *The Bather* (1910). Both the exotic non-Christian religiosity of Gauguin's adoptive culture, and the uncanny strength projected by the facial features Picasso borrowed from Iberian masks, were instantly recognizable to any Russian, whose own culture was marked by a "double belief"—a layering of Christianity over the lore and rituals of the ancient nature worship that was still practiced in the Russian countryside and formed a vital part of rural life.

The nativist claims that the avant-garde made for their art in 1912 were bolstered by the remarkable resemblance that images displayed in such masterpieces as Gauguin's *Blue Idol* (1898) or Picasso's *Seated Woman* (1907–8) (both of which hung in Shchukin's collection)

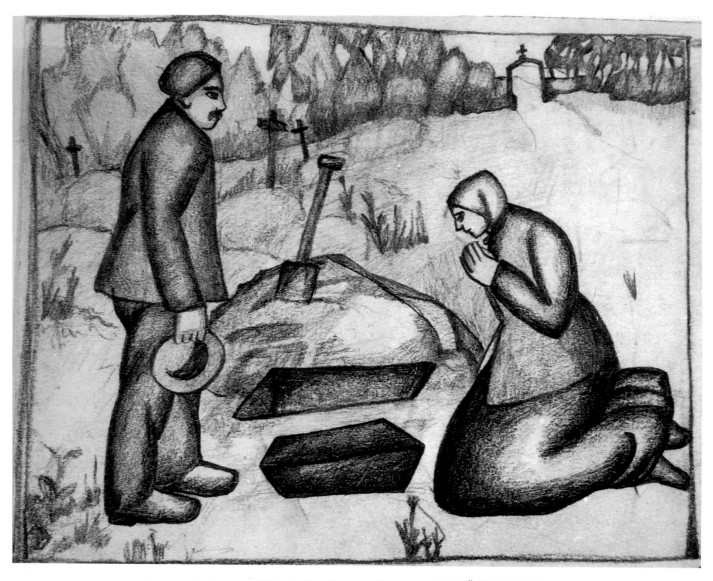

Fig. 4. *At the Cemetery*. 1910–11. Graphite pencil on paper, 6 × 7″ (15.2 × 17.7 cm).
Russian Museum, Saint Petersburg

have to the carved stone idols—the "stone women"—found in the Russian and Ukrainian countrysides (see plate 7a, page 60), and the widely known and admired masks made by Siberian tribes (fig. 3). Gauguin's exoticism, Picasso's Primitivism, and Matisse's simplifications were only a first cause; native sources were a treasure trove of visual ideas, and furnished a rich vocabulary for the expression of Malevich's deeply felt attachment to the peasantry.

An early indication that Malevich studied work by Gauguin and the Nabis artists are his self-portraits from about 1909 (plate 2) that take Nabis portraits as models. In these works Malevich's lifelong devotion to Symbolist ideas, to multiple layers of meaning, and to the compositional traditions of Russian icons are first set out. Their Western roots are clear: the brilliant colors, the Fauvist complementary reds and greens, the myste-

rious signs and hints at occult powers, all are indebted to the work of Gauguin and the Nabis. Yet there are essential differences; in several pencil sketches of Breton landscapes, and drawings after Gauguin's paintings *Yellow Christ* (1889) and *Tahitian Women with Mango Blossoms* (1899), Malevich undertakes a revision of the original subjects into Russian-Ukrainian peasants. Such transformations did not take place suddenly or uniformly; a series of pencil drawings from 1910 and 1911 documents the process. The subjects in *At the Cemetery* (fig. 4), for example, still retain a clear affinity with their origins in the Breton works. But prompted by Gauguin's primitivized peasants and island natives, Malevich treats his peasant figures more decisively as an indigenous subject in a drawing such as *Peasant Women at Church* (fig. 5). Here a group of peasant women, arms held close to only slightly articulated

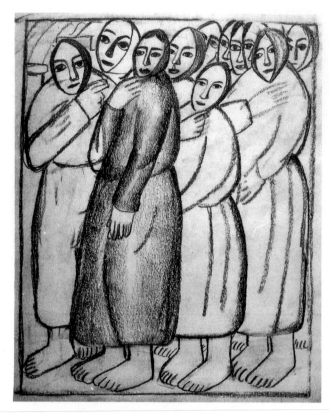

Fig. 5. *Peasant Women at Church.* 1911.
Graphite pencil on paper, 8½ × 7¼" (21.9 × 18.4 cm).
Russian Museum, Saint Petersburg

bodies, crowds within a shallow picture space. The rhythmic repetition of their heads and bodies, their repeated outsized bare feet, make of them a frieze of monumental forms. By their shape and gesture Malevich manages to invoke both the massive stone carvings of pagan Russia and a Christian form of worship, as the women, standing at a Russian Orthodox service, simultaneously make the sign of the cross.

The facial features in the pencil drawing are somewhat schematic, but they lack the emotional power of masks. In spite of the bodies' solidity, we are apt to think that this may be a drawing of smiling, sweet-tempered, uncomplicated women, attending a Sunday service; but in the oil painting Malevich successfully exploits the emotional potential inherent in the drawing. In the final version (fig. 6), the artist has sliced off the bottom portion of the work, thus eliminating the distraction of the feet, and moving the image closer to that of the stone idols (see plate 7a). The stonelike masks dramatize the women's mysterious ancient connections to the earth, their endurance, their human suffering, and their Christian spirituality. He has given the work a rough, tactile surface, outlining the heads and figures with heavy black lines and intensifying the faces by greatly exaggerating the black pupils in white

eyes, an effect that the work has in common with church mosaics and icons. Four large hands rhythmically punctuate the surface across the width of the work, emphasizing its friezelike two-dimensionality.

Like Goncharova, Malevich seems to have been strongly affected by Gauguin's ceramic figure *Oviri* (1894), modeled on a Tahitian deity. The work, strikingly similar in form to the Russian stone idols, was published in the January 1909 issue of *Zolotoe runo* and inspired fresh images of the Russian peasantry by both artists. But here, too, the subjective distance inherent in Western Primitivism, in Gauguin's visions of an island paradise and Picasso's savage masks, has been expunged in favor of a sympathetic identity of the artist with his subject. The exotic "otherness" has been converted into a vision of the peasantry that is wholly and inimitably Russian-Ukrainian.

Malevich exhibited his *Peasant Women at Church*, not at the next "Jack of Diamonds," but with a new exhibiting organization formed in 1911 by Goncharova, Larionov, and their friends expressly to promulgate Neo-Primitivist subjects and styles. Their first show opened in March 1912 under the name the "Donkey's Tail" in the exhibition space of the Moscow School of Painting, Sculpture, and Architecture. To this show Malevich sent twenty-four Fauvist and Primitivist paintings, Goncharova and Larionov contributed an overwhelming two hundred works, and there were paintings by Aleksei Morgunov, Marc Chagall, Vladimir Tatlin, and others. Larionov's group had also formed an alliance with the Petersburg-based Union of Youth, and they exhibited as a separate section of the "Donkey's Tail." It was through this association with the Union of Youth in 1912 that Malevich came to know the composer and violinist Mikhail Matiushin, who became a lifelong friend.

Many of Malevich's contributions to the "Donkey's Tail" were brightly colored paintings of peasant and "urban" subjects, such as *Argentine Polka* (plate 3) and *On the Boulevard* (plate 5). But there were also the mysterious *Peasant Women at Church* and other similar canvases that were subdued in color and of great expressive power. With this exhibition, Malevich hit his stride as a major artist. Later he remembered his and Goncharova's peasant subjects that debuted there as the most important difference between that exhibition and the contemporaneous "Jack of Diamonds."

Malevich continued to be associated with Larionov's group through the spring of 1913, when their "Target" exhibition opened in Moscow. Larionov first exhibited Rayist paintings at this exhibition, and Male-

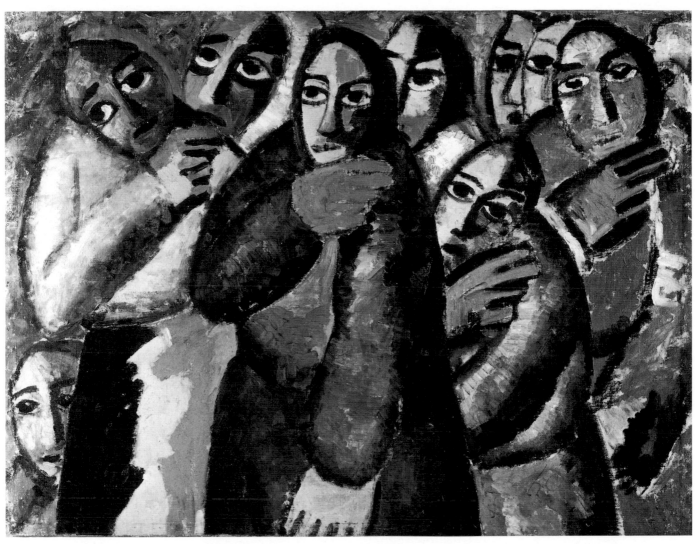

Fig. 6. *Peasant Women at Church*. 1911. Oil on canvas, 29½ × 31¼" (75 × 79.5 cm).
Stedelijk Museum, Amsterdam

vich introduced his new Futurist renditions of peasant subjects, such as *The Grinder* (plate 13) and *Morning After a Storm in the Country* (plate 10).

In 1913 yet another rearrangement in artistic allegiances allied Malevich with David Burliuk's group of painters and poets, including Kruchenykh and Khlebnikov. This additional connection was especially congenial for Malevich because it brought together artists and poets who were also particularly concerned with the philosophical and theoretical aspects of art. The most fruitful ideas for Malevich were suggested by Kruchenykh and Khlebnikov's theory of the "self-sufficient word" and the notion of *zaum*, a "beyond the mind" state of being where language and vision occur outside of conscious thought. *Zaum* postulated a higher realm, a stable and pervasive absolute universe that "stands behind" the visible world, and that is accessible to those people, especially artists, who possess a highly evolved level of perception.

Kruchenykh's theories of language and *zaum* poetry are indebted to many sources, including theosophy, the fourth dimension of Petr Demianovich Uspensky, the cosmic consciousness of Richard Maurice Bucke, and the glossolalia practiced in the Russian countryside by Christian sects. In the visual arts *zaum* advances the notion of the artist as seer, and has much in common with Umberto Boccioni's and Robert and Sonia Delaunay's contemporaneous understanding of simultaneity and abstraction. Like Gleizes and Metzinger in their 1912 essay *Du Cubisme*, Matiushin and Malevich associated such ideas with Cubism, and with clairvoyance and a new perception of space. In the 1913 publication *Troe* (The Three), Matiushin wrote:

Artists have always been knights, poets, and prophets of space, in all times. Sacrificing to everyone, dying, they were opening eyes and teaching the crowd to see the great beauty of

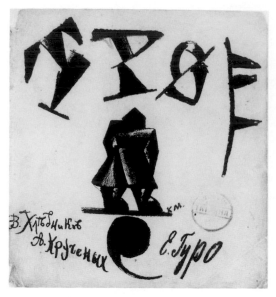

Fig. 7. Front cover of *Troe*. 1913.
Lithograph, 7½ × 7⅛″ (19.1 × 18.1 cm).
Dallas Museum of Art, The Art Museum League
Fund in honor of Mr. and Mrs. James H. Clark

the world concealed from it. So it is now; Cubism has raised the flag of the New Dimension, of the new learning about the merging of time and space.

For the lithographed cover of *Troe* (fig. 7) Malevich chose a silhouette of the symbolic peasant figure that he had repeatedly portrayed cutting or sawing—deconstructing—solid pieces of the visible world, as in *The Woodcutter* (plate 9) and *The Carpenters* (fig. 8). On the cover of *Troe*, however, all details and allusions to the subject's peasant nature have been erased, and it has become instead a hulking supernatural creature, a looming emblem of the future. Another illustration in the same publication (fig. 9) alludes to the artist's new perception of the world, literally by casting it in a new light, a procedure recommended by Kruchenykh in *Troe* in his essay, "New Ways of the Word." Malevich fractures the visible world by means of implied light; the

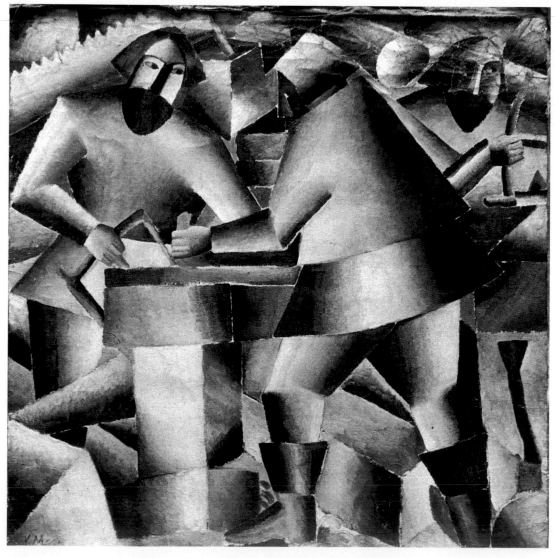

Fig. 8. *The Carpenters*. c. 1912. Whereabouts unknown

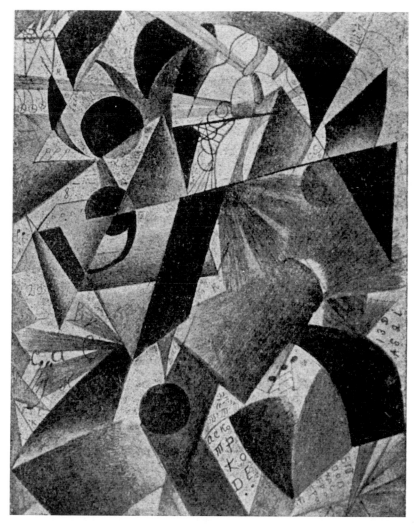

Fig. 9. Page from *Troe*. 1913. Letterpress, 5⅛ × 4″ (13.0 × 10.2 cm).
Dallas Museum of Art, The Art Museum League
Fund in honor of Mr. and Mrs. James H. Clark

shadows that extend into the picture space may be assumed to be related to objects, but it is not possible to identify the objects that have created them. In the midst of isolated musical notes and letters, independent proto-Suprematist elements have begun to emerge. The role of these shadows of worldly objects in the creation of Suprematism can be seen clearly in this lithograph. It is one of the most striking demonstrations of the importance of *zaum* among the many routes that led Malevich to the new objectless world of Suprematism.

In retrospect, Malevich placed great significance on the Cubo-Futurist opera *Victory over the Sun* as the immediate stimulus to Suprematism. *Victory* was devised at a gathering of Malevich, Kruchenykh, and Matiushin that took place from the eighteenth to the twentieth of July 1913 at Matiushin's estate in Uusikirkko, Finland. Khlebnikov was also supposed to have been present, but while swimming he had lost the train fare that Matiushin had sent him, and so was not able to come. "After it happened, I went fishing for the frog-wallet with a net and hooks, but nothing came of it," he wrote unhappily to Matiushin. Later he would contribute a freestanding prologue to the opera, but the work as a whole might have been very different had Khlebnikov not gone swimming.

At Uusikirkko the men made plans to produce several theater pieces for the coming season, and Kruchenykh composed a libretto for their opera. "I wrote *Victory over the Sun* imperceptibly," he noted later. "The stimulus of the very unusual voice of Malevich and the gentle singing violin of dear Matiushin helped me to formulate it." After the two performances of the opera at the Luna Park Theater in Saint Petersburg in December 1913, Matiushin published the text as a small brochure; it contained spoken words, songs, a scattering of stage directions, and a few excerpts of music. It

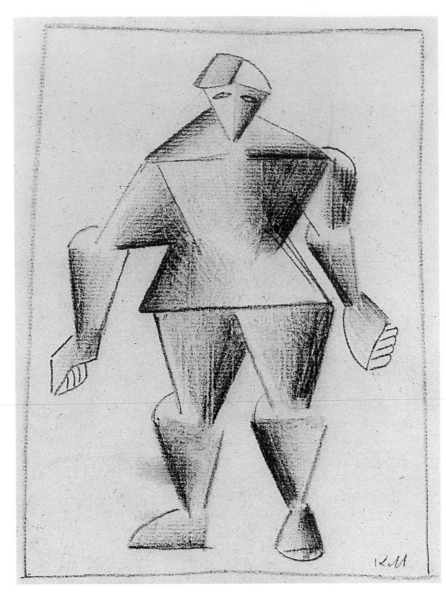

Fig. 10. *Futurist Strongman*. Costume design for *Victory over the Sun*.
1913. Graphite pencil on paper, 10⅝ × 8¼″ (27 × 21 cm).
Museum of Theatrical and Musical Arts, Saint Petersburg

is from this publication that the story line of *Victory over the Sun* must be deduced.

Victory has two "actions" or "movements," the first composed of four scenes, the second of two. The first part concerns, sometimes indirectly, the capture of the sun; the second, "Country Ten," a location in the future after the sun has been overcome. The cast includes two Futurist Strongmen (fig. 10), a dusty traveler through time, a character bent on evil, and a fused Nero-Caligula, the whining representative of the past. The characters are one-dimensional personifications of qualities, of the sort found in morality plays. Their monologues are often completely unresponsive to one another, being directed primarily at the audience, rather than eliciting motivated action. The capture of the sun takes

place offstage; the audience witnesses only a series of vignettes which convey ambient violence and the cool irrationality of the event.

The second act depicts the new age, "Country Ten." The captured sun has been confined in a concrete house. The past is gone, and with it went memories and mistakes and the bending of knees: "You become like a clean mirror or a fish reservoir where in a clear grotto carefree golden fish wag their tails like thankful Turks." But things are not perfect; as was predicted in the first act, "There is no happiness there everyone looks happy and immortal. . . . Many people don't know what to do with themselves for the great lightness. Several tried to drown themselves, the weak ones went out of their minds, saying: we can really become terrible and

strong. It oppressed them." In the last scene, the Fat Man, the representative of the ordinary person, wakes up bewildered, in a confining, houselike structure (fig. 11). "Where is the sunset?" he cries, while a skull gallops around on four legs. "Country Ten . . . the windows are all constructed inside the house is fenced in. . . . And here I didn't know one must stay locked up." At the sound of a propeller, a young man rushes in and sings a "frightened vulgar song," which begins with nine lines of individual *zaum* sounds and develops into a series of Surreal images. Athletes enter, singing a song which also evolves into *zaum* sounds and phrases (plate 15). An airplane crashes onto the stage, but the Aviator appears unharmed. The opera ends as Futurist Strongmen intone, "The world will perish but we have no end."

Malevich's scenery and costumes for the seventeen characters of the opera are no longer extant, but his preparatory designs do exist. They show that the artist planned a Cubo-Futurist decor calculated to produce a sense of confusion and spatial disorientation. The flats and backdrops depicted portions of the sun, airplane, wheels, words, wires, and unidentifiable shapes and shadows in a highly schematic way. A contemporary photograph shows that the decor for the opening scene of the opera closely followed the artist's sketch (fig. 12) and was almost totally abstract. It consisted of large vertical painted planes descending from the top of the stage, and an inclined plane rising from left to right at stage left. The sketch specifies that the scene be executed in black and white. At the performance itself, the lower portion of the design was not realized and Malevich added linear details, such as a pair of airplane wheels at the top center. The second act opened with the most abstract backdrop, which depicted a small section of a circle seen through a rectangular opening within a square, presumably the sun as seen through a window of the concrete house (fig. 13). The structure of the house of the last scene (fig. 11) is based on popular illustrations of a fourth-dimensional cube. Indica-

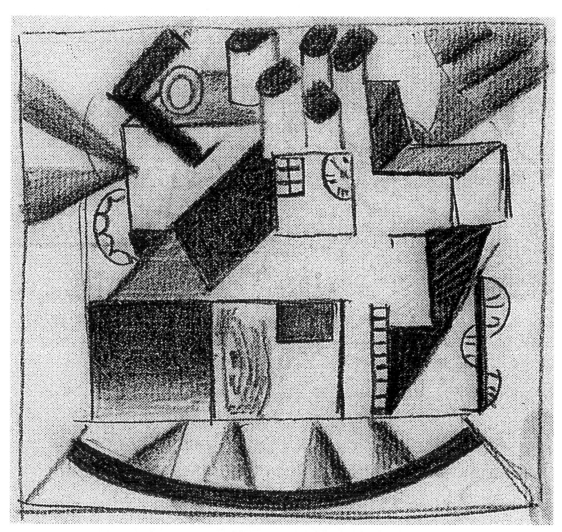

Fig. 11. Stage design for *Victory over the Sun*, Act 2, Scene 2. 1913. Graphite pencil on paper, 8¾ × 10⅝" (21.3 × 27 cm). Museum of Theatrical and Musical Arts, Saint Petersburg

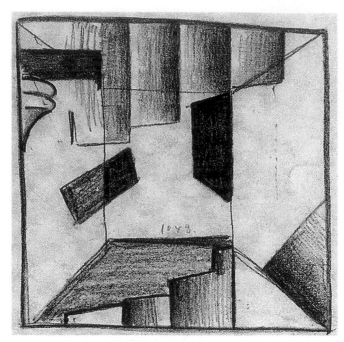

Fig. 12. Stage design for *Victory over the Sun*, Act 1, Scene 1. 1913. Graphite pencil on paper, 10¼ × 8″ (25.9 × 20.2 cm). Museum of Theatrical and Musical Arts, Saint Petersburg

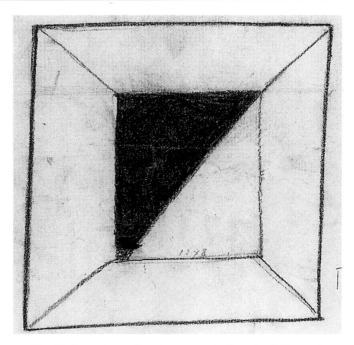

Fig. 13. Stage design for *Victory over the Sun*, Act 2, Scene 1. 1913. Graphite pencil on paper, 8¼ × 10⅝″ (21 × 27 cm). Museum of Theatrical and Musical Arts, Saint Petersburg

tions of the "inside" and "outside" have been conflated, so that the viewer, like the Fat Man of the opera, sees a roof and chimneys surrounding a window through which a farther view of outside is visible. A ladder and circular stairs are meant only to add snidely to the frustration of trying to escape.

Malevich's costume designs are based on geometric shapes. The lower portion of the Bully's shirt forms a triangle, the legs of an Attentive Worker are built of doughnut-shaped rings, the Futurist Strongman (fig. 10) is composed entirely of cones. Malevich's costumes were intended to reproduce on stage the simplified geometric figures in paintings such as *Morning After a Storm in the Country* (plate 10) or *The Woodcutter* (plate 9). The design for the Futurist Strongman bears a strong resemblance to the apocalyptic figure on the cover of *Troe* (fig. 7), a representation of the prophetic nature of the artist. But in the theater the artist also had an opportunity to work with the effects of real light. He tried to use the spotlights to isolate individual fragments of the scenery, creating the illusion that they projected backward or forward in space, to combine and confuse real and painted shadows, and to animate the entire stage composition. The poet Benedikt Livshits remembers:

> Out of the primordial night the tentacles of the spotlights snatched part of first one and then another object and, saturating it with color, brought it to life. There was no comparison at all with the "fairy-light effects" that were in use in theaters of the time. The innovation and originality of Malevich's device consisted first of all in the use of light as a principle which creates form, which legitimizes the life of the object in space. . . .[4]

Several of Malevich's set designs are composed with receding or open centers in the back plane. Isolated in the spotlight, such an area would seem to open into an undefined space, and has the potential for creating a sensation of great depth. Undoubtedly the artist was trying to produce on stage that new dimension, that "merging of time and space" about which Matiushin had written almost a year earlier.

Malevich's set designs show a great sophistication about the possibilities of light and perspective in a theater space. They apparently were conceived specifically to take advantage of the equipment at the Luna Park Theater. None of the creators was satisfied, however, with the actual performances, which had been arranged hurriedly and without adequate rehearsals. Malevich, in particular, was eager to produce the opera again. Shortly after the Petersburg performances, he began to organize a production of *Victory* in Moscow, but the war intervened, and later the Revolutions, and plans were abandoned. The artist's next work for the

theater would be realized only five years later, when he designed sets and costumes for Vsevolod Meierkhold's production of Mayakovsky's *Mysteriia-Buff*, which opened in November 1918 at the Theater of Musical Drama in Petrograd. None of these designs has yet been found. Malevich described them in a 1932 interview; his explanation could equally well have applied to *Victory over the Sun*:

> The motion of the actors was to have been combined rhythmically with the elements of the decoration. On one canvas I painted several planes. I regarded the space as Cubistic rather than illusory. I thought my task was to create, not associations with the reality that existed beyond the footlights, but a new reality.[5]

After the two performances of *Victory over the Sun*, Malevich continued to explore the metaphysical possibilities of Cubism. The fourth-dimensional "cube" that made its appearance in *Victory* (fig. 11) reappeared in *Lamp (Musical Instrument)* (plate 16). In such works as *Lady at a Trolley Stop* and *Englishman in Moscow* he pursued the notion of concealment and mystical revelation (plates 17 and 18). In collaged paintings such as *Lady at an Advertising Column* and *Warrior of the First Division, Moscow* (both 1914), he combined newspaper clippings, objects, painted numbers, letters, and schematic structures in a Cubist space. Only slightly integrated into the compositions are flatly painted rectangles of color that seem deliberately to obscure portions of the painting beneath them. In such works Malevich sought to associate formal style with the evolution of the psyche, as well as to demonstrate several stages of perception. In the contemplation of partially obscured images and the blank rectangles, the viewer was called upon to reach for a higher intuitive understanding of the visible world.

Malevich's continuing passion to convey a higher reality in his art resulted in a historic further step in December 1915, with his introduction at the "0,10 (Zero–Ten)" exhibition of the new rigorously geometric style of painting he called Suprematism. Malevich's breakthrough to Suprematism was made in the early spring of 1915. The "discovery" of Suprematism had been made, a preliminary theory worked out, and the publication of a collaborative journal entitled *Zero* had been planned by the end of May 1915.

At that time Malevich was making new drawings for another edition of the *Victory over the Sun* brochure.

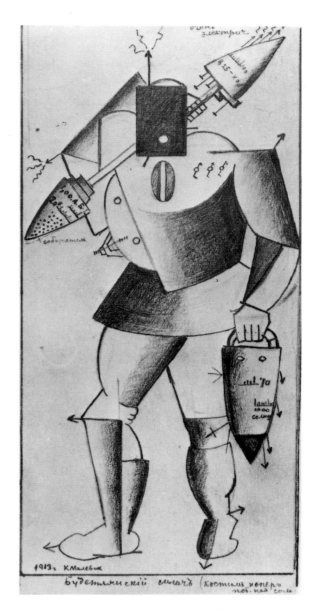

Fig. 14. *Strongman*. Costume design for *Victory over the Sun*. 1915. Graphite pencil on paper, 6⅛ × 3⅛" (16.2 × 7.9 cm). Literary Museum, Moscow

Recognizing immediately the historic importance of the new style, he went to some length to convince Matiushin that no essential changes had been made in the original drawings from 1913. He wrote anxiously to Matiushin about the publication, sent him three new drawings, and retrospectively associated his new ideas with the first production of *Victory*. The drawings that Malevich hoped to have printed in the new edition of *Victory* (fig. 14 and plate 20a, page 86), are quite distinct in subject and style from the 1913 designs. They incorporate wartime images and ideas, such as the weapon of destruction carried by the Futurist Strongman, which appears also in a view of the "victory." Malevich described the weapon as consisting of porous revolving cones capable of absorbing fire and converting it into

Fig. 15. Building in which Dobychina's gallery was located, at 7 Marsovo Pole, Saint Petersburg. Photograph 1984

electricity. The victory depicted in plate 20a is, of course, the conquest of the sun, seen as an aerial battle, complete with the electric cones, and the composition is based on the aerial maps which were published and became generally known during the war. Malevich's pivotal discovery was that the sensation of flight could be retained simply by means of the rectangles, preserved even when other references were removed. Although schematic references to aerial mapping may be detected in several Suprematist compositions, and in his explanatory charts he associated Suprematism with aerial views, most often the dynamics and the simple relationships of one rectangle to another were enough to sustain a picture.

The first public exhibition of this nonfigurative work was held in wartime Petrograd at the Dobychina Gallery, near the Winter Palace (fig. 15). Malevich showed thirty-nine paintings composed primarily of rectangles and bars of saturated color with no apparent traces of objects (fig. 16). In theory at least, the new art no longer depended on the visual world, but like Kruchenykh's *zaum* words, was self-sufficient, the free product of the artist's creative will. Malevich's new paintings advanced a nonfigurative vocabulary of a severity unknown in the history of Western painting.

Malevich's instant recognition of the importance of his discovery led to an obsessive secrecy during the time he was working on the first Suprematist canvases, and his almost immediate attempts to predate their creation. In the summer of 1915 the young linguist Roman Jakobson went to the village of Kuntsevo to visit the artist:

> I went to see Malevich—at Malevich's invitation—with Kruchenykh. We ate, and then a scene occurred that surprised me. Malevich was terribly frightened that people would find out what he was doing new. He told me a lot about it, but he couldn't bring himself to show me his new works. Kruchenykh then joked that Malevich and Morgunov were so afraid of publicity, so afraid that their secret inventions would be found out and stolen, that they painted in complete darkness. But in fact only the shades were down.[6]

Although Malevich would paint in the Suprematist style for fewer than five years, it cannot be considered just another stylistic phase in his oeuvre. The discoveries of Suprematism would mark his art for the rest of his

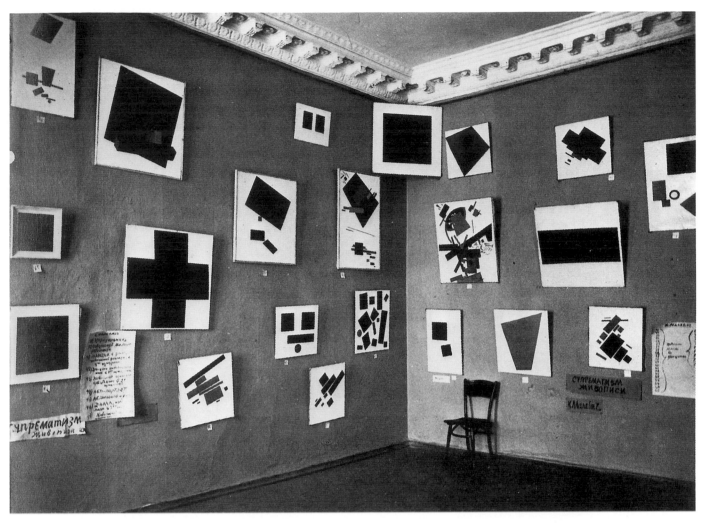

Fig. 16. Installation view of "0,10 (Zero–Ten).The Last Futurist Exhibition." Petrograd, 1915

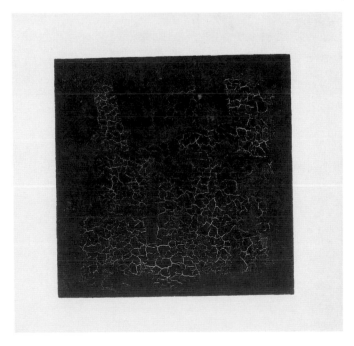

Fig. 17. *Black Square*. 1915.
Oil on canvas, 31⅛ × 31¼″ (79.2 × 79.5 cm).
Tretiakov Gallery, Moscow

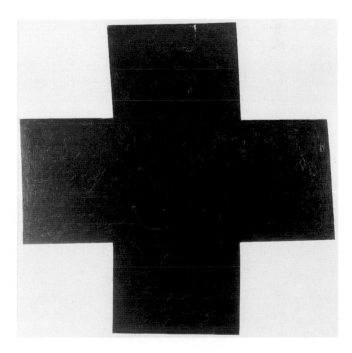

Fig. 18. *Black Cross*. 1916–17. Oil on canvas,
31½ × 31⅙″ (80 × 79.3 cm). Musée National d'Art Moderne,
Centre Georges Pompidou, Paris

life and drive the elaboration of his metaphysics and formalist theory of style. The artist recognized his new work as the advent of an entirely new era in art, as a radical readjustment in the aims of painting and its relationship to the visible world. No longer called upon to portray "little corners of nature" and "beloved objects," the new art without objects, which Malevich at first linked with penetrating sight and the sensation of a fourth dimension, very soon was described in terms of "eternal sensation," the "cosmic infinite," the "void"—in a word, the philosophical sublime. The Suprematist style also functioned as a sign of the transformed consciousness Malevich had sought for so long to express. Certain of the paintings, such as the *Black Square* and the *Black Cross* (figs. 17 and 18), acquired emblematic status, signaling by their visual strength and uncompromising intensity the artist's decisive turn toward a vision of the absolute.

In his attempt to elucidate Suprematism and establish a conceptual underpinning for it, Malevich embarked upon a concentrated study of philosophy that propounded Suprematism as a further step in the evolution of religious understanding, a development that in its universality supplanted Russian Orthodoxy and even Christianity as a whole. In 1916, recently drafted into the army and worried about losing his life without fixing Suprematism in the annals of history, Malevich wrote to Matiushin about the necessity for producing a book, a "New Gospel in Art":

> Christ revealed heaven on the earth, which put an end to space, established two limits, two poles, wherever they may be—in oneself or "out there." But we will go past thousands of poles, just as [easily as] we pass by millions of grains of sand on the banks of a sea or river. Space is bigger than heaven, stronger, more powerful, and our new book is a teaching about the space of emptiness.

Curiously coexistent with the philosophical idealism of Suprematism was a practical, even materialist, strain in its conceptual base. Even before the opening of "0,10 (Zero–Ten)" Malevich envisioned a broad transformation of the arts on the basis of the Suprematist vocabulary: not only painting, poetry, sculpture, and music were to be reinvented in the Suprematist image, but also the more practical areas—textiles, architecture, film, and technology. The absolutist philosophy of the objectless world of Suprematist painting did not keep him from subjugating its visual forms to the aims of industrial design (see plate 22a, page 90). For the front and back covers of a folder to be used at an agricultural congress, he arranged Suprematist forms to suggest a human head and shoulders (fig. 19) and invented a Suprematist alphabet that looks uncannily like an early computer-readable typeface (fig. 20).

The progressive historical perspective that Malevich adopted in his conception of Suprematism as the "next stage" of art also gave him an educational mission. In 1916, with the artists Olga Rozanova, Nadezhda Udaltsova, and Liubov Popova, he made an unsuccessful effort to publish a journal to propagate Suprematism and to illustrate the multiple possibilities of its visual vocabulary, and a year later, shortly before the November 1917 revolution, he outlined a broad revision of Russia's art education to support this vast project.

Like most other avant-garde artists and poets, Malevich had democratic and Socialist views. He had welcomed the 1905 revolution and its short-lived liberalization and by 1917 was strongly opposed to the war; in March he was generally delighted by the overthrow of the tsarist government. The March Revolution resulted in unstable political power that shifted between a temporary government and councils of workers' and soldiers' representatives. The vast reshuffling of society that ensued provided a ready outlet for Malevich's organizational and administrative skills. While still in the army, in March 1917, he was called upon by the Moscow Soviet of Soldiers' Deputies to run their newly organized Art Section; another appointee to the same organization was the artist Lazar (El) Lissitzky. Malevich immediately set about organizing art workshops in the fine and applied arts, a free "People's Academy," which was to have affiliated schools in Petrograd and several provincial centers. During the November Revolution he was appointed commissar (political administrator) for the protection of the churches and artworks in the Kremlin, and early in 1918 was elected a member of the Moscow division of the Visual Arts Section of the Commissariat of Public Education (Narkompros).

In pursuit of a clarification of Suprematism, Malevich also began to write in earnest after the November Revolution, producing numerous articles and several small books that contained his social and aesthetic ideas. In *On the New Systems in Art*, written in the summer of 1919, he described modern styles as sign systems in a metaphysical evolution that moves in quantum steps toward a grand cosmic unity. In 1920, he presented a collection of lithographs, *34 Drawings*, after Supre-

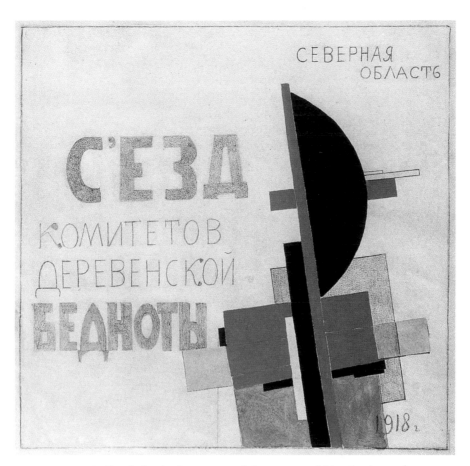

Fig. 19. Sketch for the front cover of the program folder for the First
Congress of the Committees of the Rural Poor. 1918. Watercolor, gouache,
India ink, and graphite pencil on paper, 15⅜ × 14⅞″ (39.2 × 37.9 cm).
Institute of Russian Literature, Pushkin House, Saint Petersburg

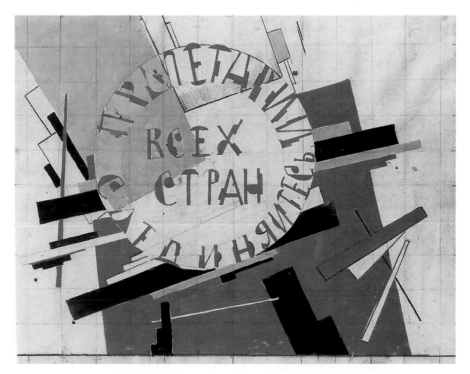

Fig. 20. Sketch for the back cover of the program folder for the First
Congress of the Committees of the Rural Poor. 1918. Watercolor, gouache,
India ink, and graphite pencil on paper, 12⅞ × 16¼″ (32.7 × 41.3 cm).
Institute of Russian Literature, Pushkin House, Saint Petersburg

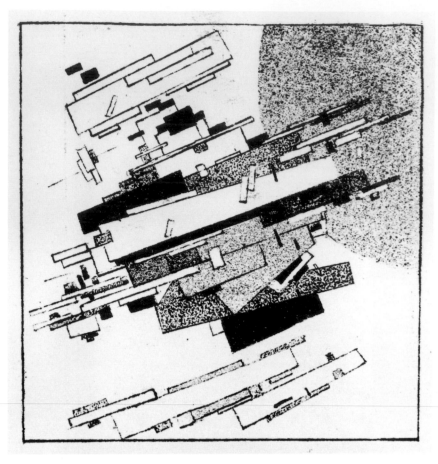

Fig. 21. *Untitled (Formation of Construction Depending upon Movement into a Sphere)*. 1920. Lithograph, 3⅝ × 3½" (8.6 × 8.9 cm). From *34 Drawings*. Dallas Museum of Art, The Art Museum League Fund in honor of Mr. and Mrs. James H. Clark

matist paintings, and discussed them in terms of energy and natural forces; *God Is Not Cast Down* (1922) is a discourse on the nature of God and the absolute. Malevich's magnum opus is *The World as Objectlessness*: a long discursive text written at intervals from about 1923 to 1926. It sets out most completely the artist's aesthetic and philosophical ideas, as well as his polemics with the state and with contemporary art criticism. Often contradictory, but with flashes of brilliance, this work, now available in English as *The World as Non-Objectivity*,[7] went unpublished in the artist's lifetime.

In 1918 Malevich taught at the Free Art Studios (Svomas) in Petrograd and was a member of the Artists' Commune group. In 1919 he moved back to Moscow and in the fall he taught at its Free Art Studio, where he had several notable students, including Sergei Senkin, Gustav Klutsis, and Ivan Kudriashev. Inspired perhaps by Kudriashev, whose father was an assistant to Konstantin Tsiolkovsky, the mystically inclined inventor of the reactive rocket, and by the formal possibilities of Suprematism, Malevich developed an interest in space satellites and space-flight imagery.

Other worlds, the unearthly, had been an underlying theme of Malevich's work since the days of Symbolism. It was present also in *Victory over the Sun* and in his approach to Cubism. But after the Revolution this interest congealed into space-flight imagery and the design of satellites. From the beginning Malevich had associated Suprematism with flight. In the summer of 1916 he had written to Matiushin:

The keys of Suprematism led me to discover what had not yet been realized. My new painting does not belong to the Earth exclusively. The Earth has been abandoned like a house infested with termites. And in fact, in man, in his consciousness, there is a striving toward space. An urge to take off from the Earth. . . .

Born at the height of the first large scale war in which balloons and airplanes played a prominent role, the new style often objectified the sensation of weightlessness and free flight in space (plates 20 and 24). During the next several years the link between Suprematism and

aerospace technology became increasingly specific. In 1915 Malevich's first Suprematist paintings were given titles that referred to people or objects that somehow "stood behind" or initiated their geometries, much as the implied objects had produced shadows in the page in *Troe* (fig. 9). A year later such titles were dropped and the artist began simply to number the works. Visually his work reflected this change; a series of drawings done before he left Moscow for Vitebsk are clearly related to technical diagrams.

The inclination to science at this time was not unique to Malevich. After the November Revolution many avant-garde artists, including Kandinsky, Aleksandr Rodchenko, Ivan Kliun, Georgii and Vladimir Stenberg, reacted to the call for rationalism and materialism by transforming images drawn from contemporary physical science and technology into abstract paintings.

Malevich's approach to space travel, however, was not only visual, but a fully thought-out extension of Suprematist gnostic philosophy, based to some degree on the ideas of Tsiolkovsky and Tsiolkovsky's mentor, the philosopher Nikolai Fedorov. Ultimately for Malevich satellites had less to do with technical advances than with their identities as perfect forms that had achieved a "harmonious introduction . . . into natural processes," a balanced interrelation between natural forces. In this respect Malevich's satellites occupied the same hermetic realm as the one depicted on the Suprematist canvas. In the text accompanying *34 Drawings* he explained:

> The Suprematist apparatus, if one can call it that, will be one whole, without any fastenings. A bar is fused with all the elements, just like the earth's sphere, which contains life perfectly in itself, so every constructed Suprematist body will be included in a natural organization, and form a new satellite. One only has to find the interrelationship between the earth and the moon, two bodies racing along in space. Perhaps a new Suprematist satellite equipped with all the elements can be built between them; it will travel in its orbit, creating its own new path.

The lithographs of *34 Drawings* comprise many examples of Malevich's conception of Suprematist apparatuses and space flight (fig. 21); all are related to Suprematist paintings and drawings. The subject of the crayon and watercolor *Study for Suprematism 52. System A₄*

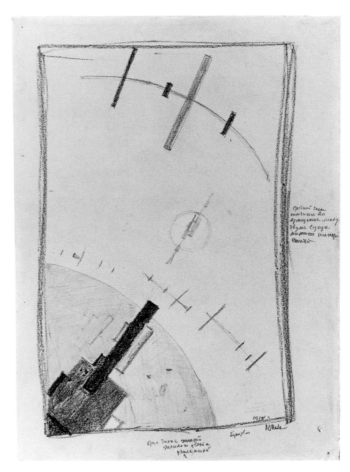

Fig. 22. *Study for Suprematism 52. System A₄*. 1917–18. Crayon and watercolor on paper, 27⅛ × 19¼" (69 × 49 cm). Stedelijk Museum, Amsterdam

(fig. 22), as of many of the objectless paintings (plates 19, 20, 23, and 24), seems to be Suprematist objects floating in a cosmic space, but here the constructions are massed to suggest satellites or space stations. At the lower left above a segment of a giant pink disk or sphere, a complex form appears to move upward and to the right. As in the set design depicting the confined sun for *Victory over the Sun*, the view of the circular element is partial, cut off by the framing edge of the composition. In the center of the drawing, but smaller and seemingly at a greater distance, a similar disk and construction are visible. Curved and straight axes supporting Suprematist bars orbit the sphere parallel to its surface. Done at a time when there were no images of modern space vehicles, Malevich's drawings of this period seem to us surprisingly prescient.

Suprematist compositions also were derived from aerial projections, and from diagrams illustrating magnetic attraction, energy, and telegraphy (fig. 23). The interest in science and technology continued for at least five or six years as Malevich's students in Vitebsk, especially Ilia Chashnik, eagerly cultivated similar ideas.

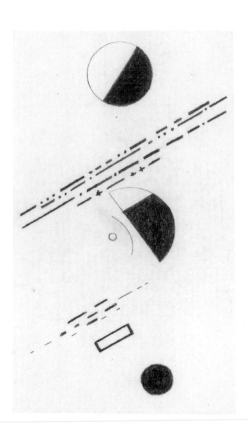

Among their sixty works shown at the 1923 exhibition "Petrograd Artists of All Trends" are several that demonstrate idealized technical images of "Suprematist structures" (fig. 24).

Malevich's first solo show—the Sixteenth State Exhibition—was scheduled for Moscow at the end of 1919. But he was finding life in Moscow extremely difficult; the inflation caused first by the Great War and then by a raging civil war was raising prices by the hour, and there was little heat or transportation in the city. Lacking a Moscow apartment, he was forced to live at his little dacha in the outlying village of Nemchinovka. Most devastating of all, there was a paper shortage and little was being printed, so he was having no success in publishing *On the New Systems in Art*. It is no wonder, therefore, that at the end of October, he seized upon Lissitzky's invitation to join him at the art school

Fig. 23. *Suprematist Group of Elements with the Sensation of a Current (Telegraph)*. Before 1927. Graphite pencil on paper, 4⅜ × 2⅝" (11 × 6.4 cm). Öffentliche Kunstsammlung Basel. Kupferstichkabinett

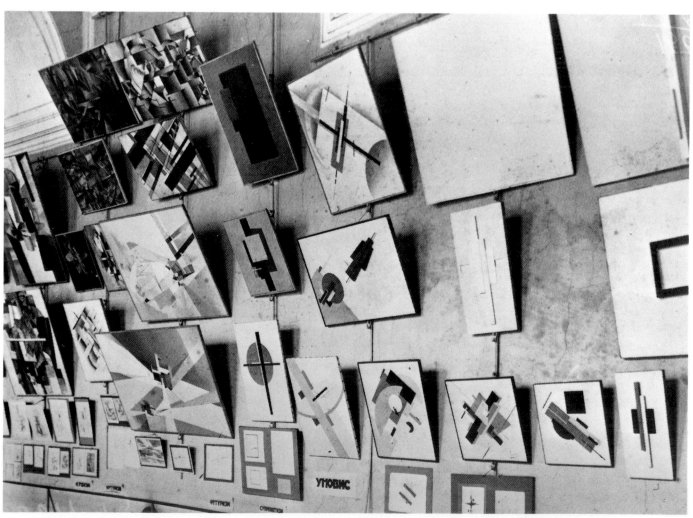

Fig. 24. Installation view of the Unovis section of the exhibition "Petrograd Artists of All Trends," 1923

in Vitebsk, Belorussia (now Belarus), and his offer to print *On the New Systems in Art* in the school's lithographic workshop. In spite of the fact that he had a major retrospective opening in two months in Moscow, Malevich left the city. From Vitebsk, he sent a telegram to the school in Moscow quitting his job: "In spite of all my desires to work at the Studios, but having no apartment (I am living in a cold dacha), nor wood, nor electric light, I am forced to accept the proposal of the Vitebsk Studios, which offered me everything necessary to live and work, and to leave my work in Moscow."[8]

Malevich intended to spend only a short time in Vitebsk but the situation in Moscow did not improve, and he soon found that the Vitebsk school provided an opportunity to carry out the educational project that he had been devising since the appearance of Suprematism. A motivated and inspiring leader, within six months of his arrival he had acquired a devoted following among the school's very young students and had converted most of its curriculum to conform to his theories.

Led by Malevich, Vera Ermolaeva, the rector of the school, and faculty members Nina Kogan and El Lissitzky, the enthusiastic young artists named themselves Unovis (Advocates of the New Art). In Vitebsk the principal efforts of Unovis were directed at the "manifestation of the world in the new color-painting," that is, at transforming the world in the image of Suprematism. Students and teachers worked anonymously, energetically designing flags, orators' platforms, fabric, placards, and decorating buildings, and even trolley cars, with Suprematist designs (fig. 25). As in other provincial towns, plans were made in Vitebsk to open a museum of modern painting, a Museum of Artistic Culture, and with the help of Narkompros paintings began to be collected.

But despite Malevich's passionate concentration on artistic activities, the toll taken on him by daily life in Vitebsk was hardly less than it had been in Moscow. To make it even remotely possible for the students to pursue their study of art under the conditions of extreme privation, the school's staff had to undertake to supply the necessities of food, clothing, and even bathing facilities. As the situation worsened, teachers and students sold the school's equipment and their own possessions in order to survive. Malevich's daughter Una (for Unovis) was born in 1920 under these difficult conditions. To make matters worse, Malevich and the school were regarded as politically suspicious. They did not fit the mold of the requisite Marxist materialism as it was

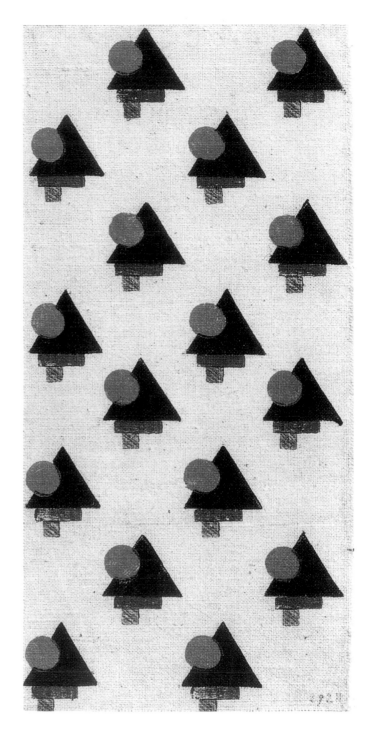

Fig. 25. Design for Suprematist fabric. 1919. Ink and gouache, stenciled on canvas, 7⅞ × 3¾" (20 × 9.6 cm). Russian Museum, Saint Petersburg

commonly understood. Suprematism was too unorthodox, too nonrepresentational, and seemed to range too freely into realms of the subjective and the nonmaterial. Malevich's art and ideas became the target of local officials; desperate appeals for aid to the official educational and professional organizations went unanswered.

Exhausted and worried, Malevich and a group of teachers and students moved from Vitebsk to Petrograd in the spring of 1922. There they continued to work under the rubric of Unovis. In the summer of 1923

Malevich was appointed director of the Petrograd Museum of Artistic Culture, and during the following year he oversaw the addition of research laboratories to the museum, thereby transforming it into the Petrograd State Institute of Artistic Culture (Ginkhuk). Administered initially by the Main Science Administration (Glavnauka), Ginkhuk retained Malevich as director, and also as head of the Formal and Theoretical Section of the research studios.

A major topic of Malevich's research at Ginkhuk was the formalist analysis of painting styles that he called the "Theory of a Supplementary Element." The artist and his students examined the forms and colors of a series of stylistic systems, isolating fundamental structural elements and a range of color characteristic of each one. On the chart of the second stage of Cubism (fig. 26), for example, the characteristic forms found in paintings by Metzinger, Popova, Udaltsova, Gleizes, Braque, and Picasso are illustrated. One sickle-shaped form, the underlying structural element, is further extracted from these (lower right). According to the theory, such an informing plastic shape could be isolated for any style of any period. Similarly, a characteristic color range was established for each style. The color ranges resemble the results of chemical chromatography, a method of separating and identifying the constituent ingredients of complex mixtures. Five stages of Cubism, illustrated with works by Braque and Picasso, and the forming element for each, are shown on *Chart No. 5* (fig. 27). It is not coincidental that Malevich shows the supplementary elements in white circular areas as if seen through the lens of a microscope. He compared the "supplements" to the transforming tuberculosis bacilli identified by the biologist Robert Koch. Like bacilli they "managed to creep into the painter and changed his behavior," acting as an infective agent responsible for a radical change in the artist's system of work. Artists' reception of these forming elements, according to the theory, was conditioned both by their physical environment and their psychological develop-

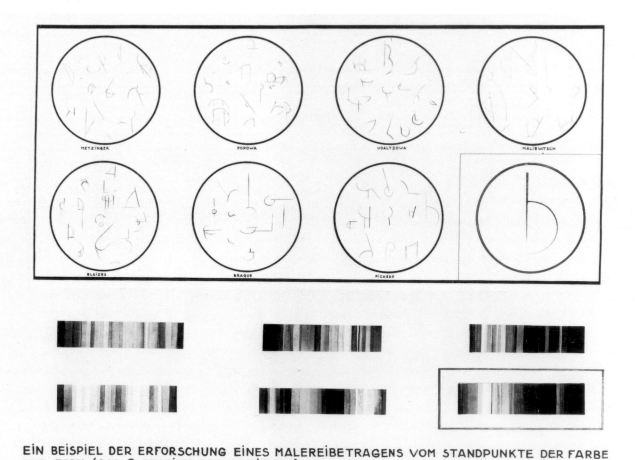

EIN BEISPIEL DER ERFORSCHUNG EINES MALEREIBETRAGENS VOM STANDPUNKTE DER FARBE UND FORM (DAS 2 STADIUM DES KUBISMUS)

Fig. 26. *Chart No. 2.* c. 1927. Paper, 28⅜ × 37⅜″ (72 × 95 cm). Stedelijk Museum, Amsterdam

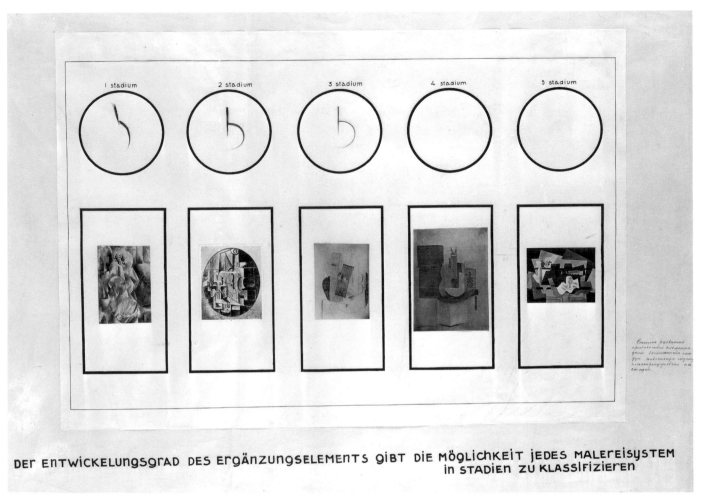

Fig. 27. *Analytical Chart No. 5*. c. 1927. Collage of cut-and-pasted papers, pencil, and pen and ink on paper, 21⅛ × 33″ (54.9 × 83.8 cm). The Museum of Modern Art, New York

ment. Malevich had good reason to be interested in bacilli and in Koch. In those days of physical privation tuberculosis was widespread. He himself had contracted the disease in Vitebsk and, soon after their move to Petrograd, his second wife, Sofiia Rafalovich, died of it.

The bacteriological model of the theory of the supplementary element was part of the extended medical metaphor that Malevich applied to his teaching at Ginkhuk. He called himself a "doctor" and his students "patients"; students new to his studio underwent an "incubation period," during which they submitted a work to be analyzed for a "diagnosis" and a "prescription." The medical metaphor may have arisen because of his first wife, who was a doctor, his father-in-law, who was a psychiatrist, or his second wife, who had worked in a mental hospital, but whatever its origin, Malevich probably hoped that it would bolster his claim to scientific objectivity.

Malevich's designs for modern houses, *planits*, originated in his space architecture and were similar to the space vehicles found in drawings such as *Study for Suprematism 52. System A₄* (see fig. 22). A series of drawings depict residences whose component parts are large three-dimensional Suprematist units (fig. 28). Malevich saw his architectural elevations as more than experiments; his habitats were part of an extensive program for modern living. The *planits* were to be black and white sleek modular buildings made of concrete and frosted glass, which could be cleaned with ease, and whose electric heating built into the walls, floors, and ceilings eliminated the need for dirty stoves and obtrusive chimneys. Although large, the *planits* were to be assembled of elements human in scale. The exterior, planned as an additional living space, was arranged so as to enable a person to move conveniently from one level to another on the outside of the building, without the necessity for ladders.

Malevich's two-year tenure as director of Ginkhuk was troubled by competition, envy, and disagreements among such colleagues as Pavel Mansurov and Vladimir

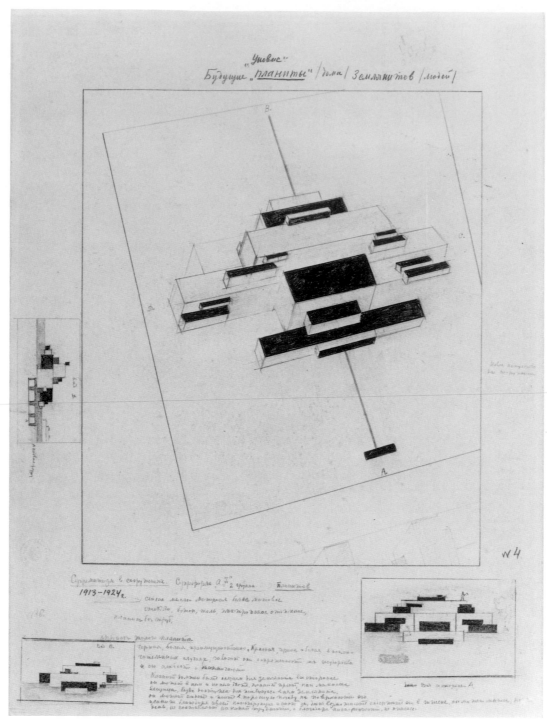

Fig. 28. *Future Planits for Earth Dwellers.* 1923–24. Graphite pencil on paper,
17¼ × 11⅝″ (39 × 29.5 cm). Stedelijk Museum, Amsterdam

Tatlin, and even among his own students. With the death of Lenin in 1924 pressures to conform to a proletarian standard in art increased markedly. Malevich's open philosophical idealism was increasingly vulnerable to attack, as right-wing artistic opinion gained ascendancy and lent its support to the popular and ubiquitous AKhRR, the Association of Artists of Revolutionary Russia, a large aggressive network of realist artists that advanced its nineteenth-century derivative styles as the only genuinely "proletarian" art. The philosophical idealism of the "objectless world" expounded in Malevich's publications was particularly difficult to reconcile with the idea of a new Marxist art based in materialism. *God Is Not Cast Down* came in for harsh criticism in the press as soon as it was published.

An even more serious denunciation came in June 1926, on the occasion of Ginkhuk's end-of-the-year show, where, along with the work of his colleagues

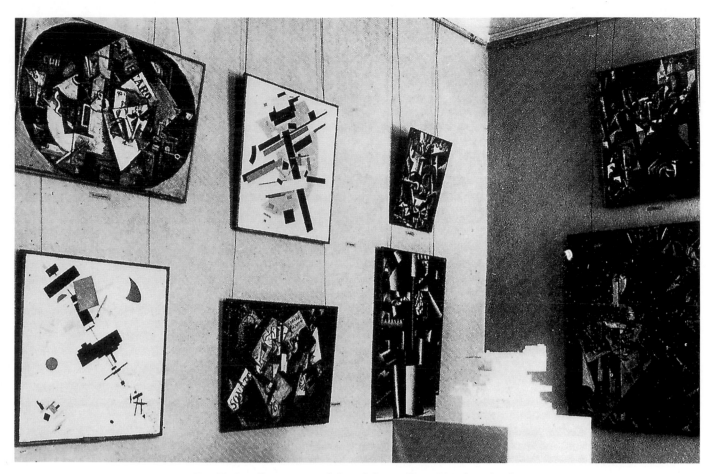

Fig. 29. Installation view of the exhibition "New Trends in Art,"
Leningrad, November 1927

Matiushin and Mansurov, Malevich's architectural models and the graphic charts demonstrating the theory of the supplementary element were displayed. The leading party newspaper, *Leningradskaia Pravda*, published a condemnation of the exhibition by a young militant, the critic Grigory Seryi. Entitled "A Government-Supported Monastery," it was shrilly polemical and deliberately crude: "This exhibition shows conclusively the depths to which the Leningrad objectless artists—who have been panting in creative impotence all these past years—have now sunk." The critic professes himself shocked at a young woman's forthright responses to his questions about Malevich's architectural models. Yes, the models express "inner experience," she told him, "but cleansed of all cultural layers, etc. We reject all utility; it doesn't matter to us whether these things are needed or not. What is important to us is to comply with our personal sensations." Seryi ends his piece:

A monastery has taken shelter under the name of a state institution. It is inhabited by several

holy crackpots who, perhaps unconsciously, are engaged in open counterrevolutionary sermonizing, and making fools of our Soviet scientific establishments. As for any artistic significance in the "work" of these monks, their creative impotence hits you right in the eye at the first glance.

The time has come to say: it is an utter scandal that Glavnauka [the Main Science Administration] hasn't yet put an end to this disgrace that it has let loose under its protection.

The Control Commission and the Workers and Peasants Inspection should investigate this squandering of the people's money on the state support of a monastery.

Now when gigantic tasks are towering before proletarian art, and when hundreds of really talented artists are going hungry, it is criminal to maintain a huge, magnificent mansion so that three crazy monks can, at government expense, carry on artistic debauchery or

counterrevolutionary propaganda that is not needed by anybody.

Seryi's public complaints put Malevich and all of Ginkhuk in jeopardy. The Leningrad branch of the Main Science Administration, fearing for its own existence, quickly set up a review committee and started an investigation of Malevich and Ginkhuk. Malevich was particularly bitter that the Science Administration did not at least support his work on the supplementary element—a theory that he maintained was based on an objective analysis of painting styles as scientific data, and should have been beyond ideological reproach. Malevich soon lost his directorship, and Ginkhuk itself was closed at the end of the year.

For at least half a dozen years Malevich had been looking for an opportunity to travel abroad. Although he had never had the money to travel, he had always seen himself and his work in the context of international art. After the Revolution he made several attempts to communicate with artists abroad. In 1926 he had planned a trip to visit Larionov in Paris, but was not allowed to leave. No sooner had Ginkhuk been closed, however, than he was granted an exit visa to Poland and Germany, and taking more than a hundred paintings, drawings, and theoretical charts with him, Malevich left Russia in March 1927. During his three weeks in Warsaw ninety-eight charts and works of art were shown in a large exhibition at the Polish Art Club; in Berlin also, in connection with the "Grosse Berliner Kunstausstellung" (Great Berlin Art Exhibition), which opened in May, he was allotted a large space in which to exhibit. The artist spent slightly more than two months in Germany; during that time he met Hans Richter, with whom he planned a Suprematist film; and he visited the Dessau Bauhaus, meeting its director, Walter Gropius, and one of the masters, László Moholy-Nagy. He was called home early in June, probably in response to the threat of war, but also perhaps to increasing artistic repression, the closing of the Main Science Administration, and the establishment of an even more threatening Arts Administration.

Malevich did not bring his work back to Russia. Much of it was still on exhibit in Berlin, and in any case he was planning further exhibitions in the West and further trips abroad. A few of his works that had gone to the Russian Museum when the Museum of Artistic Culture was liquidated were included in November in its "New Trends in Art" show (fig. 29).

After Ginkhuk was closed, Malevich and several of his colleagues were allotted laboratories at the Institute of the History of Art. After his return from abroad, he worked there on Suprematist architecture; but his position continued to be extremely precarious, and throughout 1929 and the first half of 1930 Malevich repeatedly had to fight the closing of his laboratory.

For a brief time in the 1920s, somewhat more artistic freedom was possible in Ukraine than in Russia, and avant-garde artists found shelter there. In 1929, anticipating major difficulties with his tenure at the Institute of the History of Art, Malevich traveled back to his birthplace for part of each month to lecture on art history at the Kiev Art Institute. In Kiev, too, Malevich had found an opportunity to publish. In the two and a half years from early 1928 through the middle of 1930, mostly in the cosmopolitan journals *Nova generatsiia* and *Avangard*, he published fourteen articles in Ukrainian, including discussions of Cézanne, Picasso, Braque, Léger, Gris, Herbin, Metzinger, Cubism, Cubo-Futurism, Constructivism, architecture, and sculpture. Taken together they were intended to be the basis of a book on the history and theory of the new art. By early 1930 the projected book had acquired the title "Izologia" (Artology), and chapters on Impressionism and Surrealism had been added at the beginning and end. As Malevich projected it, "Izologia" has yet to be published.

The schizophrenic treatment that Malevich endured now at the hands of the Arts Administration was epitomized by its decision to grant him a solo exhibition at the prestigious Tretiakov Gallery in Moscow at the end of 1929. Amassing the paintings necessary for such a show undoubtedly posed a major problem for the artist, since he had painted very little in the years before his trip abroad, and now, some two years later, the works that he had taken with him still remained in Germany. Undoubtedly Malevich was quite happy that his paintings remained in the West, since he was still hoping for more exhibitions there, and it must have been reassuring that, regardless of what happened at home, there seemed to be a chance that in the West they would survive, and not be lost to history. In order to continue exhibiting at home, however, Malevich had to begin painting again. In the late 1920s he took up earlier peasant subjects, and concealed the incriminating absence of much of his work by backdating the new pictures. This procedure of filling in his past with backdated work solved other pressing problems as well; the new peasant pictures supplied the artist with socially and politically acceptable work without any overt capitulation on his part to the art establishment, and crucially, it gave him time to find a way to move beyond the

white-on-white canvases of ten years earlier, works that he had felt to be the logical end of Suprematism and of painting itself. At a time when his income was minimal, there was also the chance that "early" figurative works would prove salable to government collections.

The Post-Suprematist peasant paintings, however, are easily distinguished from similar subjects of 1912. In works such as *To the Harvest* (*Marfa and Vanka*) (plate 29) and *Haymaking* (plate 30) no attempt is made to integrate the figures into the landscape, as was done before Suprematism, for example in *The Woodcutter* (plate 9). Instead, the heads of the large figures are shown projected against the sky above a clearly visible horizon, in a reference to the cosmic philosophy developed in connection with Suprematism.

Malevich was sometimes hesitant and inconsistent in his false dating; in several cases there are altered or multiple dates on a canvas, while he exhibited the work with yet another date. Many of these works are awkward and undistinguished, evidence of the artist's rushed and anxious state of mind. As they evolved, however, the backdated peasant paintings acquired a style and integrity of their own; indeed some of these works are among the artist's best.

Malevich's small "retrospective" exhibition opened in Moscow at the Tretiakov Gallery at the very end of 1929, and early in 1930 some forty-five of the works were shown in Kiev at the Kiev Art Gallery. The majority had been recently painted. For the Moscow exhibition the Marxist critic Aleksei Fedorov-Davidov published a small booklet in which he defended the showing of Malevich's art because, although "subjectively far from the fundamental positive tendencies of the new industrial art," it "objectively contributed to its birth." Not incidentally, from Malevich's point of view, Fedorov-Davidov's essay legitimized in print the artist's bogus dates.

The repainting of his artistic career in the 1920s not only allowed Malevich to continue painting without acceding to the requirements of proletarian realism, it also gave him an opportunity to establish stylistic precedence over a new Western European trend. Malevich's attraction to Surrealism in the late twenties is clear from records of his critiques of student work of that period, and also from the fact that Surrealism was added to his account of the history of twentieth-century styles; it is the successor to Suprematism and the last chapter in his projected book, "Izologia." The metaphysical nature of Malevich's late figures can be felt in the monumental abstract figures and blank faces in works such as *Girls in the Field* (c. 1929, dated 1912,

exhibited as 1915) and *Female Half Figure* (c. 1928–29, dated 1910), which were in the 1929 show. Malevich borrowed several of his late motifs and images—armless, mannequin-like figures, wide shoulders, and blank faces—from works by Giorgio de Chirico. The relationship between the two artists was noted immediately by a Kiev reviewer:

> In the *Half Figures* of 1910–1911 . . . the heads are treated in a Sur-Realist style, on the model of the work of the contemporary Italian artist de Chirico, who used this same method in the 1920s. . . . Thus the elements of Sur-Realism appeared in Malevich's works much earlier than in Western Europe. . . . In the exhibition, an increase in the Sur-Realist aspects can be noticed in Malevich's work during the war years. In *Girls in the Field* (1915), a marvelous canvas from the point of view of composition, there is the same Sur-Realist treatment of the heads of the three women.

To clinch his claim to precedence, either before or after the publication of these comments, Malevich added the notation "Supranaturalism" to the back of the canvas of *Girls in the Field*.

But Surrealism, and de Chirico's work in particular, were more than just a means to lay claim to historical precedence; they offered a real way out of the dead end of the white-on-white paintings, and suggested a productive response to the current demands for a new and figurative Soviet art. Between 1927 and 1932, partly under cover of the false dates, Malevich was developing a unique Metaphysical style of painting that continued and expanded the philosophy of Suprematism, while at the same time constituting a response to the calamitous social upheavals of the time.

Almost as soon as the Kiev exhibition opened, it was forcibly closed in an uproar about the "bourgeois" nature of Malevich's art, an incident that only increased the precariousness of his position. The identification of his work with the "foreign" West and with the bourgeois layer of society was now coupled with accusations, brought mostly by other artists and arts administrators, that he constituted a class enemy. Malevich was repeatedly publicly denounced, and his studio subject to inspections by workers' committees. The threat to his personal safety and to the survival of his art was serious. Alarmed and in search of political protection, in the spring of 1930 Malevich wrote to Kirill Shutko, his sometime summer neighbor and a personal friend.

Shutko was an Old Bolshevik and a member of the Communist Party Central Committee; throughout the twenties he had been a top Party administrator for film, and in 1928 had led the film section of the Soviet trade delegation in Paris. By 1930 Shutko was head of the Film Propaganda Section of the Central Committee and, theoretically at least, in a position to put in a good word with Stalin for Malevich.

To Shutko, Malevich wrote quite directly, naming names, complaining about the suppression of good artists by bad, such as Moisei Solomonovich Brodsky, a promoter of "worker-artists," and other such "dilettantes" and "hacks" who were in control of the official Sorabis (Art Workers' Union).

> They are burying everybody who could become a force for raising the quality of Soviet Art. . . . Imagine the style of our Socialist epoch, created under the direction of Moisei Brodsky, the Essens, the Maslovs, and those who beating their chest scream about Marxism, who underhandedly drag us down. (They'd like to have my studio.) Why don't they open [Pavel] Filonov's exhibition, which they've already set up and are keeping locked. . . . Let's proceed with an analysis of the problems of art; let's return power to the innovators. I and Tatlin and Filonov and many others—and also the Youth who do actually want to create a great Art—will become shockworkers. Demand information about artistic life in Leningrad from the secretariat of the Leningrad Art Sorabis. Familiarize yourself with it, because soon the Brodskys will declare that we are kulaks. . . . I don't know what to do. Moving to Moscow is no salvation, but I have no strength to live here. To follow Mayakovsky is somehow awkward, but "the incident is closed" in everything. . . .[9]
>
> Am I needed or not needed? And if I'm not needed, then what should be done with me? Really is all my conduct deserving only of persecution?

Throughout these letters, Malevich is not at all conciliatory. He refuses to be bought off with official honors, and argues for his work and his right to pursue his own ideas about a new direction in art:

> Yesterday they informed me that the institute decided to put in a petition to Glavnauka and Art to award me the title of Honored Artist. . . . This way they think to get out of the situation and to put me in a good position, and not to have to deal with my work. But that is a fairy tale. I'm no Brodsky. . . . Before me stands a huge task, which also sustains me, and I have hope that Soviet power in the person of Many Comrades will give me the opportunity to develop it.

As usual, Malevich expressed no doubt whatsoever about the direction of his art or the verdict of history. Rather, he compared himself to Giordano Bruno, the philosopher of an infinite universe who was arrested by the Inquisition and burned alive for his heretical views:

> I know that no matter however they call me an enemy, when everything old is changed, my forms will prevail, and they are prevailing, and only thanks to the medieval ignorance and the attitude of our leading contemporaneity to what is new, can I suffer so like Bruno. But my forms will remain, just as Bruno's proofs remained.

From the letters to Shutko it is clear that in 1930 Malevich was continuing to dream of leaving the country, and making plans, however vague, for an exhibition.

> The only good occupation for me would be to go abroad with an exhibition and to write a book with an appendix of the best foreign material. . . . It would be good if Petrov arranged my exhibition in Paris quickly; incidentally my wife [he had married his third wife, Natalia Andreevna Manchenko, in 1927] understands French beautifully, and could help me handle that work in France. You might say it would be for me the consummation, the sum, of all my 35 years' work in art. . . .

Malevich hoped that Shutko would be of practical help immediately, but he also took some comfort in knowing that, if worse came to worst, the powerful Shutko could be relied upon to bear witness to his loyalty.

> It's good that you know me inside and out, there is someone to write to at least, for the future (if there are still letters), and the fact that you know me gives me some hope.[10]

But even Shutko could not shield Malevich from arrest. Late in 1930 the artist was incarcerated for some two months and interrogated about the ideology of modern styles, and his "preaching" of a new art. Shutko himself was arrested in the fall of 1938.

Malevich's production of backdated works did not cease with the works shown at the Tretiakov and in Kiev. It continued in 1930 and 1931 alongside his historical and theoretical investigations, and teaching in Leningrad amateur art circles. History seemed stubbornly to repeat itself in a further loss of his paintings. After the Kiev exhibition was closed, there was a delay of some two years before all the works were returned to him in Leningrad, and under pressure to participate in a major exhibition commemorating the fifteenth anniversary of the Revolution, Malevich again faced a serious lack of work.

The artist's Impressionist renditions of female figures in parks, such as *On the Boulevard* (fig. 30), dated 1903, *Sisters*, dated 1910, *Flower Girl* (fig. 31), dated 1903, and *Unemployed Girl* (plate 38), dated 1904, were all done about 1930, when he was studying and writing about Impressionism. For these works Malevich looked back to the subjects and, superficially, the painting techniques of well-known works by friends and acquaintances, such as Vladimir Makovsky's *On the Boulevard* (fig. 32), Fedor Rerberg's *On the Boulevard* (fig. 33), and Pimonenko's *Flower Girl*.[11]

Although these 1930 works are different in painting style from the late peasant works, they share many of their compositional characteristics—the strong resolution of the foreground into horizontal "stripes," the solid bar of fence or figures across the central area of the canvas, spatial planarity, singular figures, and the

Fig. 30. *On the Boulevard*. c. 1930. Oil on canvas, 21⅝ × 26″ (55 × 66 cm). Russian Museum, Saint Petersburg

37

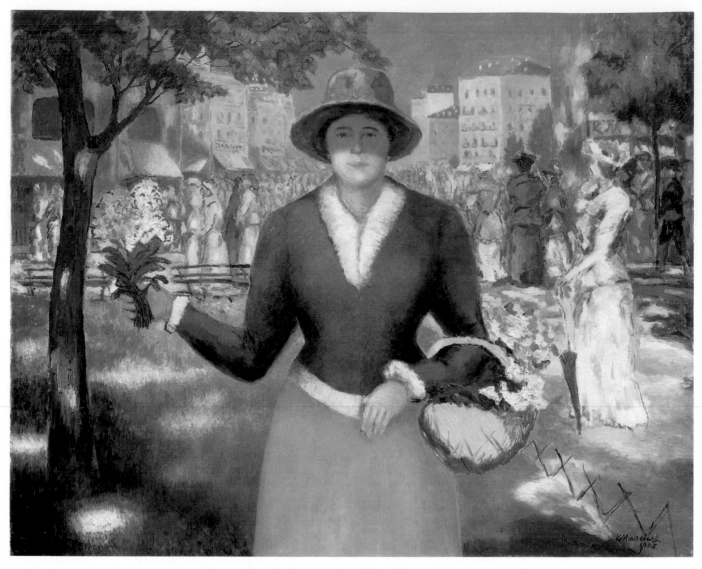

Fig. 31. *Flower Girl*. c. 1930. Oil on canvas,
31½ × 39⅜″ (80 × 100 cm). Russian Museum, Saint Petersburg

importance of centrality and the open sky, all betray their late date of execution. Malevich's idealized figure of the flower girl, a work that exists in two versions, is directly related both to contemporaneous peasant subjects and several of the fantastic "Suprematist portraits" painted a year or two later.

De Chirico gave Malevich a model for a new figurative art based on a vocabulary of motifs that take on symbolic and Metaphysical significance. As he had done earlier with images from icons (plate 31), Malevich isolated and simplified de Chirico's imagery in paintings such as *The Red House* (plate 35) and *Complex Premonition* (plate 36). De Chirico fortuitously combined in his art two of the Russian artist's own interests—a telescoping of the new and the old, the contemporary and the antique, and the simultaneous generation of another level of reality. Malevich's device in the 1920s of using

icons as a subtext for his new work was calculated to produce in the native viewer the sensation of an archetypal timelessness behind the contemporary abstracted forms. By the early 1930s he was urging his students to study both de Chirico and ancient art for the same purpose:

> It is necessary to isolate the painterly understanding of color and the sensation of the other world. We can understand it through something new, as de Chirico understood when he looked at the Greeks. . . . The most important work is to isolate this sensation, and quickly to move toward new sensations.[12]

Malevich's mining of de Chirico's images is very consistent, and seems to indicate that the relationship

Fig. 32. Vladimir Makovsky. *On the Boulevard*. 1886–87.
Oil on canvas, 20⅞ × 26¼″ (53 × 68 cm). Tretiakov Gallery, Moscow

Fig. 33. Fedor Rerberg. *On the Boulevard*. 1903.
Oil on canvas. Dimensions and whereabouts unknown

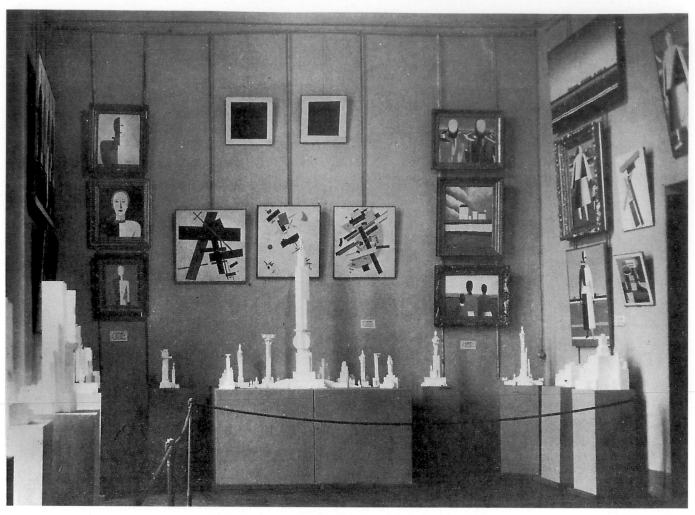

Fig. 34. Installation view of the anniversary exhibition
"Artists of the R.S.F.S.R. During Fifteen Years," Leningrad, 1932

between them was not casual. Apparently, he felt a particular sympathy with, and appreciation of, de Chirico's Metaphysical landscapes. But Malevich did not restrict his quotations to the Metaphysical work. He borrowed from every phase of de Chirico's oeuvre, from his Romantic and Neoclassical work, from his copies of Old Masters, from his portraits of his family. And indeed, the course of de Chirico's life and work—his acclamation by the Surrealists in the first half of the 1920s, the widespread sense of confusion and suspicion in the art world when he abandoned the Metaphysical vocabulary, and the estrangement from the Modernists brought on by his Neoclassical work and Renaissance-inspired portraits—bears an uncanny parallel to the course of Malevich's life and art. Clearly the Russian artist hoped that de Chirico could lead him successfully out of the aesthetic and social dead ends of objectless art, and through the uncharted visual heterodoxies of the new age. "Worldwide art is objectless art," he wrote in October 1931 to a friend in Kiev, "but Soviet art, that

is a symbolic art, and neither naturalistic or realistic. . . . I am thinking also of starting some paintings—of painting two symbolist works. I will try to create an iconic image."

Malevich was allotted his own room at the Leningrad venue of "Artists of the R.S.F.S.R. During Fifteen Years," the jubilee exhibition commemorating Soviet rule (fig. 34). He displayed Suprematist works, architectural models, and Surrealist paintings. But by the time the exhibition opened in Moscow at the end of June 1933, all artists' organizations officially had been abolished, and a strictly proletarian aesthetic reigned. Malevich's contribution was drastically reduced, and he and the other members of the "bourgeois" avant-garde were crowded into one room. That small room, wrote one critic, is "one of the most memorable for, as it were, its curious tragedy. Here are people who thought and invented and worked, but they generated such a centrifugal force in their art that it carried them out of art to the beyond, to nowhere, to nonexistence."

In spite of growing government restrictions and the ascendancy of a militant cadre of rabidly intolerant artists, Malevich continued to work. In 1933 his symbolism evolved into portraits of himself and his friends in bright fantastical clothing, rendered in a style derived from Dürer and the Northern Renaissance artists. In paintings such as *Portrait of the Artist's Wife* and *The Artist* (plates 39 and 40) Malevich's transcendental reality is still unmistakably manifest in the striking similarity to Russian icons and the bright Suprematist clothing. By the end of the year, however, the artist was ill with cancer, and this ecstatic phase of his work abruptly came to an end.

For the last time Malevich tried to arrange a trip abroad. He wrote to Andrei Bubnov, the commissar of Public Education and a powerful member of the Party's Central Executive Committee, requesting a trip to the West for medical treatment. Bubnov was no friend of the avant-garde, but travel was not infrequently allowed for medical reasons, and in his affliction Malevich hoped that Western medicine might be able to remove or alleviate his tumors. The request made its way to the Leningrad Artists' Union, which called in medical consultants and made recommendations back to the Commissariat of Public Education. There the matter came to a halt. No one informed the artist of the nature of his illness. In January 1935, now unable even to write, he dictated a grave letter to David Shterenberg, detailing his situation and asking for help in obtaining support for his petition to go abroad, and for food and doctors. Shterenberg, who had been in charge of art at the Commissariat of Public Education in the 1920s but who was now himself in a difficult political position, made inquiries, but in the end no help was forthcoming.[13]

As he became increasingly ill during the last year of his life, Malevich's portraits of himself, his family, and friends grew warmly expressionistic and intense. Four such works were on exhibition at the Russian Museum in Leningrad at the time of his death, May 15, 1935.

Malevich lay in state in his apartment (fig. 35). Under pressure from his friends, the Leningrad City Council paid for a memorial service at the Leningrad House of Artists. From there the mourners moved to the railroad station for the trip to Moscow (fig. 36). In

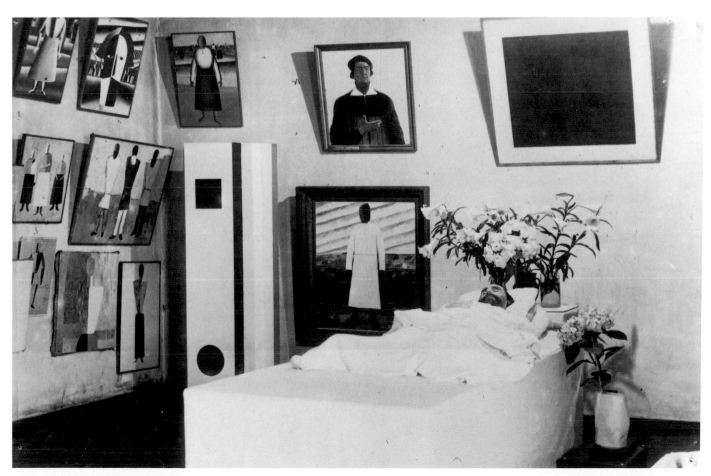

Fig. 35. Malevich lying in state in his Leningrad apartment, May 17–18, 1935

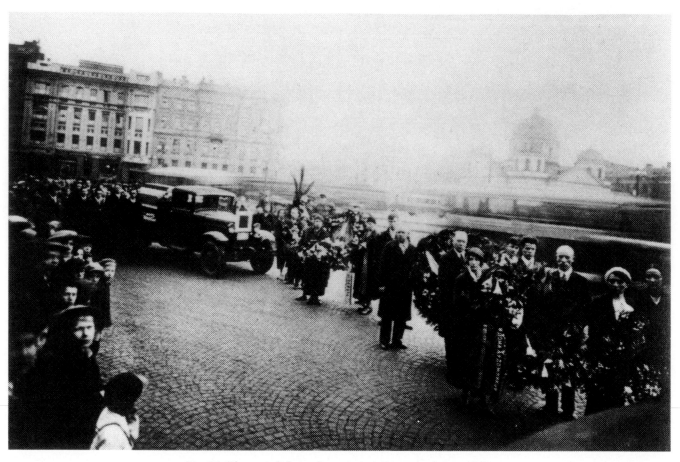

Fig. 36. The artist's funeral procession, Leningrad, May 1935

Fig. 37. Malevich's Nemchinovka dacha, near which his ashes are buried. Photograph 1988

Fig. 38. Malevich's gravestone. Photograph 1988

Moscow, according to his wishes, Malevich's body was cremated, and the urn of ashes buried in a field beneath an oak tree near the hamlet of Nemchinovka, where he had spent many summers and a few hard winters (fig. 37). For a grave marker his friend and student Nikolai Suetin fashioned a cube with a black square.

World War II erased all traces of the oak, the urn, and the grave; the Soviet government eliminated all mention of Malevich's name from the histories of Russian art. Only with the advent of *glasnost* was Malevich fully rehabilitated in his native country; the first exhibition devoted to him in Russia since 1930 opened at the Russian Museum in Leningrad in 1988. A new monument designed by the Moscow artist Vladimir Andreenkov, and bearing a red square, now stands near his original resting place (fig. 38).

CHRONOLOGY

1878: Kazimir Severinovich Malevich born February 23 to Polish-speaking parents Severin and Liudviga Malevich in Kiev, Ukraine. The father works as an administrator in a succession of sugar refineries.

1890s: Becomes interested in art as a teenager. Begins studying at the Kiev Art School.

1896: Moves to Kursk, where his father goes to work for the railroad. Participates in an art group that shares a studio and has exhibitions.

1899: Marries Kazimira Zgleits.

1901: Son Anatoly born.

1904: First trip to Moscow.

1905: Daughter Galina born. Shows Symbolist works in an exhibition in Kursk of Moscow and local artists.

1905–10: Works at the Moscow studio school of Fedor Rerberg.

1907–9: Takes part in four exhibitions of the Moscow Artists' Society.

1909: Makes sketches for the publication of the Moscow Art Theater's album on *Anathema*. Divorces first wife. Marries Sofiia Rafalovich.

1910: First participates in an exhibition of modern art, the "Jack of Diamonds," in Moscow.

1911: Exhibits twenty-four works at the Moscow Salon. In December shows four works, as part of the "Donkey's Tail" section of a Union of Youth exhibition in Saint Petersburg.

1912: Contributes colorful paintings of peasant subjects to the "Donkey's Tail" exhibition, organized by Larionov and Goncharova in Moscow. One of his peasant heads is shown in the second "Blue Rider" exhibition in Munich. Toward the end of the year develops the "New Russian Style," with metallic-looking figures.

1913: Sends several landscapes with geometric figures to the Moscow exhibition "Target." Joins Union of Youth. Designs the sets and costumes for *Victory over the Sun*, a Cubo-Futurist "opera" composed by Mikhail Matiushin with words by Aleksei Kruchenykh.

1914: Leaves the Union of Youth and contributes to the Moscow "Jack of Diamonds" exhibition. Shows at the Paris Indépendants Salon.

1915: Contributes to "The V Trolley" exhibition in March. Early in the year he initiates "Suprematism," a style of painting characterized by flat colored rectangles and other geometric forms on a white ground. Exhibits thirty-nine Suprematist pictures in December at the "0,10" exhibition in Petrograd. Son Anatoly dies.

1916: Organizes the Supremus society and prepares to issue its journal. Drafted and sent to the army in Smolensk.

1917: After the March Revolution begins to teach and to participate in administrative work in the arts. Shows Cubist and Suprematist work at the "Jack of Diamonds" exhibition, and Suprematist fabric designs at an exhibition of the Verbovka group.

1918: Moves to Petrograd. Designs sets for Mayakovsky's play *Misteriia-Buff*, performed in Petrograd on the first anniversary of the November Revolution.

1919: Returns to Moscow. Teaches at Svomas. Exhibits white-on-white Suprematist paintings in April at the "Objectless Art and Suprematism" exhibition in Moscow. In the fall moves to Vitebsk to teach at the Art Institute. First solo exhibition (153 works) opens in late December in Moscow.

1920: Unovis (Advocates of the New Art) group formed around Malevich at the Vitebsk school. Daughter Una born.

1922: With some of his colleagues and students moves from Vitebsk to Petrograd. Exhibits with Unovis at the "New Trends in Art" exhibition in Petrograd. Included in the "First Russian Art Exhibition" at the Van Diemen Gallery in Berlin and in 1923 at the Stedelijk Museum in Amsterdam.

1923: Solo exhibition opens at the Museum of Artistic

Culture in Moscow. With Unovis participates in the "Petrograd Artists of All Trends" exhibition.

1924: Appointed director of the Leningrad Institute of Artistic Culture, and heads the Formal and Theoretical Section of the research studios there. Sends work to the Venice Biennale.

1926: Shows architectural work at the "International Exhibition of Modern Architecture" in Warsaw, and at the spring exhibition at the Institute of Artistic Culture in Leningrad. Removed as director of the institute. Institute is closed at the end of the year.

1927: Makes only trip abroad, to Warsaw and Berlin; exhibits work in both cities. His paintings are included in the "New Trends in Art" exhibition at the Russian Museum in Leningrad. Marries Natalia Andreevna Manchenko.

1928: Begins to teach part time at the Kiev Art Institute.

1929: Retrospective exhibition opens at the Tretiakov Gallery in Moscow.

1930: Retrospective exhibition opens at the Kiev Art Gallery, but is closed abruptly. Is detained for two months in Leningrad and questioned about the ideology of modern art.

1932. Shows Suprematist, Metaphysical, and architectural works at an exhibition in Leningrad commemorating the fifteenth anniversary of the Revolution; his contribution is substantially abridged when the exhibition moves to Moscow in 1933.

1933: Becomes ill.

1935: Dies at home in Leningrad. At the time of his death four works are on exhibition at the "First Exhibition of Leningrad Artists," held at the Russian Museum. His ashes are buried at Nemchinovka, near Moscow.

NOTES TO THE READER

Before January 31, 1918, twentieth-century dates in Russia were thirteen days behind the Western calendar. The dates in this book have been converted to the Western calendar. Thus, for example, the October Revolution becomes the November Revolution.

Most of Malevich's Suprematist works are untitled. Over the years they have acquired such descriptive designations as "Suprematism," "Suprematist Composition," or "Suprematist Painting." To keep the inevitable confusions to a minimum we have retained these designations in parentheses, but it should be kept in mind that they are not the artist's titles.

Malevich's paintings suffered sad and complex fates, which may be grouped into three general categories:

First, a collection of more than a hundred paintings, drawings, and charts that Malevich took with him to Poland and Germany in 1927 remained in the West after his return to Russia. Malevich deliberately left these works in Germany because he hoped to have further exhibitions abroad and to sell his work, and also because his future and the future of his art were seriously in doubt in Russia. Not only had he been ridiculed in the press, been deprived of his administrative post, and seen his institute liquidated, but Suprematism as a style was becoming dangerous—it was considered antiproletarian and tantamount to counterrevolutionary. Malevich had been trying to go abroad for years because he considered his art part of European culture, and was convinced it would be received and appreciated there. After this trip, he repeatedly attempted to leave again.

The question of the return of these works was further complicated by the mounting Nazi repression of modern art, when it became just as dangerous to possess such work in Germany as it was in the Soviet Union. The largest portion of this group—about fifty works—are now in the Stedelijk Museum, Amsterdam. Twenty-one, four of them purchased from their Western caretaker, went to The Museum of Modern Art, New York. Of these, one was bartered to the Peggy Guggenheim collection. Several are unaccounted for.

Individual works from this 1927 group have appeared on the Western market; others remain in private collections; still others seem to have been permanently lost. It is undoubtedly true that Malevich intended to leave this work in the West, and that he would have been pleased that his paintings found sanctuary and recognition in Western museum collections. He never made any attempt to retrieve them; on the contrary, he made several attempts to go to them.

A second group consists of the works that remained in the former Soviet Union in private hands: a few in the possession of the artist's relatives, and a few in individual collections. In 1919 the Commissariat of Public Education purchased many of Malevich's paintings as part of its program to build collections of modern art throughout the country. For this purpose some works were shipped to provincial museums, and some were transferred to the Museums of Artistic Culture in Moscow and Petrograd. When the Moscow Museum of Artistic Culture was closed in 1929, the Tretiakov Gallery received its holdings, including paintings by Malevich. Two major Suprematist paintings from this collection were exported by the Ministry of Culture of the U.S.S.R. in the 1970s; one went to Armand Hammer in exchange for a painting attributed to Goya; it is now in the Ludwig Collection, Cologne. The other was traded in 1975 to an individual for letters concerning V. I. Lenin, and was purchased in 1978 by the Tate Gallery, London.

The third and largest group of Malevich's paintings in Russia is held by the Russian Museum in Saint Petersburg. It acquired this collection in a variety of ways. A few works went to the museum when the Leningrad Museum of Artistic Culture was closed in the spring of 1926 and its holdings were transferred to the Russian Museum. A few were conveyed to the museum by the artist himself in the early 1930s; others were acquired after the artist's death in exchange for part of the death benefits allotted to support his family. A major portion of the museum's holdings, almost one hundred works, accrued from the fact that it provided a place of safekeeping for Malevich's legacy after the artist's death. From the mid-1930s until the 1960s it was dangerous to be in possession of such works, and Malevich's mother, wife, and daughters left their chancy legacy in the care of the Russian Museum. In the mid-1970s the Ministry of Culture, by then cognizant of the value of Malevich's works on the Western market, went through a process of regularizing these holdings; the inheritors were each paid a modest sum, and were permitted to retain only a few personal works. These actions are now disputed by the artist's relatives.

COLORPLATES

1. LANDSCAPE WITH YELLOW HOUSE

c. 1904. Oil on cardboard, 7½ × 11⅝" (19.2 × 29.5 cm).
Russian Museum, Saint Petersburg

This small landscape, painted on cardboard, is one of the earliest known works by Malevich. In a snowy woods, a country house or church, painted a yellow ocher as was customary in Russia, shimmers invitingly through the winter air. The unstable forms of the building and trees are dissolved in a textured lace of sun and snow.

Despite its small size and the economy of the artist's method, the work evokes a completely concrete Russian landscape. Unlike Malevich's later landscapes, as, for example, *Morning After a Storm in the Country* (plate 10), in this early work no human being has been introduced into the scene. Instead, the allover composition—the trunks of the narrow trees rising to the top of the work and descending to its lower edge—seems to place us in its midst, as if we ourselves were on a walk through the woods on a bright December day.

The painting was made without preparatory drawing on the cardboard: the house, trees, and ground are created by small areas of thickly dabbed-on color. Malevich's use of this tactile technique to render the glittering atmosphere in *Landscape with Yellow House* suggests his early familiarity with Monet and the Impressionists. A related work, *Church*, in the George Costakis collection, has even closer affinities to Monet. (It is interesting that two of Monet's paintings of Rouen Cathedral had been in the Shchukin collection in Moscow since 1901–2.)

Malevich was not the only Russian artist to depict the dissolving properties of light and air. Konstantin Korovin and Ilia Grabar employed similar techniques in their landscapes, and there are related works by Malevich's friend Mikhail Larionov from about the same time. Later, in 1912, Larionov would take the approach to an extreme, moving to a semiabstract style known as Rayism.

This view of a building that is interwoven so much into a deep scintillating landscape contrasts markedly with Malevich's later treatment of a similar subject in *The Red House* (plate 35). There the house is a solid, flat rectangular structure, and instead of forming part of the landscape it stands out clearly on the surface of the earth as a separate and emblematic image.

2. SELF-PORTRAIT

c. 1909. Gouache and varnish on paper,
10⅝ × 10½" (27 × 26.8 cm).
Tretiakov Gallery, Moscow. Gift of George Costakis

In *Self-Portrait* the artist presents himself as a satanic figure. The red shirt, the collar edged in red, the hermetic-looking insignia, the × of the black tie, all may be interpreted as attributes of the demonic. The artist's high protruding temples deliberately hint at horns as, lit by a greenish glow, he looks out with a sinister stare.

The hellish red of the "bathers" in the background, and their insistently displayed sexuality, allude to their location in the realm of the damned. In spite of the forbidding nature of the subject matter, there is a touch of Malevich's sardonic humor here, since such monochromatic areas, usually a heavenly blue, have traditionally indicated the "higher world" in Russian icons.

Here the artist has in effect abandoned the ironic ambiguities present in an earlier *Study for a Fresco Painting* (plate 2a), where in a related portrait the artist, shown in imitation of Van Gogh with a goatee and an exaggerated floppy red bow, stares menacingly out from in front of a group of piously praying and innocently naked saints. The bright colors and the bold curvilinear stylization of *Self-Portrait* distinguish this work from the erotic morbidity widely fashionable in Russia at the time.

In *Self-Portrait*, Malevich has adopted a Post-Impressionist coloring and style of painting. The inspiration for this work may have been Van Gogh's *Portrait of Dr. Rey* (1889), which had come into Shchukin's famous Moscow collection in 1908, or Gauguin's devilish *Self-Portrait (Les Misérables)* (1888). Both works employ a colorful wallpaper design as background and hint at the inhuman nature of the sitter. It is, however, closest to Emile Bernard's *Self-Portrait* (1888) (plate 2b), which employs a similar background of nudes.

This small gouache is not dated, but its color and style suggest that it was done about 1909; it can be considered one of the last and most notable achievements of Malevich's Symbolism. The notion conveyed here of the artist as master and magician, the possessor of unearthly powers, is a Symbolist concept *par excellence*, and one that Malevich retained throughout his life.

Although this self-portrait is small in size, its centrality and symmetry, reinforced by its square format, give it the assurance and impact of a much larger work.

The painting was donated to the Tretiakov Gallery in 1977 by the Moscow collector George Costakis, as part of an arrangement that permitted the removal of some of his collection from the Soviet Union.

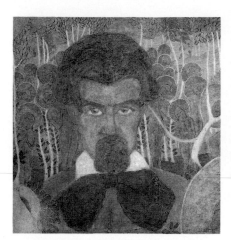

Plate 2a. *Study for a Fresco Painting (Self-Portrait)*. 1907. Tempera on cardboard, 27¼ × 27⅝" (69.3 × 70 cm). Russian Museum, Saint Petersburg

Plate 2b. Emile Bernard. *Self-Portrait*. 1888. Oil on canvas, 18 × 15" (46 × 38 cm). Durand-Ruel—Document Archives Durand-Ruel, Paris

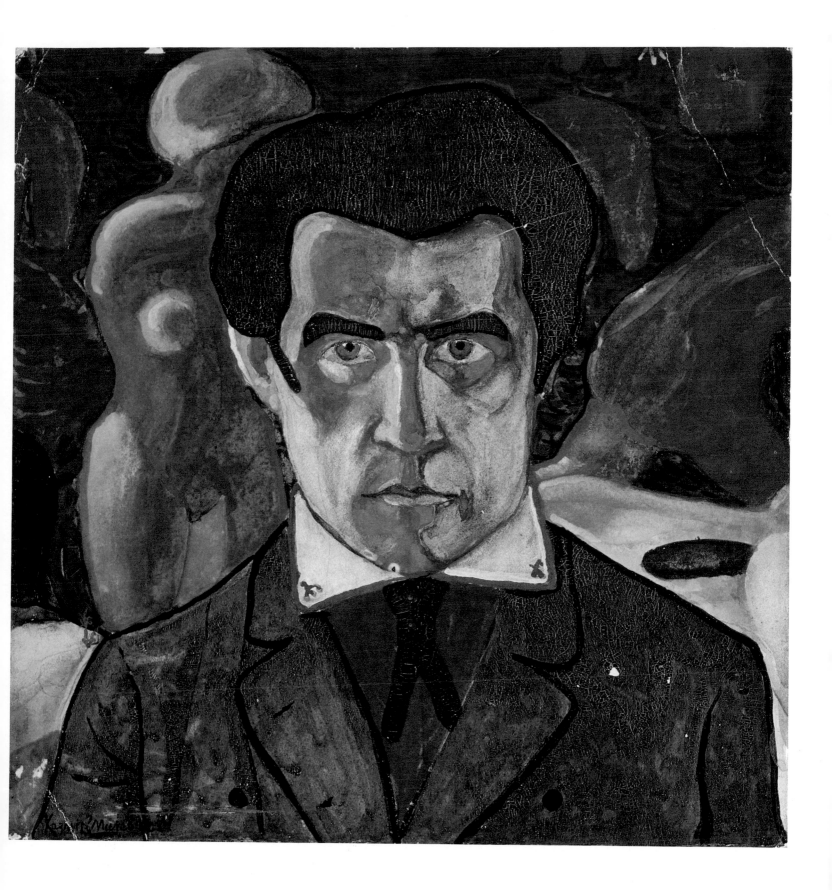

3. ARGENTINE POLKA

1911. Gouache on paper, 41 × 27" (104 × 68.5 cm).
Formerly collection Joachim Jean Aberbach, Sands Point, New York

In this humorous depiction of a dancing couple, a staunchly upright man in tails and white tie, knee raised and foot in mid-air, clasps a white-gowned, limp-wristed woman with such proper exactitude that the little finger of his right hand extends archly backward. The awkward flattened figures outlined in black resemble those on Russian signboards; but here lively patchy colors animate the entire surface of the work, accentuating its joviality.

The male figure in *Argentine Polka* is one of the earliest occurrences of Malevich's large figures placed directly before the viewer. The dancing man looks not at his partner, or even at the viewer, but into the distance, as he concentrates on instructions arriving from outside the picture, or on some inner rhythm. The figure's position in space is emphasized by his round face, the severe symmetry of the hair, eyes, and mustache, and the divided shirt front. All serve to stabilize the image and impart to it a certain ritualized importance, even as the dancer purports to bound with his partner to the polka. This double message—of an incidental scene and hidden significance— is one of Malevich's favorite devices and betrays his Symbolist roots.

Like many of Malevich's other works, *Argentine Polka* was derived from a photographic image. Its source was an article on the latest dances in a popular illustrated weekly newspaper. In the painting the artist has even preserved the title of the dance as it appeared beneath the photograph.

Argentine Polka was first exhibited in December 1911 at a Union of Youth exhibition in Saint Petersburg. Malevich brought the painting with him to exhibit in Berlin in the spring of 1927. It remained with Malevich's hosts in Berlin, the family of Gustav von Riesen, and thereafter entered private collections.

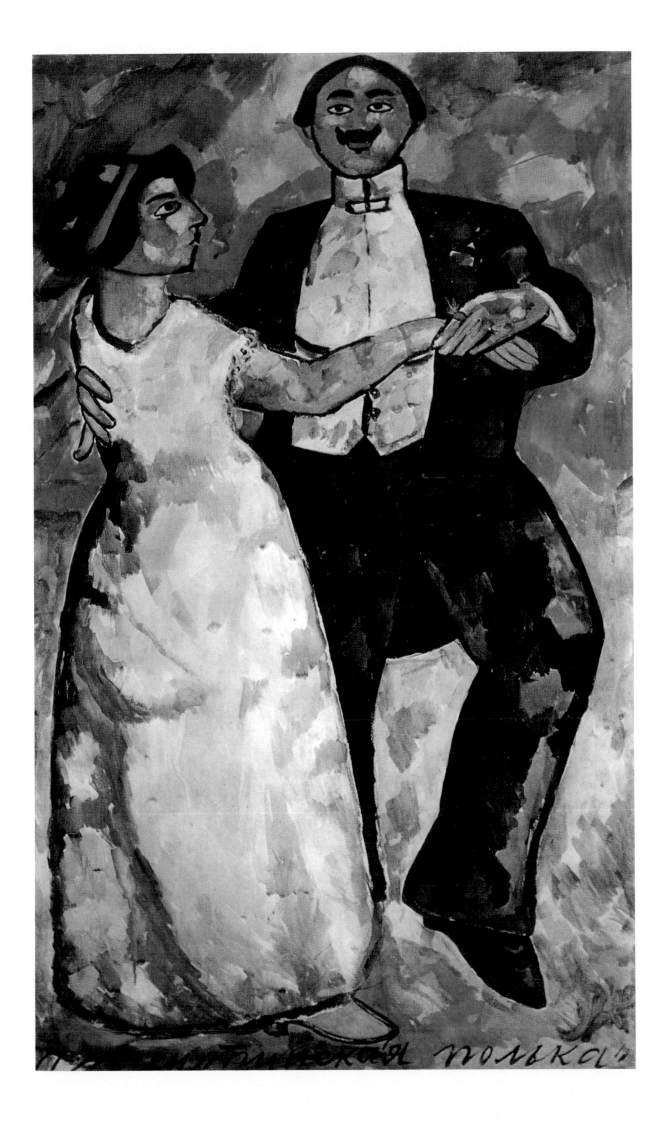

4. MAN WITH A SACK

*1911. Gouache on paper, 34⅝ × 28" (88 × 71 cm).
Stedelijk Museum, Amsterdam*

In this gouache, dominant, childlike blues, reds, greens, and yellows in rhythmic curvilinear forms create the figure of a walking man seen from behind. The single figure is large, occupying almost the entire height of the paper. The massive red hands and feet imitate naïve painting, and are characteristic of Malevich's early depictions of peasants.

The narrative apparent in *Man with a Sack* is minimal: A person carrying a large sack on his back walks along a street, away from the viewer. The artist reveals neither the subject's face nor where he is going. The details of the street are given in only the vaguest way and we have no means of guessing what lies beyond the limits of the picture. Yet this simple scene expresses an idea that attracted Malevich over several years and that appears repeatedly in his work. Between 1910 and 1914 many of his paintings, such as *Morning After a Storm in the Country* (plate 10) and *Woman with Water Pails* (plate 11), depict an ordinary person, crossing our vision on the way to some unseen place. Often the subject is bent beneath some burden. Malevich here invents an image to convey the difficulties and cares of life that burden us on life's journey, and points to some ultimate destination for humanity, to another place or dimension beyond the earthly one.

What appears in this work to be a disregard for the natural curiosity of the viewer—by turning the subject's face away—is the artist's way of concisely expressing a philosophical meditation. The cheerful Fauvist colors serve to draw attention to the subject of the painting and the physical sensuality of the paint, and to hide its philosophical content.

Man with a Sack was first exhibited in March 1912 at the "Donkey's Tail" exhibition in Moscow.

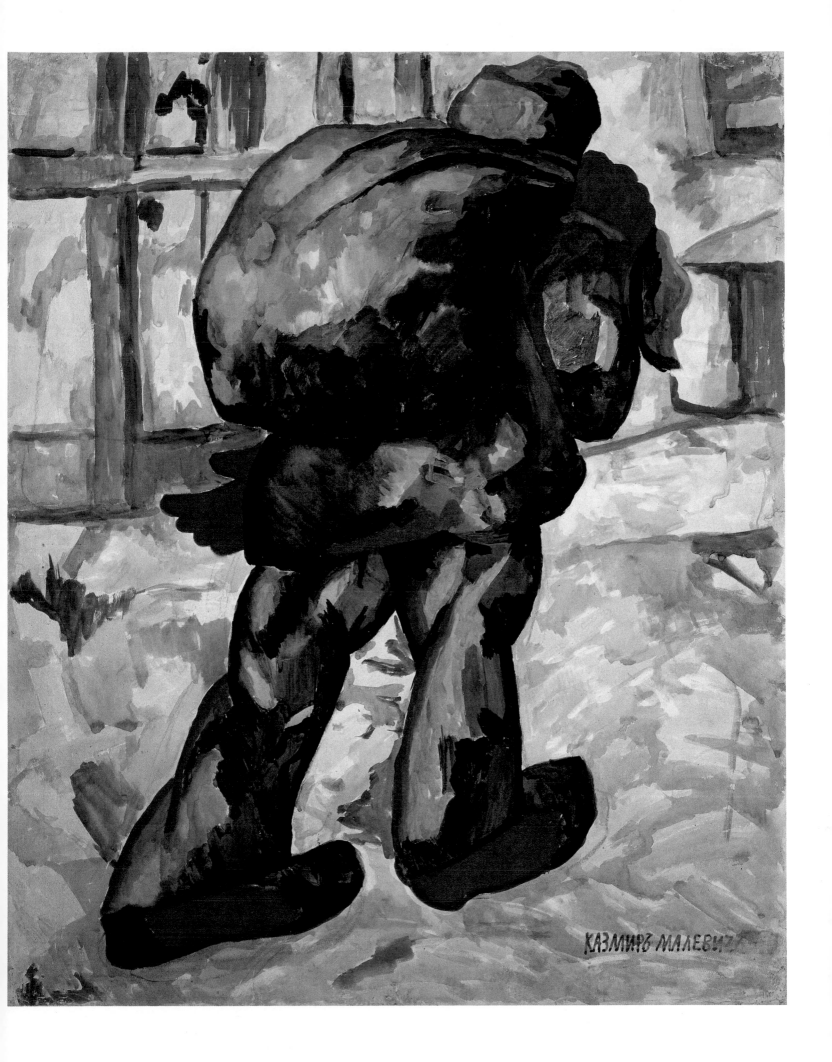

5. ON THE BOULEVARD

1911. Gouache and charcoal on paper,
28⅜ × 28" (72 × 71 cm).
Stedelijk Museum, Amsterdam

The bright Fauvist colors of the *Man with a Sack* (plate 4) appear again in *On the Boulevard*. Here a large yellow figure, boldly outlined in black with red-orange hands and face, sits on a blue park bench. The landscape is painted in flat, childlike forms, and the man seems accidentally to be drawn too large to fit within the confines of the picture. His body is slouched forward so that his head just fits below the top edge of the work, but his feet extend below its lower edge, left to the imagination of the viewer.

In *On the Boulevard*, unlike in *Man with a Sack*, the subject's face is evident, composed of simple schematic features. He appears lost in thought. Paths from either side of the central figure rise diagonally to meet behind his head; with the blue bench that stretches across the width of the paper, the paths form a firm triangular composition, the head of the man at its apex. A small black figure strolls toward the top of the picture along the path at the left.

The pensive stare that Malevich has given his subject and the meeting of the paths at his head suggest the identity of the subject's thoughts with the landscape. The artist hints that he shows us both the worried, confined figure who lacks feet, and his vision of himself walking out of the picture, on his way to some other, unseen, place.

On the Boulevard was first exhibited in December 1911, in Saint Petersburg, as part of the "Donkey's Tail" section of a Union of Youth exhibition. Malevich brought it with him to exhibit in Berlin in 1927.

6. CHIROPODIST AT THE BATHS

1911–12. Gouache and charcoal on paper,
30⅜ × 40½" (77.7 × 103 cm).
Stedelijk Museum, Amsterdam

Chiropodist at the Baths was first shown in 1912 at the "Donkey's Tail" exhibition. Malevich's other work at this and previous exhibitions indicates that it was done sometime after the spring of 1911.

The massive hands and feet, schematic eyes, and the rhythmic bodies, so large that they seem hardly able to fit within their allotted space, are characteristic of the artist's early Neo-Primitivist style. But the bright reds, oranges, and blues found in Malevich's other Neo-Primitivist works are absent here. Black and warm grays dominate the work, augmented only by washes of yellow and pink, and small greenish accents on one foot, the wooden bucket, and the hands of the chiropodist.

Chiropodist at the Baths can be called Neo-Primitive also for its humble subject matter: Two men wrapped in large towels sit to the left and right of a small table in a room at the public baths. The figure at the right extends his leg to have his calluses removed. The other smokes a cigarette. At the center the chiropodist kneels at his work behind the table. The large rounded forms outlined in black are very simple; few details of anatomy, clothing, or furniture are in evidence.

Art historians have pointed to the similarity to Cézanne's *Cardplayers* (especially the version now in The Barnes Collection) (plate 6a). Although in medium, style, and perspective the paintings are very different, Malevich has adopted the rounded shoulders and arms of Cézanne's central figure along with the picture frame partially visible on the wall above his head.

A further subtext for the *Chiropodist*, and one that no Russian viewer could have missed, is perhaps the best-known and most sacred image in Russian culture, depicted in icons of the Old Testament Trinity, in which three angels are seated around a small table in the garden of Abraham and Sarah (plate 6b). According to Orthodox interpretation, the angels symbolize the three persons of the Holy Trinity, and their meal ritualistically presages the incarnation of Christ in the New Testament.

The towels of the figures ironically imitate the draped robes of the angels; the small central table, as is customary in the icon, is shown in reverse perspective, that is, it is narrower in the foreground near the viewer. The prominence of the foot of the figure on the right and the two large rounded shapes left and right all mimic the icon. The symbolic theme of bathing and cleansing, the kneeling central figure, the burning candle, and even the white smoke all ironically and maliciously invoke the religious motif.

Malevich meant the deliberate coarseness of the scene—the foot on the eucharistic altar!—to shock his viewers. For the Russian public at the time this work first made its appearance, it must have bordered—perhaps more than bordered—on the sacrilegious. Painting offensive to Russian Orthodoxy is not unique to Malevich. Indeed, some of the Neo-Primitivist works by the artist's friend Natalia Goncharova were confiscated by the authorities for this very reason.

Far from Malevich's later intention to ennoble and idealize the image of the Russian peasant by borrowing compositions from icons, the reference here is still irreverently humorous. He opposes the ordinary and the sacred, degrading the image of the icon while adding a dimension of incongruity and even heresy to the most humble of human activities.

Plate 6a. Paul Cézanne. *Cardplayers*.
1890–92. Oil on canvas,
52¼ × 70½" (133 × 179 cm).
Photograph © Copyright 1994 by
The Barnes Collection, Merion, Pa.

Plate 6b. Andrei Rublev.
Old Testament Trinity. c. 1425–27.
Panel, 55½ × 44½" (141 × 113 cm).
Tretiakov Gallery, Moscow

7. PEASANT WOMAN WITH BUCKETS AND CHILD

1912. Oil on canvas, 28¾ × 28¾" (73 × 73 cm).
Stedelijk Museum, Amsterdam

In *Peasant Woman with Buckets and Child*, Malevich has created a strikingly modern image of prehistoric Russia, and at the same time projected a sense of the ancestral past that endures within a domestic present. He shows us the daily repetitions of unending work and the routines of peasant motherhood as contemporary continuations of age-old human rituals.

The indigenous images in this painting invoke visions of a timeless countryside and venerable peasantry that appeal powerfully to the cultural heritage of Malevich's Slavic audience. The scene, a woman carrying wooden water buckets on a yoke, is one that is repeated to the present day in the Russian and Ukrainian countrysides, where water is commonly drawn from a village well. Although this homely subject is a frequent one in Russian painting, and its national and cultural overtones are immediately recognizable, Malevich has put his stamp unmistakably on it.

His primitivizing style, with its massive bodies and the heavy, somber features of the woman and child, is taken from the carved stone idols—the "stone women"—that are the remnants of pagan rituals. A source of wonder and veneration, these images of old Slavic nature deities could be found until quite recently in the fields throughout rural Russia and Ukraine (plate 7a). In spite of their profound Christianity, many peasants preserve elements of their pre-Christian natural religion, a phenomenon known to ethnographers as "double belief" or "syncretism." The "stone women" serve to connect the modern rural population with its ancient roots in a most dramatic and concrete way.

Malevich appears to have had difficulty with the composition of this work, or perhaps initially it was quite different. The landscape is abstracted to the point of appearing unfinished. As usual, he has placed the figures' feet at the edge of the canvas, but they thereby avoid completely the yellow path running across the center of the canvas. Details of the ground, trees, a chicken, are barely sketched in. The oval shapes above the left bucket and the vertical curves in the upper right may originally have been intended to suggest the oscillating motion of the yoke, but in the final picture this has been rejected in favor of overall stasis. In the end, however, the schematic background serves to keep distractions from the viewer and so to emphasize the massive figures.

A Cubo-Futurist rendering of a similar scene may be seen in *Woman with Water Pails* (plate 11).

The painting was first exhibited at the "Contemporary Art" exhibition of the Free Art Society in Moscow in December 1912.

Plate 7a. Stone idol.
Abramtsevo Museum

60

8. THE MOWER

1912. Oil on canvas, 44⅝ × 26⅛" (113.5 × 66.5 cm).
Art Museum, Nizhni Novgorod

Late in 1912 Malevich simplified his peasant figures still further, eliminating their bright colors and leaving only gray and white refined and metallic-looking surfaces. Other colors were used only sparingly for modeling volume. Facial features, recently so massive and stonelike, now appear closer to carved wooden masks, and there is little outward emotion. Although the bodies have a metallic sheen, they are not meant to suggest robots or modern alienation. Rather, the "New Russian Style," as Malevich initially called it, was intended to suggest a future "strong man," a representation of humanity evolved. In works such as *The Mower* the artist depicted an idealized and essential human form, suppressing all particularizing details. The peasant is portrayed here motionless, outside of any specific time, and, as in icons, holding an emblematic object that conveys his identity. The advance toward generalization is evident in comparing a preparatory sketch (plate 8a) with the final work.

The loss of color in the figure with the scythe is compensated for by the bright field behind it. Decorated with schematic plants and hillocks of a growing field, the red background calls to mind at once the landscape conventions of icon painting, the red backgrounds of Novgorodian icons, and Art Nouveau ornamentation. The large rounded figure and planar background are spatially distinct, united only by the curved lines that indicate earth and leaves, and that repeat the outlines of the figure's hair, shoulders, and scythe. Malevich's static full-length portrait against such a backdrop accentuates the symbolic nature of the painting. In *The Woodcutter* (plate 9) the plants and mounds of earth will be transformed into logs and wood chips, and figure and ground will become integrated. In that work and in *Morning After a Storm in the Country* (plate 10) the assertive symbolism of *The Mower* becomes moderated in the descriptive narrative of peasant work.

The painting was first shown at the "Contemporary Painting" exhibition of the Free Art Society in Moscow late in 1912. After the November Revolution it was bought by the Purchasing Committee of the Visual Arts Section of the Commissariat of Public Education, and in March 1920 transferred to the Art Museum in the city of Nizhni Novgorod, where it remains to the present time.

Plate 8a. *Mower (Man with a Scythe)*. 1912.
Watercolor, graphite pencil on paper,
6⅞ × 4½" (17.4 × 11.6 cm).
Russian Museum, Saint Petersburg

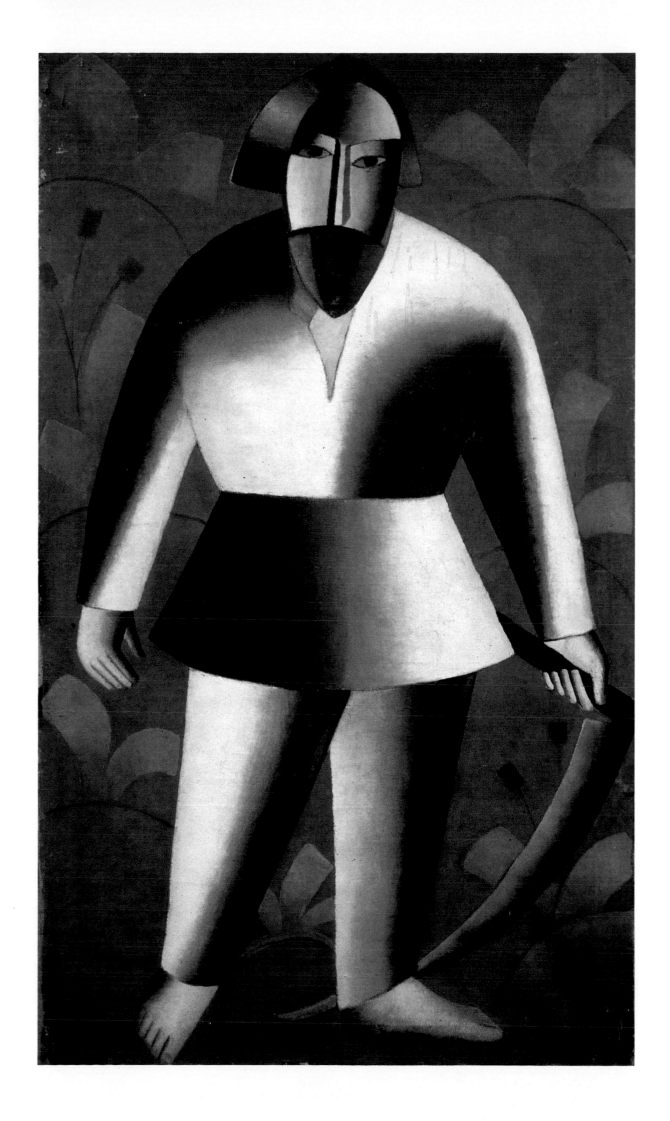

9. THE WOODCUTTER

1912. Oil on canvas, 37 × 28⅛" (94 × 71.5 cm).
Stedelijk Museum, Amsterdam

The Woodcutter is a major canvas that, although relatively small, has a presence and symbolic monumentalism that presages much of the artist's future work.

In this uncompromising painting Malevich has abandoned all naturalistic imitations of appearances. The studied naïveté of Neo-Primitivism has been exchanged for a vision of the world so idealized that it tends to concentrate our attention on the manner of painting itself, rather than on the scene depicted. The smooth volumes of the peasant woodchopper and the logs are modulated in the yellows, reds, and greens seen earlier in the Fauvist and Neo-Primitive pictures, but here there is no expressive reference to idols or to naïve drawing. The schematic eye of the woodchopper is all that is left of the former peasant faces. Bestriding a huge horizontal log, the figure occupies the entire height of the canvas. He wears a long Russian shirt belted at the waist as he bends over his labor. We see his ax raised, but frozen prominently in profile without any indication of movement.

The limited space surrounding the figure is occupied entirely by the angular tangle of logs of wood; there is no hint of anything else—field, forest, or village. The figure of the woodchopper and the logs surrounding him are simplified to the point of archetypal representation. The precision and uniformity of the shapes and the overall density of the color unify the picture, and give the view a solidity we have not seen before in Malevich's work.

But it is precisely this solidity that the woodchopper is engaged in destroying. He has been chopping the logs into the smaller and thinner sections visible at the lower left of the canvas. For Malevich, this emblematic figure represented the contemporary Russian poet and painter, whose art was committed to breaking up the word and the visible object in order to reveal the real nature of language and the world.

The notion of the artificiality and penetrability of the visible world arose in part from recent technological advances such as radiotelegraphy and X-ray photography, and in part from ideas such as clairvoyance. "We have cut the object! We have begun to see through the world!" Malevich's poet friend Aleksei Kruchenykh wrote in a contemporary manifesto. Malevich shows the artist-woodcutter in the process of doing just this.

The geometrization of form was a stylistic stratagem widespread among modern artists at the time. Picasso's proto-Cubist work of 1908–9, such as *The Dryad*, which was in the Shchukin collection in Moscow, was quite familiar to Russian artists. Malevich's friend Natalia Goncharova had, in fact, based her own painting of a woodchopper on this Picasso work. It is also probable that Malevich knew Léger's geometric compositions, such as *Nudes in the Forest* (1909–10). Like Picasso's, Malevich's subject is a single monumental figure, and like Léger's, his pictorial elements are rigorously reduced to geometric forms. But Malevich's painting stands apart from these works because of its bright color, its native subject, and the overriding symbolic nature of the image.

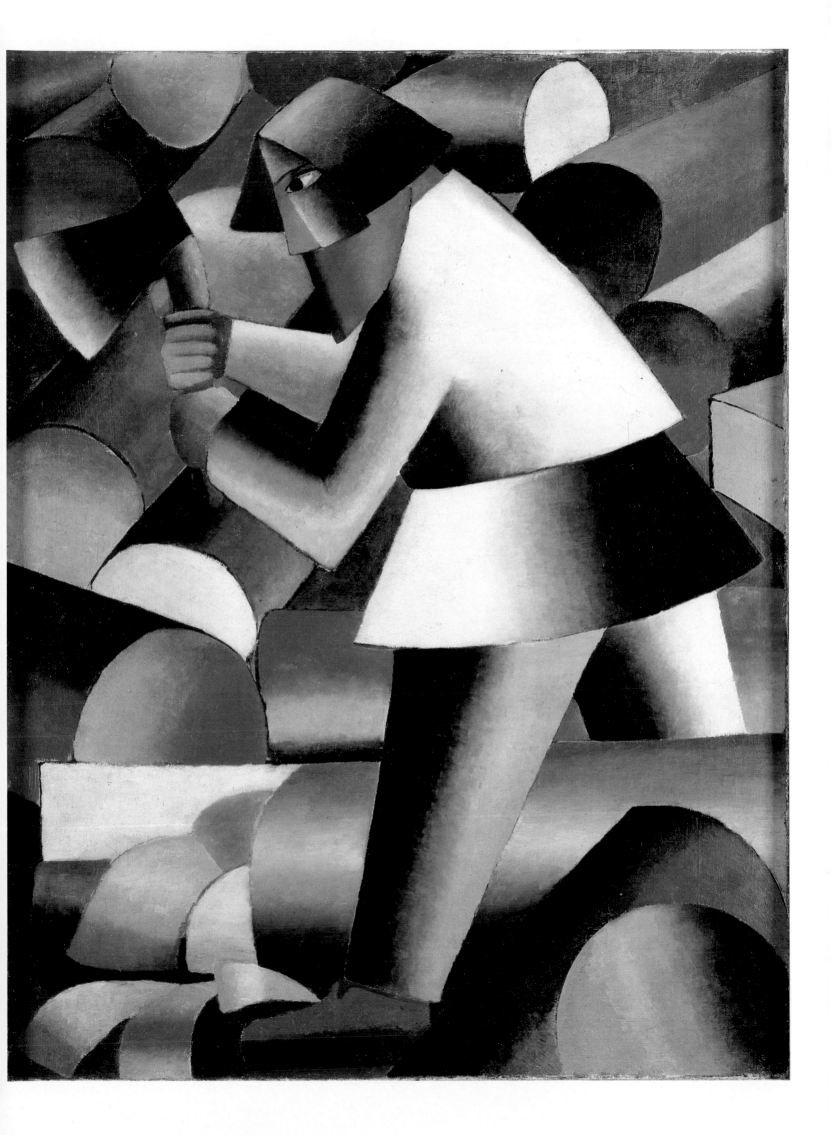

10. MORNING AFTER A STORM IN THE COUNTRY

1912–13. Oil on canvas, 31¾ × 31⅞" (80.7 × 80.8 cm).
Solomon R. Guggenheim Museum, New York. 52.1327

A quiet, radiant masterpiece, *Morning After a Storm in the Country* is a vision of ordinary activities taking place in a Russian country settlement: two women carrying buckets to the village well walk between rows of small houses, another figure crosses the end of the path, pulling a loaded sled. The whites, grays, and blues, the rigid peaks of the snow, the smoke billowing from the chimneys, all convey the frigid temperature and the frosty air.

As in *The Woodcutter* (plate 9), the entire scene is composed of unifying geometric shapes; here the triangle predominates. The bundled figures are reduced to stiff truncated triangles, the repeated roofs of the cottages are similarly built of triangles and partial triangles. The rectangular windows and walls are crossed by shadows dividing them into triangular areas. The shadows, the distant hills, the mounds of snow, all reiterate this form throughout the work; even the puffs of smoke from the chimneys are divided into "rounded triangles." The colorful modulation of this basic form throughout the painting produces a distinct three-dimensional, sculpted, effect: the scene seems almost to have been cut from cubes of sugar or ice.

In *Morning After a Storm in the Country*, Malevich does not yet entirely annihilate deep space by filling the picture plane with a mass of tight-fitting geometric shapes. There is some depth to this landscape and even an indication of some hills in the distance. Still, the artist does not encourage any escape into a space beyond the picture. The two rows of houses that line the sides of the picture fill all the space to the sides of the work, and the area between them narrows to a small opening in the distance; the figure crossing in the center of the work effectively cuts off even that small exit. Clearly the bucket carriers will fill their pails and return along the same path, without a thought of another place or life.

This work was painted in late 1912 or early 1913. It was first shown at the "Target" exhibition in Moscow in March 1913. The artist initially called this geometric style of painting, begun in 1912, the "New Russian Style," but by the second half of 1913 he had renamed it "*Zaum* [Beyond the Intellect] Realism."

Malevich must have been quite satisfied with this painting. In February 1914 he sent it to Paris to be exhibited at the Salon des Indépendants. He also included it among the works that he took abroad with him in 1927. It was shown in Warsaw at the Polish Art Club, and in Berlin in association with the "Grosse Berliner Kunstausstellung" (Great Berlin Art Exhibition). After the exhibition it went to the family of Hans Richter, with whom Malevich had planned a Suprematist film, and was acquired by the Guggenheim Museum from the Rose Fried Gallery in New York in 1952.

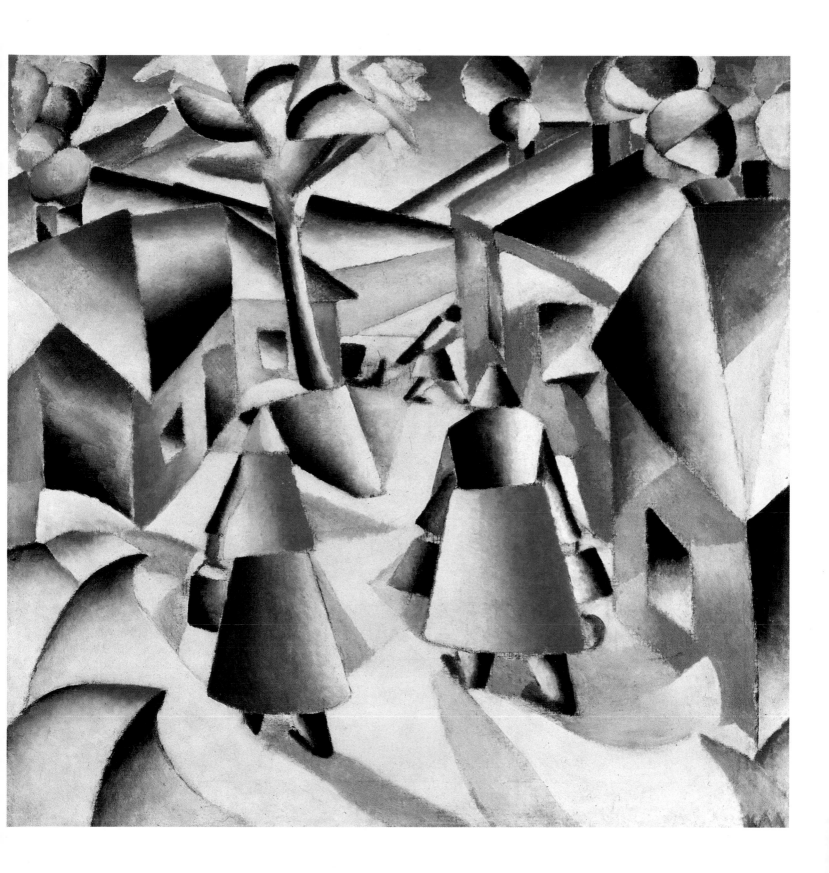

11. WOMAN WITH WATER PAILS: DYNAMIC ARRANGEMENT

1912–13; dated 1912. Oil on canvas, 31⅝ × 31⅝" (80.3 × 80.3 cm).
The Museum of Modern Art, New York

In *Woman with Water Pails* Malevich pursues his interest in peasants at work in the village, but here he has moved to an extremely close-up view of a single figure, filling most of the canvas with a severely geometrized version of a peasant woman carrying two water buckets at the ends of a wooden yoke. The woman and the landscape have been broken into truncated cones and convex trapezoids of a similar metallic color and painted sheen, making it difficult for the viewer to identify individual objects. In contrast to *The Woodcutter* (plate 9) or *Morning After a Storm in the Country* (plate 10), the artist in this work controls the shape and volume of the idealized forms through gradual transitions between black and white, rather than through modulations of color.

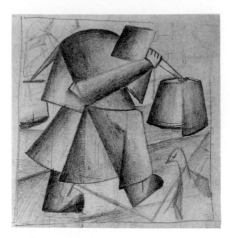

Plate 11a. *Peasant Woman with Buckets.* c. 1912. Graphite pencil on paper, 4⅛ × 4¼" (10.5 × 10.7 cm). Russian Museum, Saint Petersburg

The division of the canvas into a clutter of simplified volumetric forms of similar shape and tone seems to block the view into the distance. The color passages are deployed mainly to create slight indications of the landscape space. The path along which the woman walks and the open area around her are suggested by the few white and yellow or green areas, which seem to be small chinks in the metal-filled surface. This provides the only possibility of orienting ourselves, even in a rudimentary way, in the extremely shallow three-dimensional space. Even the neutral square shape of the canvas itself militates against experiencing *Woman with Water Pails* as a landscape; we do not see a broad horizontal expanse in it, nor can we detect much of a difference between forms in the top and bottom halves of the canvas.

The most easily distinguished parts of the central figure are the water pails, the yoke, and especially the hand grasping it. Logic forces us to conclude that the irregular reddish parallelogram to the left of the hand is the woman's head, although it seems too low—a conclusion that is corroborated by Malevich's drawing of the same subject (plate 11a). Again, even in so abstract a work, Malevich produces the impression that only by bending over does the subject fit into the picture.

In addition to the woman with buckets we can recognize another smaller peasant figure (just above the right-hand bucket) and a tilted white house with windows and a pink roof (top right). Other indications of surrounding objects are more ambiguous because of the uniformity of their color.

Malevich has given us some indication that the figure is walking. The tilted structures may be explained by the woman's unstable perception as she makes her way through the village, and the gray curves repeated above the water pail on the left refer to its oscillating motion as it is carried along. The movement implied by these devices is not very strong, however; the intricate composition, smooth surface, and precise edges of the forms, seem to hold the entire scene firmly in place. Ultimately the dynamism of the picture springs from the complexity of its angled and contrasting forms rather than from painted motion.

Woman with Water Pails was probably painted in the spring of 1913; it was shown in Saint Petersburg at the Union of Youth exhibition in November of that year. In the catalogue to this exhibition Malevich labels it "*Zaum* [Beyond the Intellect] Realism." He meant to suggest by this that the scene is not one produced by ordinary sight and logic, but by a perception so highly developed that it presents the world in an entirely new and profound way.

As in *The Woodcutter*, Malevich shows us a human figure embedded into its surroundings, but here the woman is almost indistinguishable from everything else, so that she appears to be an integral part of the entirety of nature, seen at its most fundamental level.

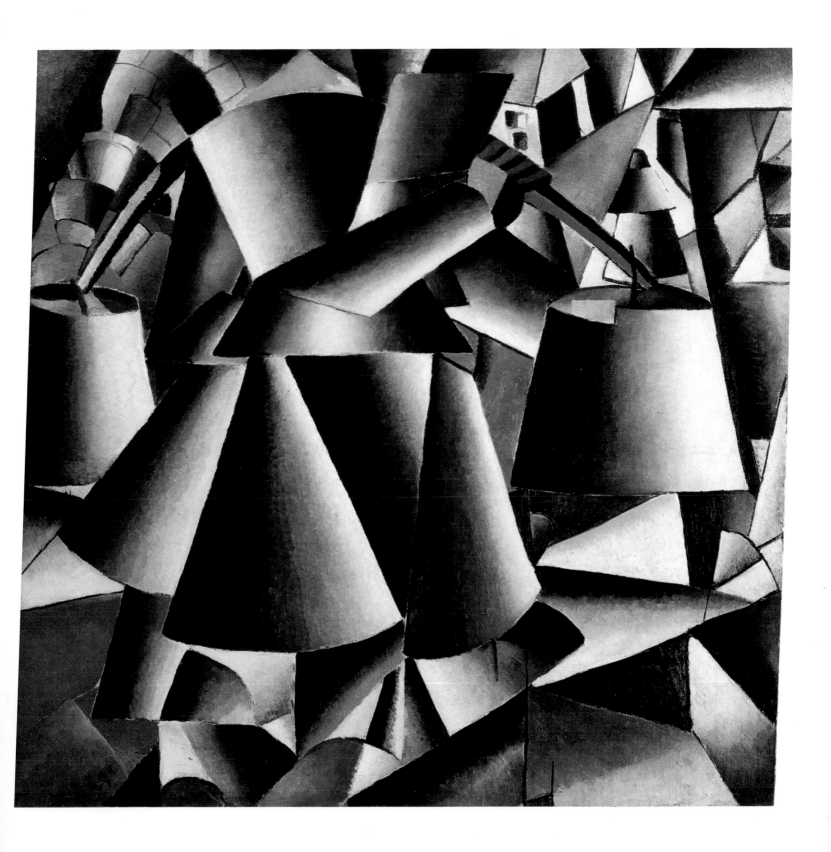

12. FINISHED PORTRAIT OF IVAN KLIUN

1913. Oil on canvas, 44⅛ × 27⅝" (112 × 70 cm).
Russian Museum, Saint Petersburg

The subject of Malevich's enigmatic portrait is one of his closest artist friends, the painter and sculptor Ivan Kliun (Kliunkov). Kliun's burnished, bearded face is depicted sawed apart, deconstructed into several discrete sections. In spite of the multiple disjointed forms, the careful symmetry and balance of the composition produce a brooding, harmonious whole.

While the motif of the saw and sawing in this work may in part refer to Kliun's activities as a sculptor who worked in wood, its philosophical import is similar to that of *The Woodcutter* (plate 9). The major theme of the work—the artist's vision and the development of a new kind of penetrating sight—is conveyed through displacing half of the eye on the left (a technique Malevich called "*sdvig*" [shift]) and opening the other to interior abstract and faceted structures. Malevich's concern with the "inner eye" at this time is related to his interest in the elevated states of consciousness and advanced modes of perception that were associated with the concept of *zaum,* or an awareness beyond all logic. These ideas—as well as the image of the saw blade—are continued and further developed in slightly later works such as *Englishman in Moscow* (plate 18).

The unusual title of the work refers to the fact that earlier Malevich had painted another—less geometric—portrait of the same subject. *Finished Portrait of Ivan Kliun* was first exhibited at the Union of Youth exhibition that opened in Saint Petersburg in November 1913. In the exhibition catalogue it is listed as "*Zaum* Realism." Immediately after this exhibition closed, Malevich sent the painting to Paris for the "Salon des Indépendants."

In 1919, *Finished Portrait of Ivan Kliun* was bought by the Russian government and transferred to Vitebsk as part of a collection for a future museum of modern art. After Malevich left Vitebsk for Petrograd, however, it was deposited at the Museum of Artistic Culture in that city. In 1926 the museum, then part of the Institute of Artistic Culture, was forcibly closed, and the painting was transferred to the Russian Museum. There Nikolai Punin, the museum's director, included it as part of the "New Trends in Art" show that opened in November 1927. The painting has remained in the museum since that time.

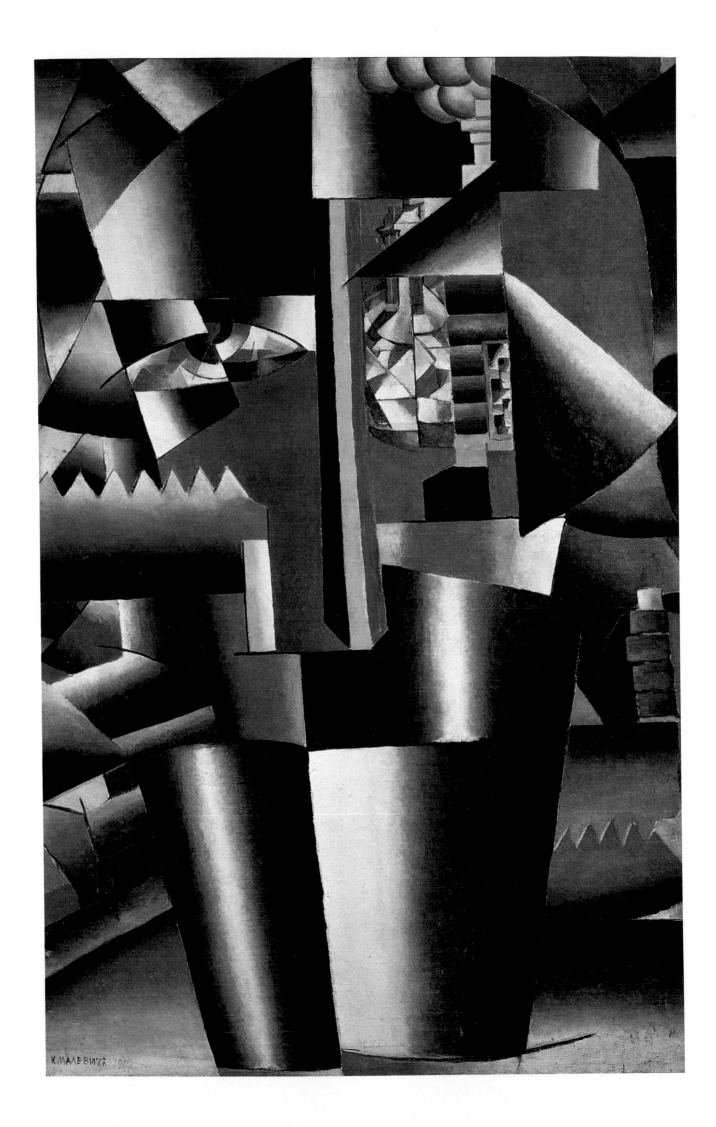

13. THE GRINDER: PRINCIPLE OF FLICKERING
(THE KNIFE GRINDER/THE SCISSORS GRINDER)

1912–13. Oil on canvas, 31¼ × 31¼" (79.5 × 79.5 cm).
Yale University Art Gallery, New Haven. Gift of Collection Société Anonyme

This painting, which has been exhibited in the West variously as *The Knife Grinder* and *The Scissors Grinder*, was entitled by Malevich simply *The Grinder*, and subtitled *Principle of Flickering*. He first showed it in March 1913 at the "Target" exhibition in Moscow.

The single large hunched figure of a blade sharpener bends over a revolving grindstone. As in *On the Boulevard* (plate 5) and similar works, the figure seems barely to fit within its allotted square of canvas. Although the subject is a continuation of Malevich's theme of the humble laborer, the style of painting is a new approach for the artist, brought to mind undoubtedly by his recent acquaintance with the work of the Italian Futurists Umberto Boccioni and Gino Severini. The body of the figure is shown from several points of view; we see his head and shoulders straight on, his legs and feet in profile. The entire figure has been subjected to the fragmentation of displaced and repeated forms. The grinder's hands and arms especially, and the foot that operates the treadle of the grinding wheel, are shown in several distinct positions, the depicted motion of stop-time photography.

Malevich has filled the space surrounding the figure with forms that are static, but also repetitive—the stone steps of a staircase to the right of the work, knives on a table, and the supports of a railing to the left. The representation is not at all flat: the fingers look carved and chunky, and the railing and steps are almost illusionistic. The figure's head and knees even seem to project beyond the surface of the canvas into the viewer's space.

The Grinder was acquired by the Soviet government from the artist about 1920 as part of the store of works from which it established museums of contemporary art throughout the country. At the time, Malevich was teaching in Vitebsk, and *The Grinder* was designated for a projected museum in that town. But the museum never materialized, and Malevich left Vitebsk in 1922.

The extensive holdings of the Russian government formed the basis on which David Shterenberg organized the "First Russian Art Exhibition" in Berlin. The exhibition, including *The Grinder*, opened at the Van Diemen Gallery in the fall of 1922; profits from the show were designated for Russian famine relief. The painting was acquired from the exhibition by Katherine Dreier, the American collector and founder of the Société Anonyme, for $41.62 (180,000 marks); it was included in at least seven exhibitions in the United States before World War II, and was donated to Yale University in 1941 as part of the Société's collection.

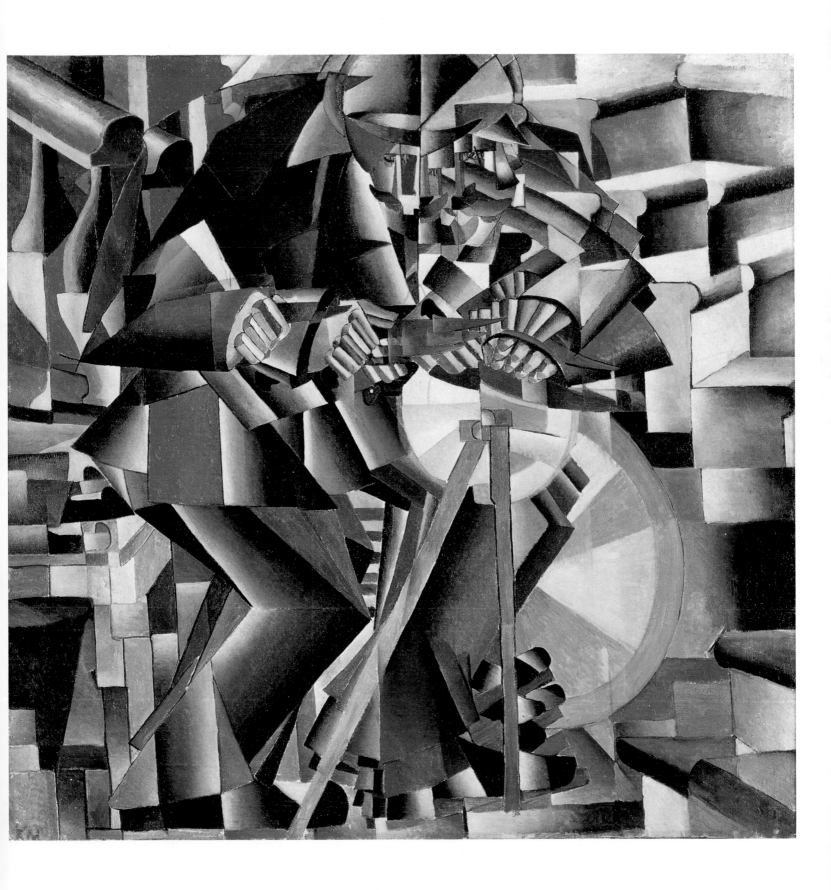

14. SAMOVAR

1913. Oil on canvas, 35 × 24 ½" (88 × 62 cm).
The Museum of Modern Art, New York.
The Riklis Collection of McCrory Corporation (fractional gift)

In the fall of 1913, destitute and hungry, unable even to afford to eat at a workers' cafeteria, Malevich moved to the Moscow suburb of Sokolniki and rented out rooms for a living. Here, between running the boardinghouse, buying coal and wood, and cooking meals for his tenants, Malevich adopted his closest approach to an Analytic Cubist style, and turned to household objects as subjects for his paintings: *Stove, Clock, Lamp,* and the innovative *Samovar.*

The composition is dominated by the diagonal grid that the artist adopted at this time for several works. His method of painting is very loose and tactile, an abrupt change from the refined surfaces of works such as *Woman with Water Pails* (plate 11). The expansion and schematization of the forms make it difficult to distinguish the subject, although Malevich has aided the viewer in this process with a few drawn lines in the lower center of the work that delineate the base of the samovar and its spigot.

In *Samovar,* Malevich moves toward the extinguished color commonly associated with the Cubism of Braque and Picasso, but this does not prevent him from referring to the colors present in the samovar itself: the silver metal color of the body of the samovar dominates the center of the work, and the browns signify the wooden table on which it rests. The curved and ribbed dark shapes in the center right and upper and lower left refer to the turned wooden knobs and handles of the samovar. Malevich's paintings in this style were the first works he designated "Cubo-Futurist."

Shortly after finishing it, Malevich sent *Samovar* to Saint Petersburg for the Union of Youth exhibition that opened in November 1913 and then, in the spring of 1914, to Paris—through his friend Nikolai Kulbin—to be exhibited at the "Salon des Indépendants." It was included also in his retrospective exhibition in December 1919.

Because of the exhibition history of this work, some question has arisen about its proper orientation. It was shown at the Indépendants and at Malevich's 1919 solo exhibition rotated 180 degrees from the orientation given here. But Malevich was probably not present for the hanging of either exhibition, and related drawings (plate 14a), stylistic details, as well as the few fragments of imagery that can be discerned in the work, suggest that the painting should, in fact, be viewed as it is reproduced here.

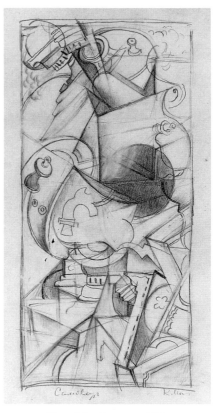

Plate 14a. *Samovar.* 1913.
Graphite pencil on paper,
9½ × 6" (24.9 × 15 cm).
Collection Lev Nussberg

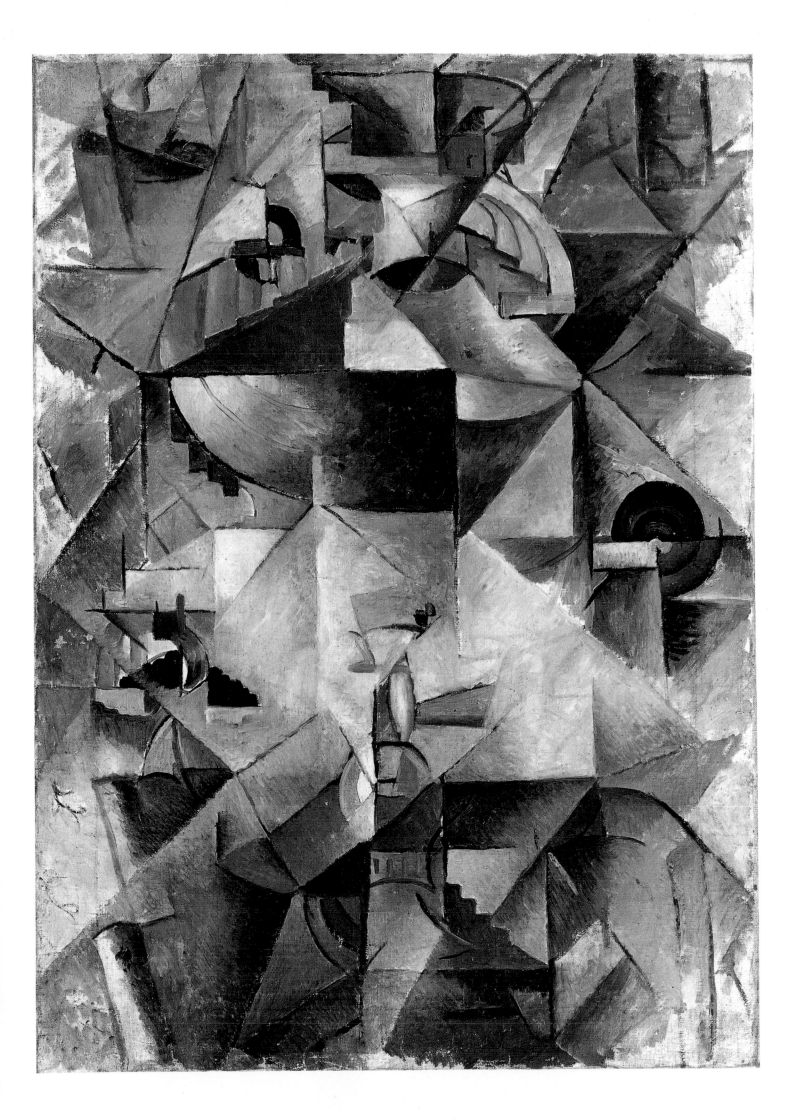

15. ATHLETE (SPORTSMAN)

1913. Watercolor and india ink, 10⅝ × 8¼" (27.2 × 21 cm).
Russian Museum, Saint Petersburg

Malevich considered his designs for the opera *Victory over the Sun* one of the highlights of his career. Although called an opera by its creators, *Victory* was actually a small avant-garde theater piece in which Malevich, the poet Aleksei Kruchenykh, and the composer Mikhail Matiushin tried to synthesize on stage Cubo-Futurist styles in painting, poetry, and musical composition. *Victory* had many precedents—the science fiction of H. G. Wells, the impudent Russian peasant theater, and the wandering players called *skomorokhi,* but in its absurdist language and enigmatic costumes and sets, it was a uniquely modern performance. In retrospect, Malevich credited *Victory* with inspiring his move a year later to the abstract Suprematist style.

After performances in Saint Petersburg on December 16 and 18, 1913, attended by riots in the audience, Malevich repeatedly attempted to revive the opera. His effort to bring it to Moscow in 1914 was frustrated by the advent of the Great War. With designs by Malevich and Vera Ermolaeva, it saw one additional performance, by their students at the Vitebsk school in February 1920, and it was the subject of a series of colored lithographs made by El Lissitzky in 1923. Still later Malevich created new designs for the opera, but it was not performed again in his lifetime.

In his first designs for *Victory,* Malevich endeavored to create asymmetrical costumes which worked against the integrity of the body, building the forms from sections that look as if they had been cut from Cubist paintings. The costumes are frequently geometric, but they are always far from mechanical. In this design for the Athlete's costume, for example, angular, colored sections are isolated by areas of white, a device which highlights the unexpected irregularity of the shapes. There was a theatrical purpose to this formal irrationality. Clothed in such costumes and moving about the stage in front of spatially ambiguous painted sets and roaming spotlights, the actors created continuous variations in the scenic illusions.

The Cubo-Futurists associated the figure of the athlete with intimations of superhuman people in the future; athletes were later Malevich's subject for a major painting (see plate 37).

The designs for the sets and costumes of *Victory over the Sun* are kept in the Saint Petersburg Museum of Theatrical and Musical Arts and in the Russian Museum, which acquired the Athlete's costume in 1928 from Levkii I. Zheverzheev, a collector of theater designs and the backer of the 1913 production.

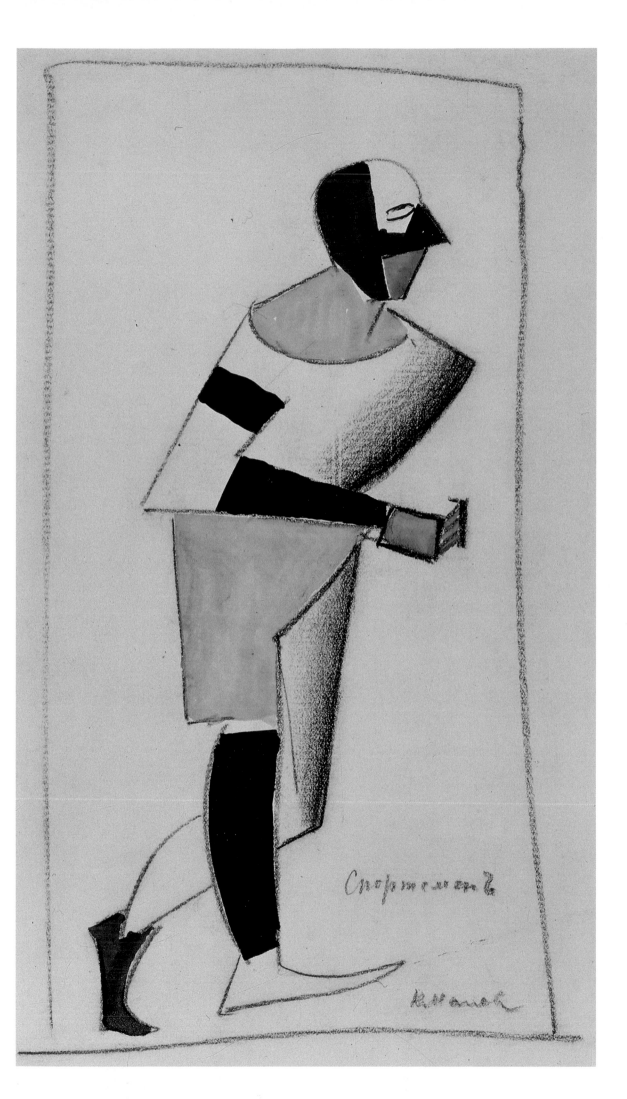

Спортсменъ

К. Малевичъ

16. LAMP (MUSICAL INSTRUMENT)

1913–14. Oil on canvas, 32⅞ × 27⅜" (83.5 × 69.5 cm).
Stedelijk Museum, Amsterdam

Malevich explored various approaches to Cubism in 1913 and the first half of 1914. He was concerned with the Cubist styles particularly as a possible means to express in painting his ideas about *zaum* (beyond the intellect). Through apparently nonrational imagery Malevich hoped to incite the viewer to a heightened perception of the world, and a new understanding of the power of art.

Lamp (Musical Instrument) contains many of the motifs found in Malevich's decor for the Cubo-Futurist opera *Victory over the Sun*, and we can assume that he painted it about the same time—at the end of 1913 or early in 1914, shortly after the performances had taken place. References in the painting to music—the three musical notes, the piano keys at the lower right, the body and curved neck of a musical instrument at the upper and lower left—relate to his experience with *Victory*. In the musical context of this work we might even be tempted to read the four white diagonal lines across the black center of the composition as strings across the sound hole of an instrument.

Lamp (Musical Instrument) discloses the emergence of a distinct Cubo-Futurist style. The spatial ambiguities borrowed from Analytic Cubism and the purely painterly interests of paintings such as *Samovar* (plate 14) have been set aside here. Now many of the depicted shapes, such as the lamp in the upper left, are recognizable, and have depth and weight, and the entire diamond-shaped structure has been firmly located in the center of the canvas, leaving the corners more or less empty.

Yet there is some question about space here also. The dark area crossed by white lines at the center of the canvas may be read as a "window" giving onto a space beyond the three-dimensional structure that occupies most of the canvas. Through that opening we can see the saw-toothed top of a brick kremlin or fortress wall quite realistically rendered. The artist does nothing to alleviate our resulting confusion about the location of the remainder of the composition and its relationship to the central view, except, perhaps, for providing us with what appears to be a handy ladder to the right of the window, which, he seems humorously to suggest, we might need to get a better perspective on the "outside." Also surrounding the center is part of the chunky cross that was popularly understood to signify a fourth-dimensional cube. *Lamp (Musical Instrument)* and the stage design for *Victory* are the first incontestable visual indications of Malevich's awareness of hyperspace philosophy.

The double title of this work is an art-historical artifact. It stems from two labels that were found on the reverse of the canvas: an earlier one with the designation "Lamp," and one from 1921 indicating that "Musical Instrument" was the title. The painting was probably exhibited first in February 1914 at the Moscow "Jack of Diamonds" exhibition. It was also shown at Malevich's retrospective in 1919 in Moscow. In the spring of 1921 Malevich included this painting in a group of works that he attempted to sell to the Russian government's museum collections, but his offerings at this time were ultimately rejected. He took the painting abroad with him in 1927.

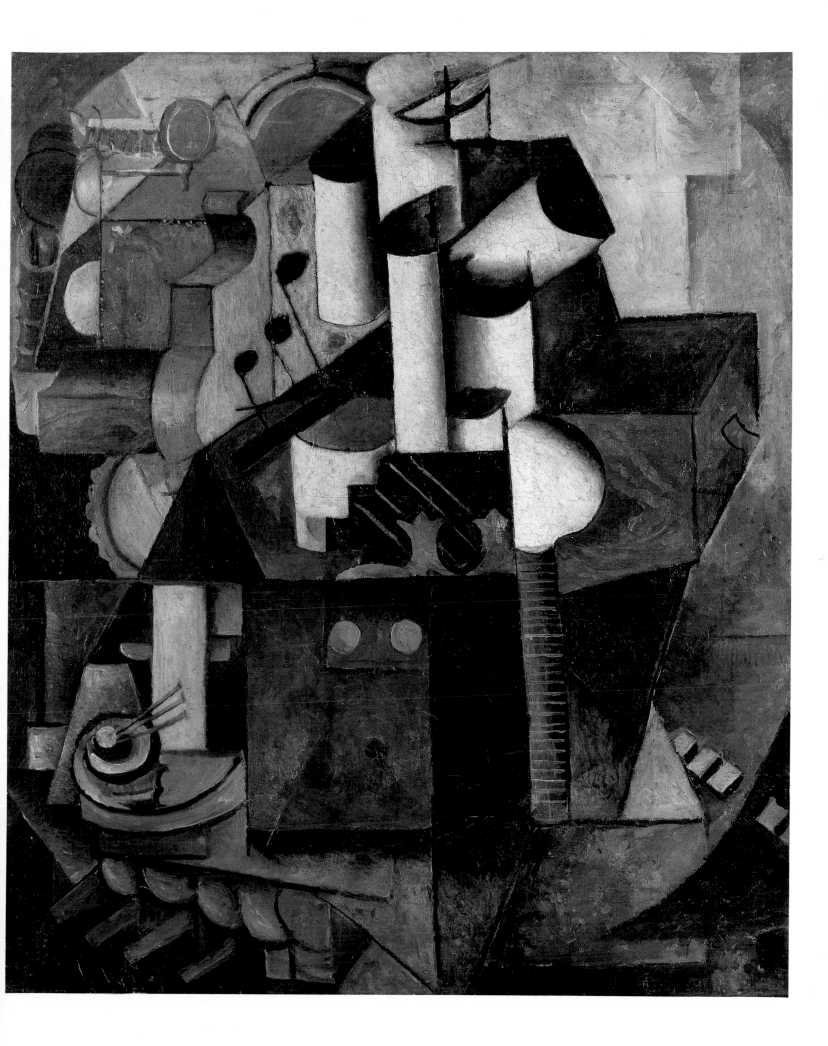

17. LADY AT A TROLLEY STOP (LADY IN A TROLLEY)

1913–14. Oil on canvas, 34⅝ × 34⅝" (88 × 88 cm).
Stedelijk Museum, Amsterdam

The Russian Cubo-Futurists considered themselves people of the future, and they adopted the Cubist style of painting as a sign of an advanced ability to see the world in a way that was fundamentally different from common perception (see Introduction, page 15). Significantly, the central position in *Lady at a Trolley Stop* is occupied by a timetable, a reference to future time, and also the conceptual complement to the allusions made to space in *Lamp (Musical Instrument)* (plate 16).

In *Lady at a Trolley Stop*, Malevich juxtaposes different painting styles to indicate the old and the new modes of perception. He retains the diamond composition and the thematic central rectangle of *Lamp (Musical Instrument)*, but now he contrasts the Cubist structure of overlapping planes and schematic lines with illusionistically drawn objects. He wants us to understand that the two modes of seeing are related to each other, and that the "objectless" Cubist vision is an alternative to the old realm of objects. Just above the center he shows us a Cubist rectangle half peeled away to reveal the bottle that it stands for, while from behind a rectangle to its right peers a man in a bowler hat.

The subject indicated in the title of this work, the "lady," is, however, nowhere to be seen. A preliminary drawing (plate 17a) reveals that the artist initially had in mind a composition of the many objects one might see while waiting on the street or riding in a trolley: a hand, a fence, a bicycle wheel. In the drawing the head of a woman wearing a feathered hat appears below and to the left of the timetable. X-ray studies of the painting reveal that in fact Malevich went through the process of painting some of the objects indicated in the drawing and then covering them up with the planar Cubist composition seen now.

Lady at a Trolley Stop is one of the first paintings in which Malevich's major "concealment" theme is clearly demonstrated; it is also an early manifestation of the extensive study that the artist undertook in the 1920s of artistic style as a function of biological and psychological evolution.

Lady at a Trolley Stop was first exhibited in February 1914 at the Moscow "Jack of Diamonds" exhibition. After trying unsuccessfully to sell it in 1921 to the Russian government for its museum collections, Malevich brought the painting to Berlin in 1927.

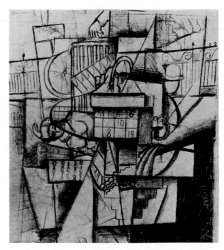

Plate 17a. Sketch for *Lady at a Trolley Stop*. c. 1913. Pencil on paper, 6¼ × 6" (16 × 15 cm). Whereabouts unknown. Formerly collection Anna Leporskaia, Saint Petersburg

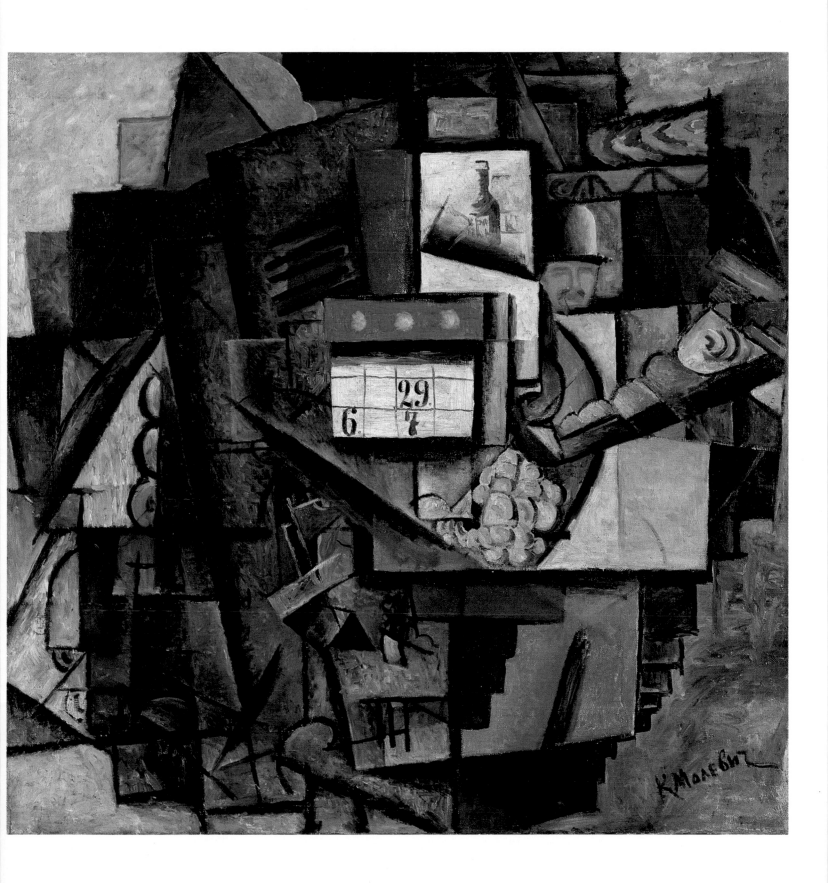

18. ENGLISHMAN IN MOSCOW

1914. Oil on canvas, 34⅝ × 22½" (88 × 57 cm).
Stedelijk Museum, Amsterdam

In *Englishman in Moscow*, Malevich pursues many of the ideas that he has explored previously, but in a dramatically new way that alludes to the visual and occult notions of Cubo-Futurism. Instead of intersecting Cubist planes, in *Englishman in Moscow* the artist has devised a colorful composition of objects, words, and parts of words designed to entrance, but also to mystify the viewer.

Englishman in Moscow engages familiar themes: the notion of concealment, expressed here most obviously by the covering of half the subject's face, and that of cutting or slicing, denoted by the wartime images of the sword and bayonets, as well as the scissors and the saw. The ladder, with its reference to raising up or to a higher perspective, is an image seen previously in one of the set designs for *Victory over the Sun* (fig. 11) and in *Lamp (Musical Instrument)* (plate 16). The portrait of the Englishman is reminiscent of *Finished Portrait of Ivan Kliun* (plate 12) in its greenish tone and dominant verticality, as well as the saw and the obscured eye.

Yet in a way that we have not observed before, the images are strikingly clear, even though the meaning is far from apparent. *Englishman in Moscow* is a hermetic picture, but not demandingly so. Malevich has abandoned the previous visual difficulty of his ideas for an attractive and interesting array of objects that can be enjoyed purely for their color and variety.

Malevich began to introduce letters and words into his work in 1913—at first in drawings and lithographs, and then in the decor for the opera *Victory over the Sun*. By 1914 painted and collaged words add to the texture of the composition. But these linguistic elements have more than a decorative or formal significance; they enrich the symbolic complexities of the work. In the four words and their fragments here Malevich provides clues to the painting's significance. They succinctly allude to two major ideas we have noted in previous works: time and concealment. The two words at the top and bottom of the canvas are *zatmenie* (eclipse) and *chastichnoe* (partial). Their most immediate reference is to the face half blocked by the vertical fish. The word for "eclipse" has been further divided into another two words that convey the notion "beyond the dark," or "beyond that which is doing the obscuring." Similarly, *chastichnoe* has been divided in such a way as to isolate the word *chas* (hour) from the suffix of an adverbial adjective, *-noe* (hour*ly*). The two words written across the scissors just to the right of the half face are *skakovoe obshchestvo* (galloping society). The semantic ambiguity in Russian is the same as it is in English: the phrase may connote a riding club, or a society that in general is galloping into the future.

Malevich in both words and images reiterates here his notion that the visible world is not what it seems to be, that one thing conceals another, and that it is necessary to penetrate this illusion. The subject of *Englishman in Moscow*, like that of *Finished Portrait of Ivan Kliun*, is ultimately that of the knowing mind, rather than the eye that sees merely surfaces. Malevich suggests that with the advance of time this eclipsed vision will end—literally, that the scales will fall from our eyes! The fish, the candle, the Orthodox church, and the emblematic cross suggested by the candle and sword, all hint at the spiritual dimension of these ideas.

Englishman in Moscow was first exhibited at "The V Trolley. The First Futurist Exhibition" in Petrograd in March 1915.

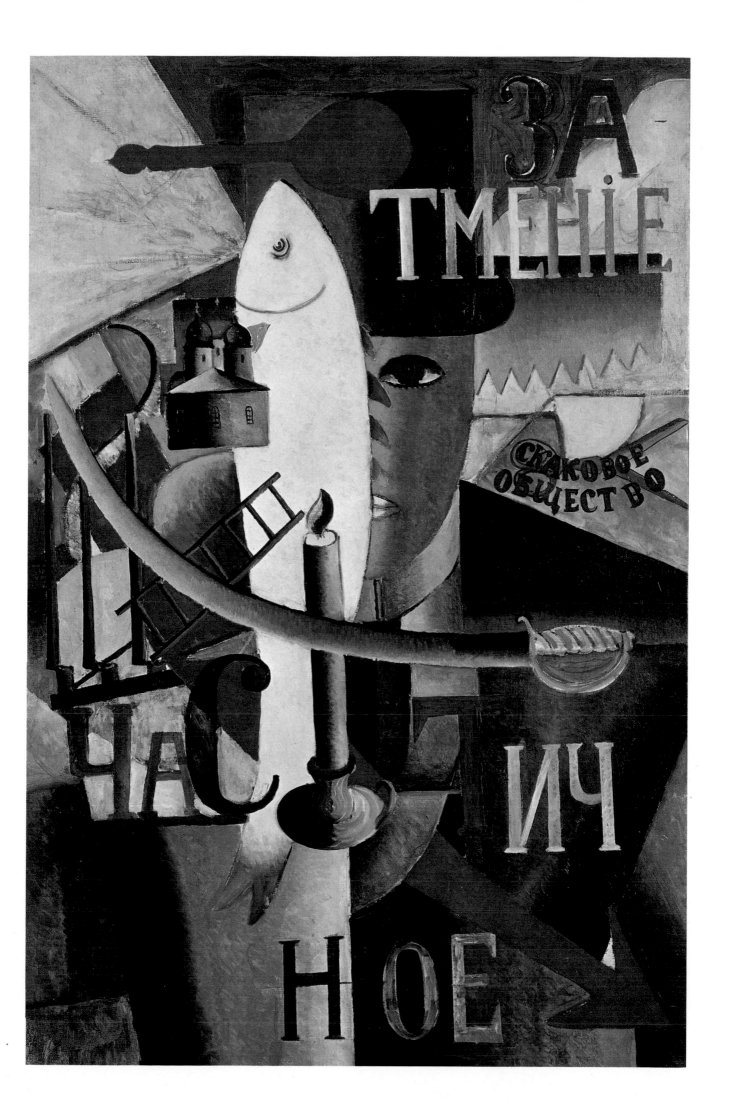

19. AIRPLANE FLYING (SUPREMATIST COMPOSITION)

1915; dated 1914. Oil on canvas, 22⅞ × 19" (58.1 × 48.3 cm).
The Museum of Modern Art, New York. Purchase

The exquisite *Airplane Flying* is one of the Suprematist canvases first shown at the famous "0,10 (Zero–Ten). The Last Futurist Exhibition," where Malevich introduced this new, severely abstract style of painting to the public. The exhibition, opened in Petrograd in December 1915, created a sensation because of the radical Suprematist abstractions.

This early Suprematist painting clearly demonstrates the conceptual nature of Malevich's stylistic innovation. The series of three black elements that increase in size from right to left, followed by the three yellow rectangles progressing from left to right, refer to the relative size of the plane as it zigzags up from the earth. In these new works Malevich often positions the viewer in the air; here we see the moving plane from above, and as if in stop-time motion. The red horizontal element establishes a reference point, a tipped horizon line, that the plane crosses as it climbs. Malevich succeeds in creating a sensation of lift and flight without any mimetic illustration of the airplane—a method he called "objectless." The clear primary colors distance the painting from its visual inspiration still further, by preventing us from seeking clues to the scene through naturalistic color.

Suprematism was the direct result of the desire to convey a new kind of sight, to disguise or eliminate the commonly perceived object. The subject of the painting—and the very fact that Malevich has given it an explanatory title—are clear indications that Suprematism was an extension of Russian Cubo-Futurism. Malevich here is still interested in implied motion, multiple viewpoints, and in the novel experiences created by advanced technology. In many cases the experiences and images connected with flight stand behind the first Suprematist paintings, all the more so since the artist arrived at Suprematism during the time that the Great War dominated the consciousness of the country. Regardless of the pictorial origins of Suprematism, Malevich immediately recognized its pioneering nature, and associated this new style of painting with an elaborate cosmic, "objectless" philosophy.

Airplane Flying was included in the artist's 1919 retrospective in Moscow, and was then taken abroad by the artist in 1927, where it was exhibited in Warsaw and Berlin. It remained in Germany after Malevich's return home to Leningrad, and in 1935 was purchased from Alexander Dorner of the Hanover Museum by Alfred H. Barr, Jr., the founder and director of The Museum of Modern Art in New York. The painting was smuggled out of Nazi Germany concealed in Barr's umbrella, and was shown first in the United States at the 1936 exhibition "Cubism and Abstract Art" at The Museum of Modern Art. It has been in the museum since that time.

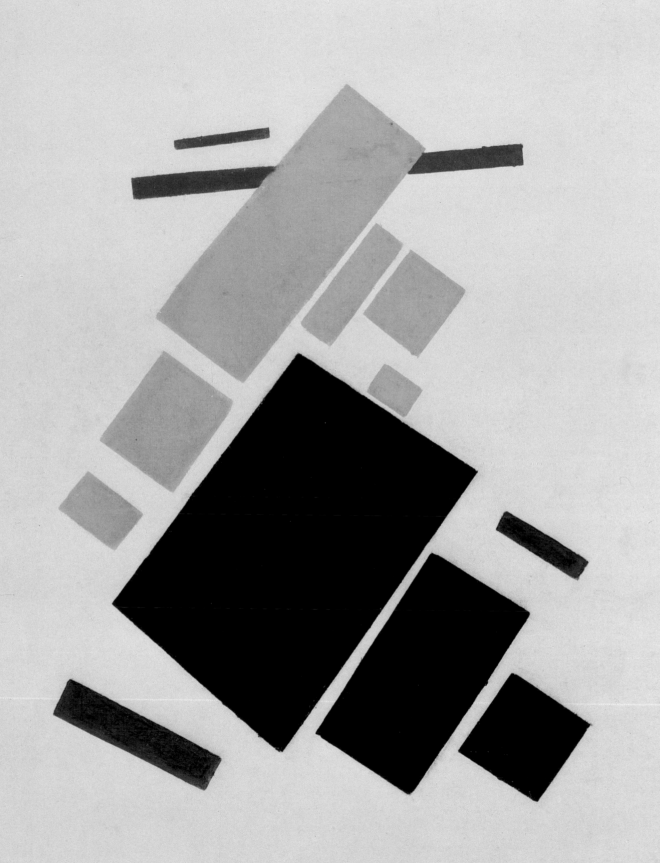

20. UNTITLED (SUPREMATIST PAINTING)

1915. Oil on canvas, 39⅞ × 24⅜" (101.5 × 62 cm).
Stedelijk Museum, Amsterdam

In this large untitled painting, which also made its debut at the historic "0,10 (Zero–Ten)" exhibition, the theme of flying and of weightlessness is given considerably more scope than in the previous *Airplane Flying* (plate 19).

In a letter to his friend Mikhail Matiushin, the artist himself marveled at the astonishing effect of colored rectangles on a white ground: "A plane of painted color hung on a white sheet of canvas imparts a strong sensation of space directly to our consciousness. It transports me into an endless emptiness, where all around you sense the creative nodes of the universe."

The tilted composition and upward thrust of this painting immediately communicate a sense of flight. Here we tend to read as perspectival the narrowing of the large black rectangle as it angles toward the top of the canvas. There is also a kind of aerial perspective here. The small size and the absence of color in the nine elements in the upper left corner seem to give evidence that we are viewing them at a great distance as they fly away from us. Contrary to our normal expectations, the mass of the composition is greatest in the upper two-thirds of the work, located entirely above the very narrow horizontal line that serves as a reference, or horizon, line. The large black trapezoidal shape seems to move through space in spite of its size, and contrary to the laws of gravity, while the large white empty area beneath it emphasizes its buoyancy and weightlessness.

The absence of any recognizable or "earthly" details seems to put the viewer, too, high in the air, precisely, in fact, at the level of the red square, the one element that is seen upright and on the picture plane. Below and to the right, dark-toned bars that appear to be at a distance rise toward the viewer in a series of elements that increase in size as they approach, an effect similar to the one we noted in *Airplane Flying*.

In *Untitled (Suprematist Painting)*, Malevich has conveyed a cosmic landscape conceptually, merely through color and geometry, and without describing any particular object. Yet it is probable that he associated this startling abstraction with ideas made common by the war. A sketch for a projected new edition of *Victory over the Sun*, done in the spring of 1915 and now in Moscow's Literary Museum, shows a similar enormous Suprematist structure as part of an aerial battle scene (plate 20a). Malevich described it to Matiushin: "This monster (just like a louse) is supposed to run over the sun; it can absorb fire, and by eliminating the sun's combustion, it [achieves] a complete victory." The drawing has traces of aerial mapping of the ground; in the painting the artist has removed all suggestions of a background plane, thus casting his Suprematist forms into a deep, limitless cosmic space.

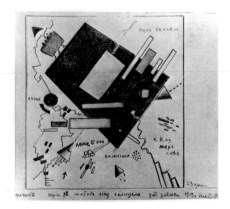

Plate 20a. Stage design for *Victory over the Sun*. 1915. Graphite pencil on paper, 4½ × 4⅘" (11.3 × 12.2 cm). Literary Museum, Moscow

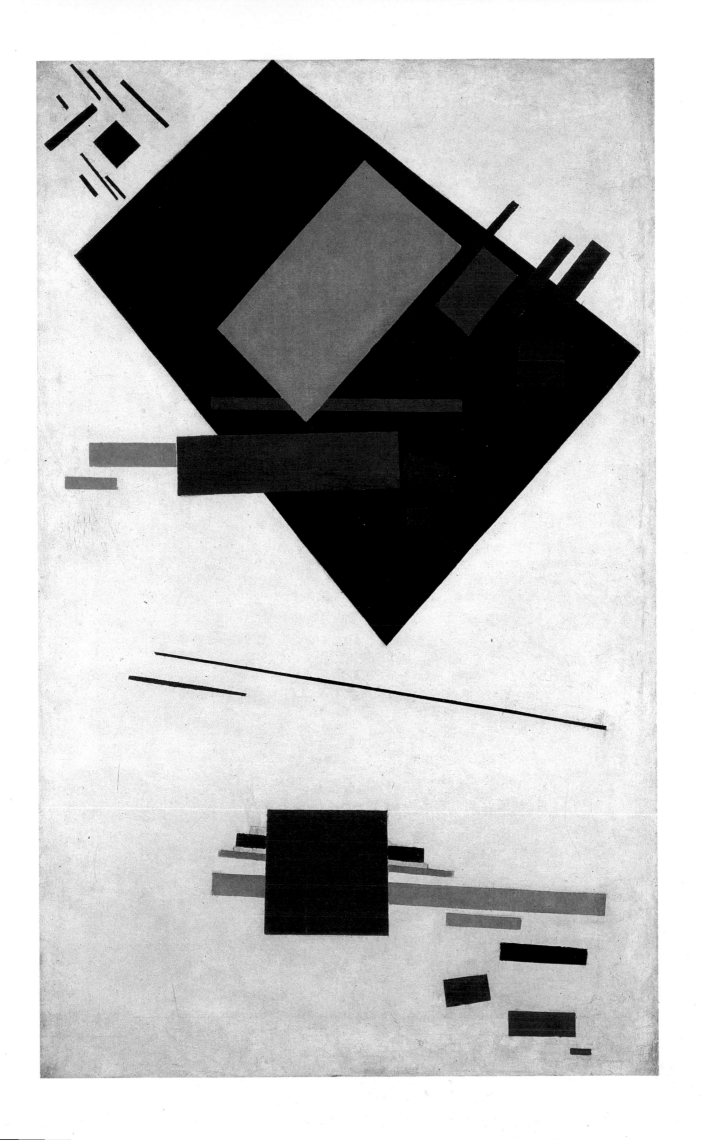

21. UNTITLED (SUPREMATISM)

1915. Oil on canvas, 34½ × 28⅓" (87.5 × 72 cm).
Russian Museum, Saint Petersburg

Untitled (Suprematism) is among the earliest of Malevich's Suprematist canvases; it can be seen in a photograph of the 1915 "0,10 (Zero–Ten)" exhibition. A vivid and powerful work, it demonstrates how varied the early Suprematist paintings, in fact, were. In spite of having several important details in common with the previous Suprematist works, this canvas produces an entirely different impression. As in the previous untitled painting (plate 20), the canvas is divided by a black tilted bar, and in the upper left a large trapezoid flies toward the top of the canvas; the left corner contains a similar cluster of small forms. But this painting has more than twice as many elements in about the same area, and they are larger and more varied. While the previous work had a cosmic serenity about it, this one is full of action and conflict.

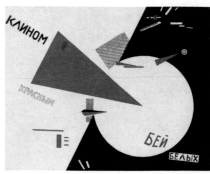

21a. El Lissitzky. *Beat the Whites with the Red Wedge*. 1920. Poster

The motion depicted here pushes in various directions: the three acute triangles in the upper left corner appear to be moving counter to the black rectangle, rather than with it. Similarly, the force of the blue V in the left center of the canvas is downward into the horizontal red bar, while the yellow trapezoid moves up and away from it. An unusual feature is the group of small round and rectangular elements on a football-shaped red ground in the upper left. They seem more or less static as they are progressively covered by the yellow trapezoid. The series of four yellow chevrons at the center right, along with several of the surrounding elements, marches vigorously toward the right, escaping off the edge of the canvas from the black bar that threatens to descend on them.

Malevich's Suprematist forms are associated in his thinking with the ideas of concealment and a new kind of sight, ideas he related to occult and hyperspace concepts. But perhaps he was also encouraged to conclude that these forms had the potential to stand on their own in a work of art by the aerial diagrams of troop movements that in 1915 appeared in the newspapers daily. For a new version of *Victory over the Sun* Malevich associated such images with the military conflict depicted in the opera (plate 20a, page 86); ultimately he discovered that he had found an entirely new artistic vocabulary. In 1920 Malevich's friend and follower El Lissitzky again exploited the diagrammatic and military nature of Suprematism for his Civil War poster *Beat the Whites with the Red Wedge* (plate 21a).

Sometime after 1919 this painting was apparently acquired by the government's Museum Purchasing Committee of the Commissariat of Public Education and designated for a museum in the city of Nizhni Novgorod. But it was among the holdings of the Leningrad Museum of Artistic Culture in 1926, and went to the Russian Museum when the former museum was forcibly closed. It has remained in the Russian Museum's collection since then.

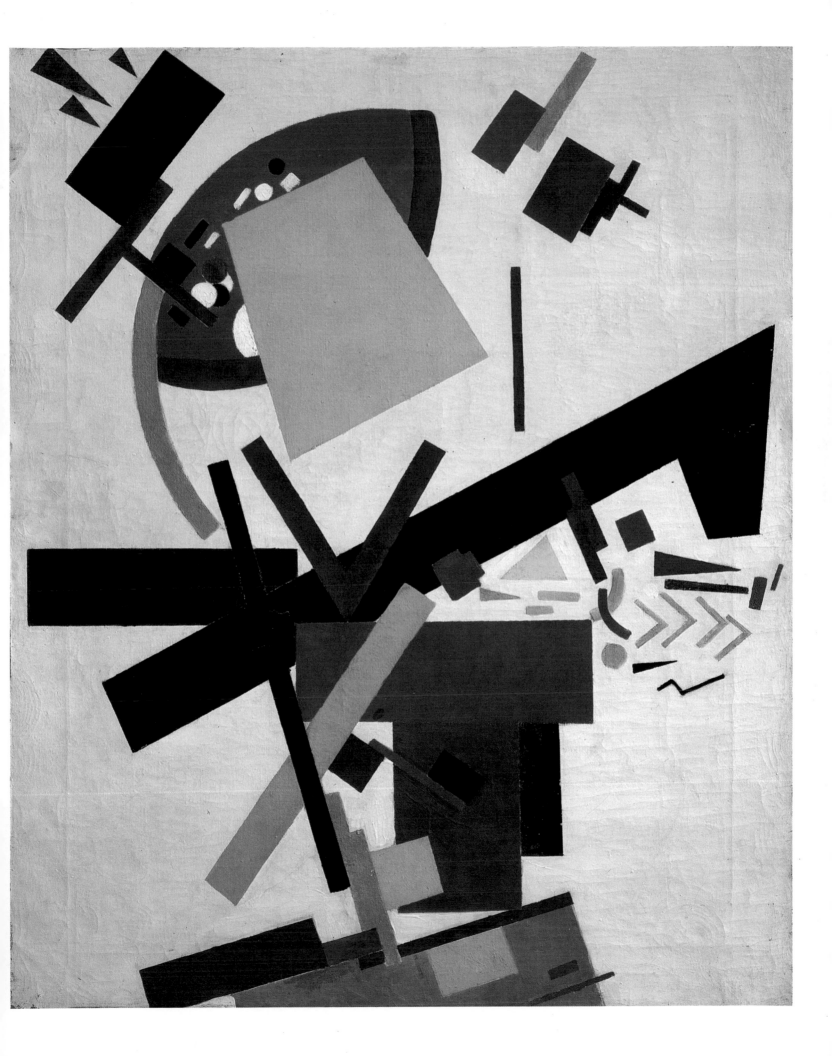

22. UNTITLED (SUPREMATIST COMPOSITION)

c. 1916. Oil on canvas, 20⅞ × 20⅞" (53 × 53 cm).
Peggy Guggenheim Foundation, Venice

In this small work Malevich has created a kind of giant Suprematist pinwheel. Because this early Suprematist painting is in the square format Malevich often favored, and because of the symmetry of its composition—as well as Malevich's later cavalier attitude toward the hanging of his work—there has been some confusion about the proper orientation of this painting.

The firm intersection of large elements from four directions in the middle of the painting is strikingly different from the Suprematist paintings previously considered. The clustering of massive forms in an otherwise empty space creates the impression that they are attracted by some unseen force to a common point in the upper center of the canvas. Moreover, the repetition in three colors of a similar trapezoidal shape and the tangential point of the red triangle that pushes left set up an implied rotation around the center. Still, the large sizes and similar tones of the elements that comprise the principal structure, together with their overlapping of the smaller forms, induce us to see it as clearly in front of the smaller elements. These, as we have noted in other works, appear to float in space, but their orientations, too, serve to reinforce the sensation of counterclockwise rotation.

The centrality and compactness of the composition make it more self-contained than the more cosmic Suprematist paintings, and in fact, for the "Second Decorative Art Exhibition" in Moscow, Malevich utilized this composition as an embroidery design. One of the nine motifs for pillows that he contributed to this 1917 exhibition was a simplified and reversed version of this painting (plate 22a). The appliquéd pillow lacks four of the smaller horizontal elements and the shape of the canvas ground has been adapted to the pillow's rectangular shape, but the composition is otherwise identical.

This painting is one of two by Malevich purchased two weeks after his death in 1935 for New York's Museum of Modern Art by its director, Alfred H. Barr, Jr. (The other was *Airplane Flying*, plate 19.) Barr bought the painting from Alexander Dorner of the Hanover Museum in Germany, and in 1942 he exchanged it with Peggy Guggenheim for a work by Max Ernst, *Napoleon in the Wilderness*. *Untitled (Suprematist Composition)* hung in the Abstract Gallery of Guggenheim's Art of This Century gallery, which opened in 1942. It has remained in the Peggy Guggenheim collection since that time.

Plate 22a. Appliquéd pillow.
1916–17. Whereabouts unknown

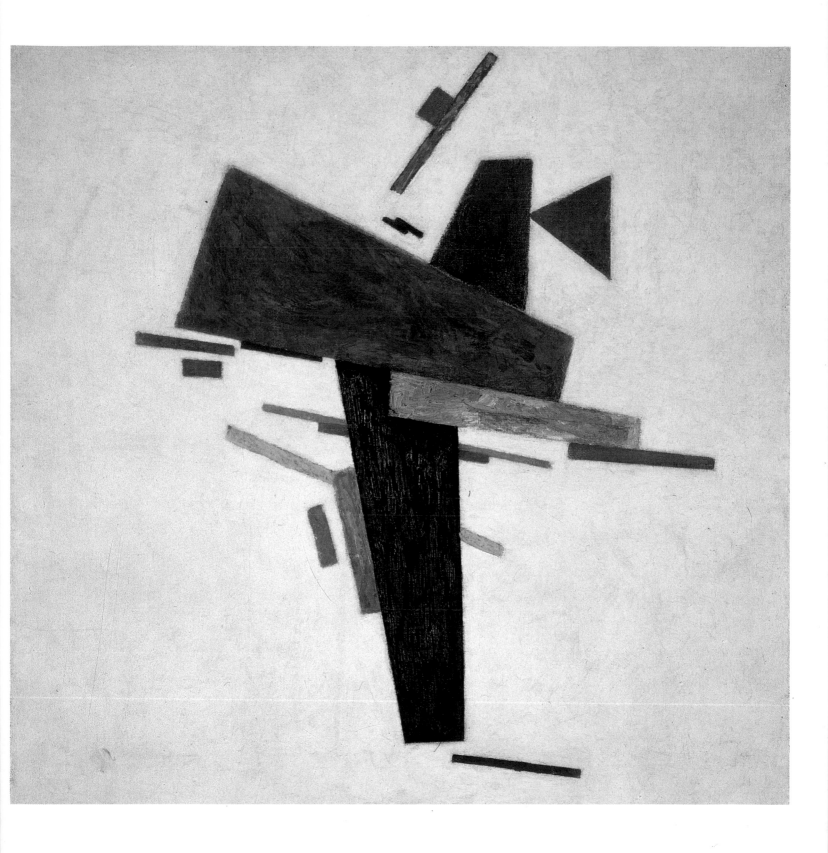

23. SUPREMUS NO. 56

1916. Oil on canvas, 31¾ × 28" (80.5 × 71 cm).
Russian Museum, Saint Petersburg

In its sensation of space and flying, *Supremus No. 56* is related to the earlier *Untitled (Suprematist Painting)* (plate 20). But in *Supremus No. 56* we note at once that Malevich has unified the small individual elements by connecting them on long thin axes. A majority of the forms no longer seem to function individually, but move rather as clusters attached to axes in ways that are balanced, but not always perfectly symmetrical. These long, straight configurations hint at an association with space technology. The unattached rounded forms, so distinct from the rectangular elements, suggest qualitatively different objects, and seem to allude to celestial bodies seen at various angles of view. As in *Untitled (Suprematist Painting)* (plate 20) the majority of the elements are distributed diagonally from lower right to upper left, creating a sensation of upward movement.

Very noticeable, too, is a change in the mode of Malevich's aerial perspective. Previously we observed a darkening of colored elements to facilitate a perception of distance; here throughout the work the artist has distributed groups of small elements painted in grays and pale colors to signify their extreme depth in space. While these are the conventional tones of aerial perspective, their allover placement leaves the viewer no stable orientation. Although in confronting this Suprematist space we seem to be located opposite the green circle, and close to the large red, yellow, and black forms, our exact position seems to be arbitrary, and along with the colored structures the viewer swims in a fluid, undifferentiated space. A glance in any other direction, Malevich suggests, would result in a similar scene.

Supremus No. 56 is Suprematism at its most complex and refined. Yet with its marked aerial perspective, and hints at technology and celestial bodies, this objectless painting comes closer than any we have seen to mimetic representation. Here the depiction of a kind of flying architecture has almost overwhelmed the sense of concealment and mystery that was evident in earlier works. The exploration of geometric relationships, and the issues concerning the nature of painting itself that were raised by earlier and simpler works, are here completely absent.

This painting was bought from the artist by the Museum Purchasing Committee of the Commissariat of Public Education at the time of Malevich's 1919 solo exhibition. It was transferred to the Russian Museum at that time.

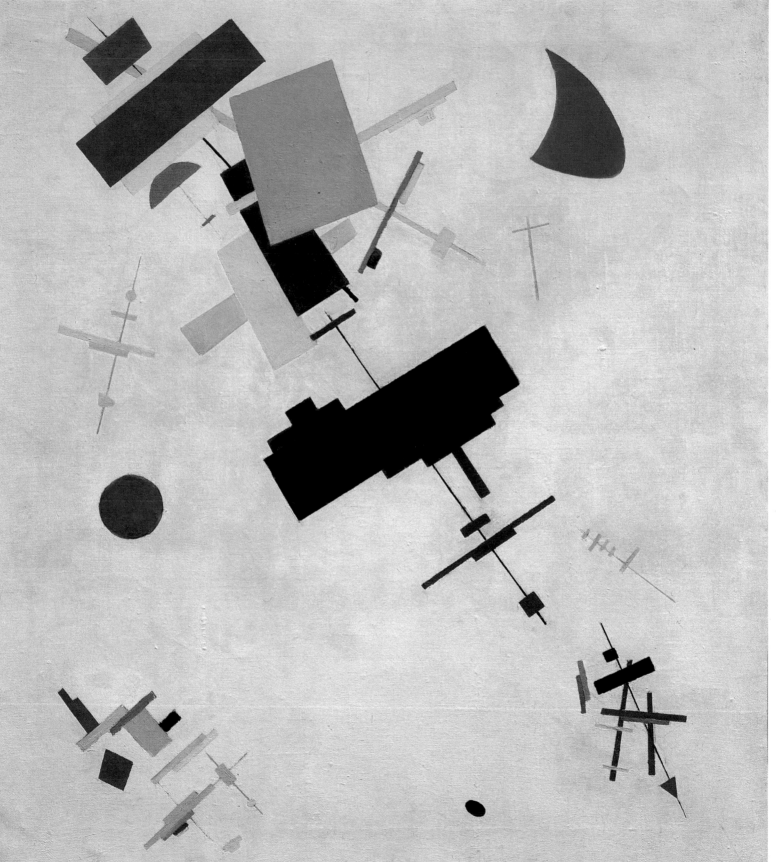
1936.

24. SUPREMUS NO. 57

1916. Oil on canvas, 31½ × 31⅝" (80.2 × 80.3 cm).
Tate Gallery, London

In this splendid painting the principal means of uniting the many rectangles is not long axes, as in the previous work (plate 23), but rather an unmodulated gray isosceles triangle that stretches across the center of the painting and appears to be located behind the principal elements. Malevich has placed the largest groups of rectangles in the lower right and the upper central portion of the work, near the points of this large form, while leaving the center of the canvas strikingly empty.

For *Supremus No. 57* the artist has returned to his favorite square format. As the sides of the triangle reach toward the edges of the canvas, they produce a strong spatial tension and create irregular areas between the edges of the triangle and those of the canvas. In these areas small Suprematist structures can be detected. Their size and weak color, as well as their location beyond the edges of the background triangle, seem to imply that they are very distant from the viewer, floating deep in space. These small nebulous objects, so tenuous that they can scarcely be seen, will soon become the sole subjects of entire Suprematist compositions.

Malevich has adjusted the composition with utmost care. The triangle reaches its apex slightly over two-fifths of the distance from the left to the right corner, thus dividing the upper width of the canvas into the harmonious proportions of a golden section. The two most striking colored elements, the small blue triangle at the top of the work and the gold rectangle on the right, serve subtly to mark the bilateral points of the square: the upper tip of the blue equilateral triangle is close to the center of the width of work, while the far right corner of the yellow rectangle farthest to the right marks the approximate midpoint in the height.

Thus despite the painting's many elements, the square shape of the canvas, its empty center, and its division into harmonious proportions combine to give the work an unusual tranquillity and stability.

Supremus No. 57 was purchased in May 1919 by the Museum Purchasing Committee of the Commissariat of Public Education, which assigned it in 1920 to the Museum of Painterly Culture in Moscow. When this museum was liquidated in 1929, its holdings, including this painting, were transferred to the Tretiakov Gallery. There it remained sequestered after the artist's retrospective, unseen by the public for some forty-five years. At the end of 1975 it was exported by the Ministry of Culture of the U.S.S.R. in an arrangement to acquire some letters by V. I. Lenin, and in 1978 was acquired by the Tate Gallery.

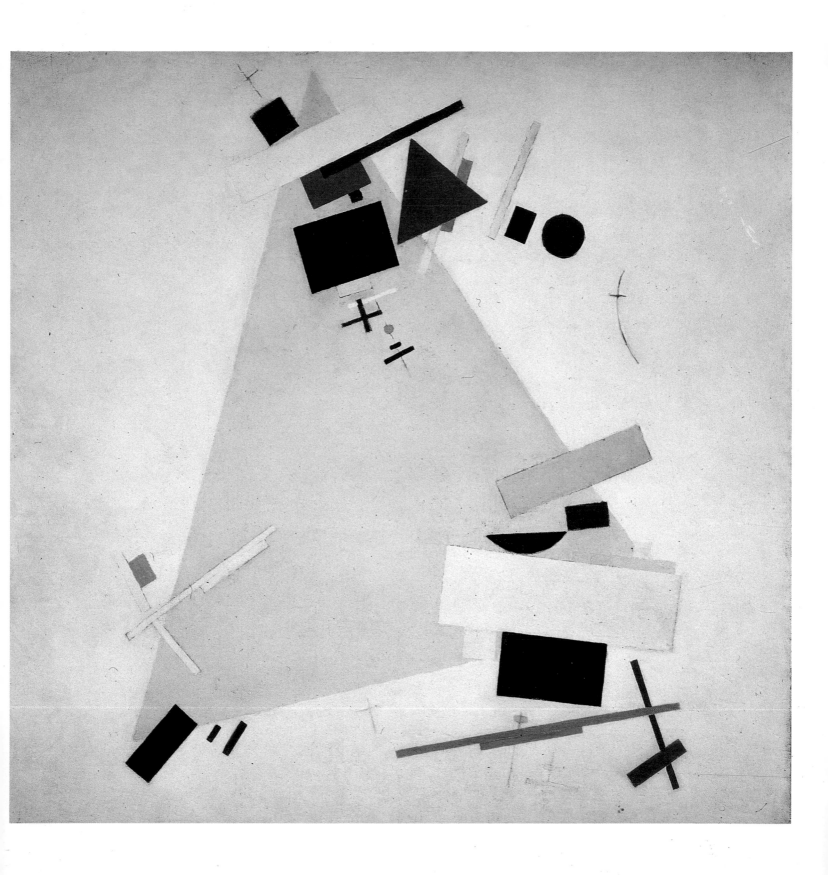

25. SUPREMATIST COMPOSITION

1917. Oil on canvas, 38½ × 26⅛" (96.5 × 65.4 cm).
The Museum of Modern Art, New York

The large pastel-colored forms in *Suprematist Composition* make it one of the most unusual of Malevich's Suprematist works. Their shapes are similar to vertical sections or "slices" of the representational shapes in one of Malevich's earlier compositions. This "slicing" enabled the artist to express a hidden content, and a connection between the earthly world and an archetypal one, while still maintaining a strict geometrism. A more complex but essentially similar scheme of "concealed" references was used also by Vasily Kandinsky in his Symbolist landscapes after 1909.

Suprematist Composition is covertly related to *The Woodcutter* (plate 9), a painting that for Malevich was emblematic of the artist's ability to penetrate the illusions of this world to reveal their intangible essence. In *Suprematist Composition* the large figure of the woodcutter is ethereally present as a white form that extends across the length and width of the canvas. He is described only in the most abstracted way; the angles of his head and shoulders are visible at the top left of the composition, and the curve of his back as he bends over his work can be seen descending to the lower right. Only three sides of the ghostly figure are visible; on the left side, that is, the direction in which the figure is facing, there is no demarcation of the body; it simply melts into the surrounding space.

The Suprematist elements in this work are analogous to the logs of wood that surround the figure in *The Woodcutter*. The two parallel bars in the upper right, the central round and square forms, and the truncated oval at the lower edge of the work may all be seen as geometric sections of the earlier composition. The pink bar that obliquely intersects the white figure substitutes in the composition for the diagonal of the woodcutter's arm.

As in *Supremus No. 57* (plate 24), Malevich uses the large "more distant" figure to unite the separate geometric elements formally; but in this instance the artist clearly suggests an unearthly force, an incorporeal presence, that lurks behind these forms and imparts an enigmatic significance to them.

It is impossible to say exactly when *Suprematist Composition* was first exhibited. We do know, however, that it was part of Malevich's retrospective exhibition that opened in Moscow late in 1919. He took the painting with him on his trip to the West in 1927, and it was exhibited in both Warsaw and Berlin. In 1935 Alfred Barr borrowed this work from Alexander Dorner at the Hanover Museum for exhibition in the "Cubism and Abstract Art" show at The Museum of Modern Art in New York the following year. It has remained in the museum since that time.

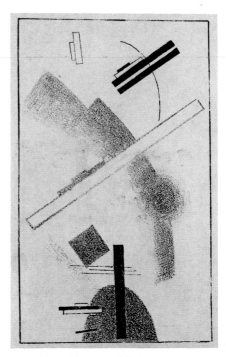

Plate 25a. *Untitled* (*Suprematist Composition*). 1920. Lithograph, 7 × 3½" (17.7 × 8.8 cm). From *34 Drawings*. Dallas Museum of Art, The Art Museum League Fund in honor of Mr. and Mrs. James H. Clark

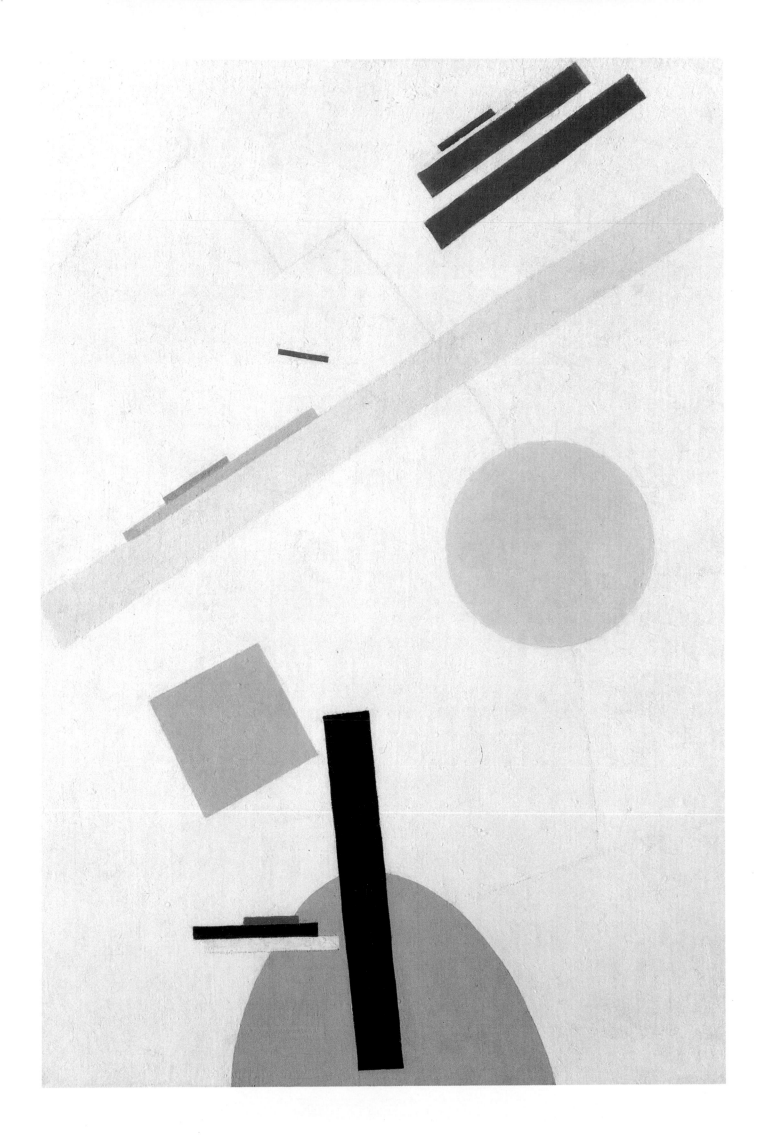

26. UNTITLED (SUPREMATIST PAINTING)

c. 1918. Oil on canvas, 38⅛ × 27½" (97 × 70 cm).
Stedelijk Museum, Amsterdam

In a series of "white on white" paintings, Malevich represented subtle differences between the material and the immaterial, expressed as refined distinctions between the shades and textures of the color white. In these works he was concerned with conveying the sensation produced by nonvisible phenomena—electrical energy, magnetism, sound, cosmic space—and even the awareness of sensation itself.

"Our eye is worthless; to lay the foundation of our vision on that, and accept what we see as fact, would be a lie," the artist wrote. But not only did he believe that the visible world was deceptive, he thought that the invisible phenomena that filled the universal void were, in a sense, more real, closer to the edge of creation than the illusory forms that the eye creates. Such ideas prompted the artist to examine the boundaries between the ethereal and the material, and to try to distill the small shifts involved in the passage between existence and nonexistence.

In this work Malevich relies, as he had earlier, on schematic representation. The composition of *Untitled (Suprematist Painting)* was suggested by diagrams of electromagnetic or sound waves being emitted outward into space. He has marked well only the instants of their creation, that is, the leading edges of the transverse waves as they move in bursts from the lower right upward and to the left. The lack of definition of the lower edges of the curves reflects the waves' progressive dissolution in space, to the point where the energy depicted merges with space, and no longer can be said to exist. The waves are more evident in a subsequent lithograph (plate 26a).

To Malevich the white color also located the subject of this work in cosmic time and space. The artist associated it with the universe far beyond the blue sky that is seen from the earth. In the catalogue for the April 1919 "Objectless Art and Suprematism" exhibition, which first displayed Malevich's white paintings, he wrote: "I conquered the lining of the colored sky and tore it off, put color into the resulting bag, and tied a knot. Fly! A white, free, endlessness—infinity—is before you!"

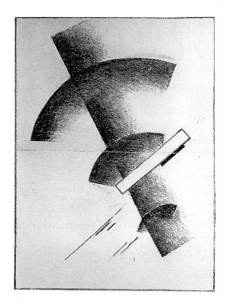

Plate 26a. *Untitled (Suprematism Splitting of Construction)*. 1920. Lithograph, 10¹³⁄₁₆ × 8" (27.3 × 20.3 cm). From *34 Drawings*. Dallas Museum of Art, The Art Museum League Fund in honor of Mr. and Mrs. James H. Clark

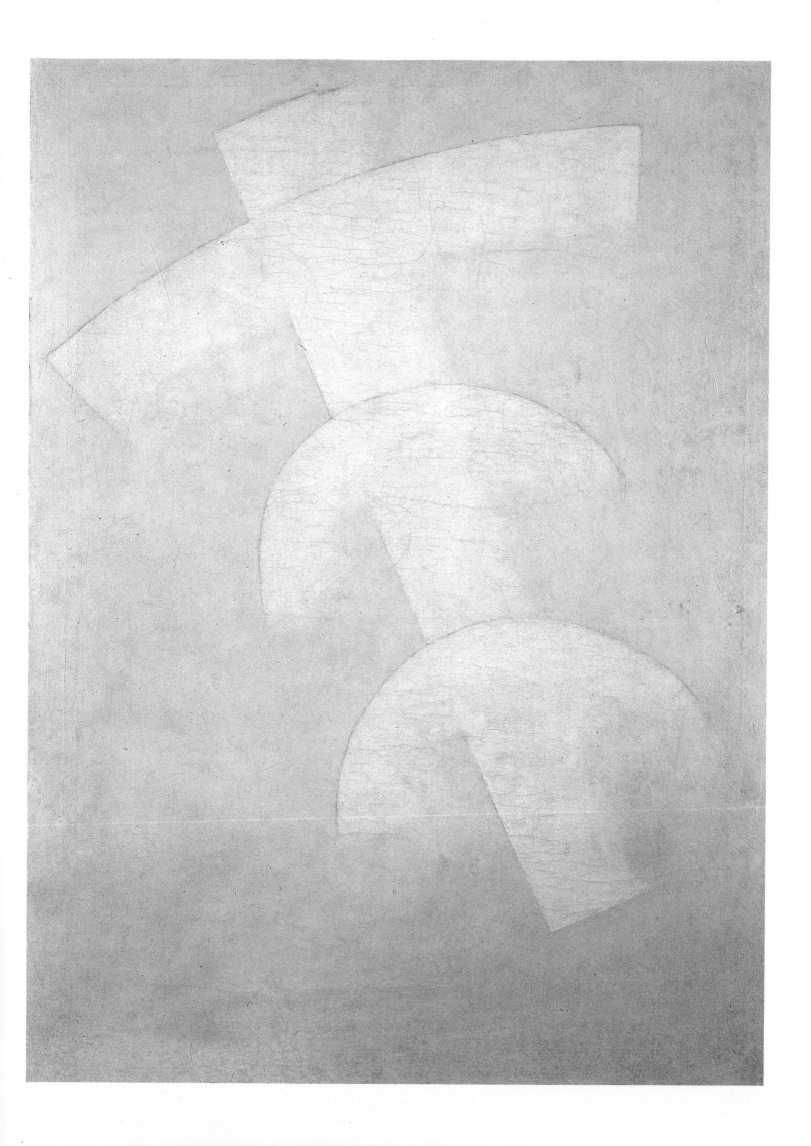

27. UNTITLED (SUPREMATIST PAINTING)

c. 1918. Oil on canvas, 38⅛ × 27½" (97 × 70 cm).
Stedelijk Museum, Amsterdam

This very distinctive painting, displaying a minimum of color—it is composed entirely of slightly differing shades of white and a subtle alteration of textures—depicts not the abstract forms usually associated with this degree of idealization, but rather a discernible and readily understood figure. The white figure on a white background is a ghostly geometrized human form, merging with a limitless white space.

Comparison of this painting with the one illustrated in plate 25 provides a good demonstration of Malevich's transition to the monochrome series of paintings that he made just after the Russian Revolution. The two paintings are very close to the same size and both show a white figure on a white ground facing left. But in the work being considered here, not only have all the colored floating forms been eliminated, but the man's rounded back—a form often used by Malevich to express creative labor and the human condition generally—has been straightened, so that it establishes a flat oblong plane inclined to the right edge of the canvas. The instrumental arm of the figure, originally derived from the subject of *The Woodcutter* (plate 9), has been reduced to two white lines that, like the back, lack any hint of volume.

Although *Untitled (Suprematist Painting)* retains a distinct representational image, the artist is equally concerned with the visual tensions created by the approach of lines and planes to the edges of the canvas. The left boundary of the figure is absent, as it was on the earlier figure, so that the disembodied phantom appears simultaneously to move forward into the white space and to be composed of it. The removal of the various colored elements focuses our attention on the spatial relationships, which compete with the figure for our consideration. The two motifs of the work—the figure and its white geometries—force the viewer to acknowledge their equality and their fusion, the intimate and essential kinship of the human figure and cosmic space.

The subject of this painting, as of so many other Malevich works, is human consciousness in the world, but here the world has become a cosmic and spiritualized one, and the geometric relationships seem to define the connections with precision. Malevich was forming his ideas about cosmic evolution at this time, and he viewed the white paintings as evocations of the future: "Our century is a huge boulder aimed with all its weight into space. From this follows the collapse of all the foundations in Art, as our consciousness is transferred onto completely different ground. The field of color must be annihilated, that is, it must transform itself into white. . . . The development of white . . . points to my transformation in time. My imagining of color stops being colorful, it merges into one color—white."

28. SUPREMATIST COMPOSITION: WHITE ON WHITE

c. 1918. Oil on canvas, 31¼ × 31¼" (78.7 × 78.7 cm).
The Museum of Modern Art, New York

In this painting, Malevich has brought his white paintings a step further into an uncompromising idealism and abstraction. There is no hint here of a subject originating in the visible world. Rather than the suggestions of a vestigial human form seen in the previous work (plate 27), or even the white schematic representation noted in plate 26, the artist has returned to the square-within-a-square format that he began to work with some four years previously. Now two squares, such as the one seen in *Black Square* (fig. 17), are established inside of one another in a way that focuses attention on their dissimilar, rather than their coincident, orientations. In *Painterly Realism. Boy with Knapsack—Color Masses in the Fourth Dimension* (plate 28a), Malevich had also explored the idea of variant positions using a black and a red square, but here, in *White on White*, one square has been placed inside of another, and both have been bleached almost to the point of obliteration. On the square canvas the smaller tipped square is thrust toward the top and right edges. Between these two visual elements there are no distinctions in form and only minimal differences in their color, texture, and size. We can focus only on the angles the sides of the inner square make to the perimeter of the canvas, the tantalizing approach of its corners to the picture's edges without ever actually reaching them. This is painting in its purest form, concerned with subtle distinctions in form and color, and with essential proportional relationships in two dimensions.

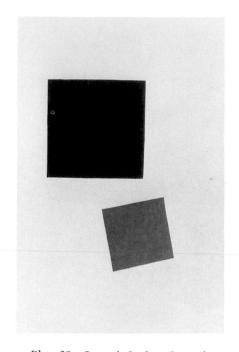

Plate 28a. *Painterly Realism. Boy with Knapsack—Color Masses in the Fourth Dimension.* 1915. Oil on canvas, 28 × 17½" (71.1 × 44.5 cm). The Museum of Modern Art, New York

In spite of the emphasis on pure geometric forms and their orientations in this painting, it is far from merely analytical; the perfect shapes and white colors of the painting glow with a suffused idealism and spirituality. Malevich conceived Suprematism as having a grander scope than the purely aesthetic pleasures of formalism: he imagined it to be, rather, the outward expression of a philosophical system. "The system is hard, cold, and unsmiling," he wrote. "It is set in motion by philosophical thought, or [rather] its practical force already is moving within the system." Such a system he saw as coordinate with humanity's spiritual evolution. "Man is an organism of energy, a particle striving to form a single center. All the rest are simply excuses. . . . Our consciousness . . . develops new signs on the way to overcoming the infinite; and perhaps the new Suprematist conclusion will lead us to new systems beyond the jumble of objects, to a purely energic force of movement."

In *White on White* can still be found Malevich's interest in cosmic landscapes, and his love of a diagonal upward pull and the sensation of weightlessness. In spite of the absence of color modulation and the coincidence of the squares with the picture plane, the painting conveys a sense of dynamism and infinite space. In the white monochrome canvases, Malevich discovered a meditation on the vital movement of humanity toward universal harmony, a sign of a coming perfection, and the ideal state of consciousness.

The work was probably first exhibited in April 1919 at the exhibition entitled "Objectless Art and Suprematism" held in Moscow. It was shown again at Malevich's 1919 retrospective, and taken abroad by the artist in 1927. In 1935 Alfred H. Barr, Jr., borrowed it from the director of the Hanover Museum for the New York exhibition "Cubism and Abstract Art." It has remained in The Museum of Modern Art since that time. X rays reveal that the work was painted over an earlier Suprematist work.

29. TO THE HARVEST (MARFA AND VANKA)

c. 1927–29. Oil on canvas, 32¼ × 24" (82 × 61 cm).
Russian Museum, Saint Petersburg

In this delightful painting a large figure of a peasant woman fills the entire height of the canvas, the heel of her foot centered at the lower edge, her head just short of the top. She is carrying food to the workers in the field; in her left hand is a cloth-covered bundle, in her right, a jug. A child walks at her right side.

To the Harvest (Marfa and Vanka) is a later version of a subject that Malevich first painted in 1912 in such works as *Peasant Woman with Buckets and Child* (plate 7) and *In the Field* (plate 29a). In the earlier paintings of peasants Malevich's figures are embedded in their environment; we do not see distant views, the horizon, or the sky. But when Malevich returned to painting figurative works in 1927–28, his compositions reflected the philosophical and cosmic interests that first manifested themselves in Suprematism. In the later peasant works the principal subjects are more detached spiritually and physically from the earth than his earlier subjects, and their heads are projected against the sky.

Plate 29a. *In the Field*. 1912.
Graphite pencil on paper,
6½ × 7" (16.6 × 17.7 cm).
Russian Museum, Saint Petersburg

Although the figures in *To the Harvest* are quite similar to those of *In the Field* (Malevich retained sketches and probably even a photograph of this painting—it had been reproduced in a review of 1912), major differences in the composition of the two paintings reflect the evolution of his philosophical views. Instead of filling the upper half of the composition with additional large figures of laboring peasants, as he did in the early version of this subject, in *To the Harvest* Malevich introduces a more distant landscape, sharply divided into horizontal stripes of color. Small figures of peasant women, some working, some standing upright facing the viewer, are distributed along these lateral lines; in the distance the horizon is clearly visible, and above it the head of the principal figure interrupts the expanse of blue sky.

To the Harvest (Marfa and Vanka) was exhibited at Malevich's retrospective exhibition in 1929, and in the large exhibition in Leningrad in 1932 commemorating fifteen years of the Revolution. It was loaned for safekeeping to the Russian Museum after Malevich's death, and was transferred to the museum's collection in 1977. The Russian Museum also owns a smaller oil-on-board version of the figure of the child Vanka.

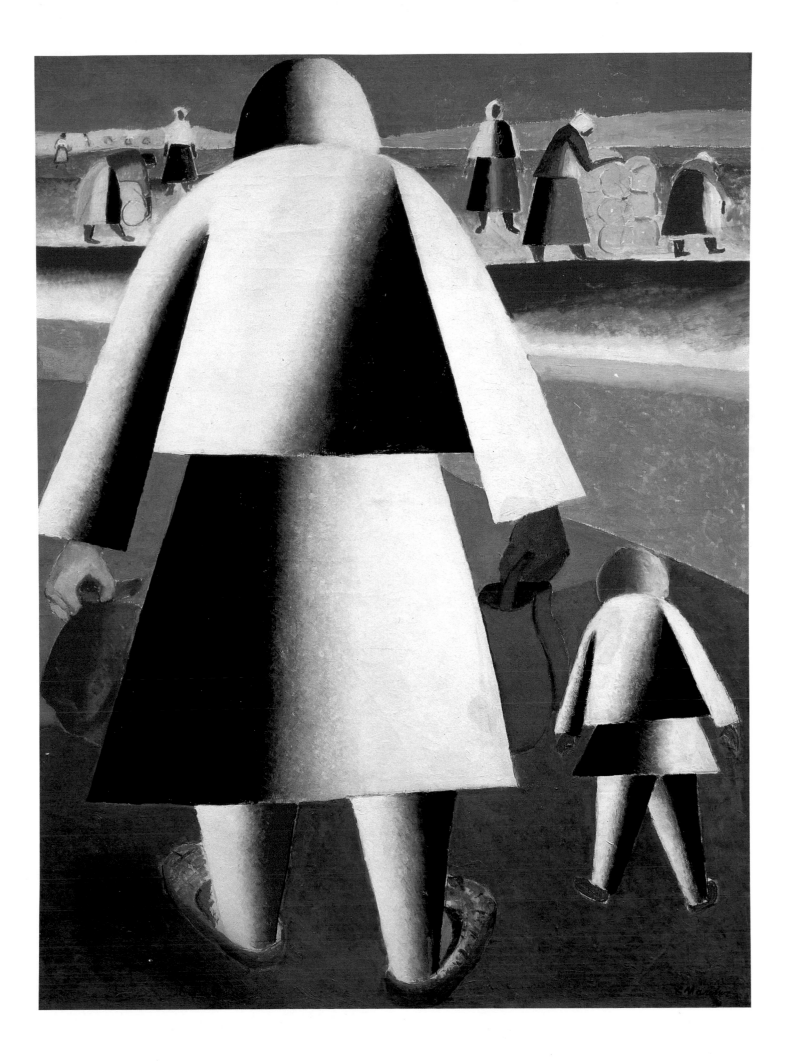

30. HAYMAKING

c. 1927–29. Oil on canvas, 33¾ × 25⅞" (85.8 × 65.6 cm).
Tretiakov Gallery, Moscow

In *Haymaking* one central and monumental figure stands facing the viewer. The bright red of his shirt, the volumetric partitioning of the body and haystacks, and the green geometric patterns of the field create a work that is strikingly decorative.

Malevich here paints a landscape of even greater symmetry and depth than the one in *To the Harvest* (plate 29). Our eye is drawn into the intermediate distance by two smaller full-length figures, a woman and a man, respectively facing toward and away from the viewer. Beyond them six smaller figures, three on either side of the subject, lead the eye farther into the depth of the scene. A narrow warm stripe indicates land at a still greater distance, and farther still there is a line of bluish hills. At the extreme reaches of the depicted scene, the sky shades into white, suggesting once again the presence of Malevich's infinite space. As in many of his late works, Malevich places the horizon line low enough for the face to be seen, at the very center of the picture, against the sky.

Haymaking is a major and innovative work. In spite of its thematic and formal similarities to *To the Harvest*, it was an important step for the artist. Here the burdens and labor that Malevich had previously seen as the essence of the human condition have been minimized. This man, standing boldly upright, is clearly mediatory, a link between earth and sky. Like the static saints of Russian icons, he is motionless, and confronts us holding symbols of his identity. We see this peasant subject "here" and "there" simultaneously, a contemplative and evolving organism that exists in both the mundane world and the transcendent universe.

To understand the changes that are manifest in Malevich's late peasant work, we can compare the isolated figure and open vistas of *Haymaking* with the composition of the earlier *Woodcutter* (plate 9). There the figure was bent over his work. Caught in a claustrophobic environment composed of logs of wood, without any hint of other places or dimensions, the woodcutter concentrated exclusively on his task. In 1912 Malevich compared the woodcutter to the artist, whose task it was to cut through the illusions of the world. The compositional parallels to icons that the artist constructs in the late 1920s, however, suggest the divine nature of the artist, and of human beings in general.

Such connotations were far from purely philosophical. For a contemporary Russian audience the heroic peasant subject of the work remarked directly on the current tragic situation in the countryside. The figure of the reaper and the harvest scene in *Haymaking* pointed to moral and spiritual responsibilities in the cultivation of a new society. The decorativeness and the false "1909" date on the lower right edge of the canvas served only to conceal the contemporary relevance and high seriousness of the work.

Haymaking was exhibited first at Malevich's 1929 retrospective and reproduced as the frontispiece of the pamphlet that accompanied that exhibition. It was acquired from the artist by the Tretiakov Gallery at the time of the exhibition, and has remained in the collection of the museum since that time.

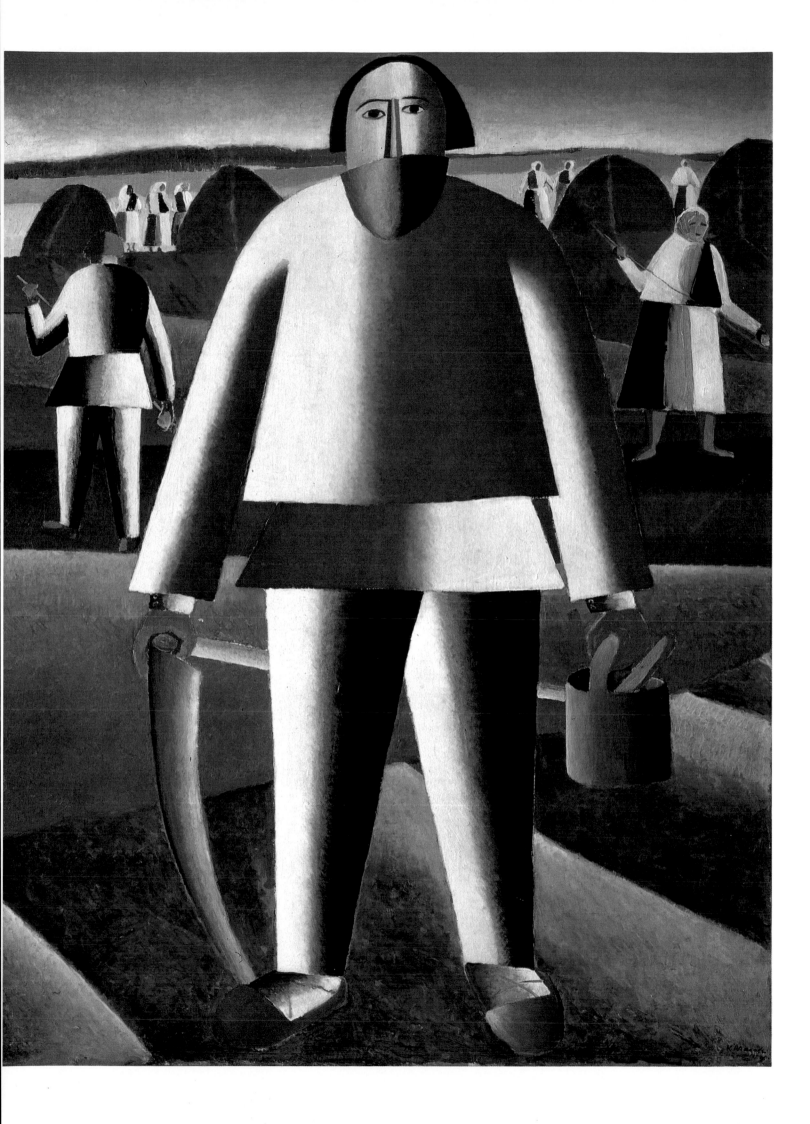

31. HEAD OF A PEASANT

1927–29. Oil on wood, 27¼ × 21⅛" (69 × 55 cm).
Russian Museum, Saint Petersburg

After a hiatus of eight or nine years in which Malevich did not paint, he returned again in the late 1920s to his images of Russian peasants. They had been a primary subject for him before the Great War, but had been subdued or absent entirely from his abstract Suprematist works since then.

Malevich probably returned to working in figurative styles for a variety of reasons (see Introduction, pages 34–35). But one of the most compelling stimuli for a return to this theme must have been the sad predicament of Russian peasants, who in the late 1920s were suffering famine, exile, and the cruel process of collectivization.

The artist's new paintings were not simply repetitions of old works. *Head of a Peasant*, in spite of its superficially Cubist style, actually is innovative and unlike anything that Malevich had done previously. Its forms are much flatter and more simplified than those in *Finished Portrait of Ivan Kliun* (plate 12), for example, and instead of his earlier practice of filling the space surrounding the subject with fragmented forms, here the artist has resolved the space into just two distinct and widely separated planes. Malevich's experience with Suprematism can also be felt in the strict geometricity of the composition, and in the stark contrasts of the black and white of the head and the red cross.

Head of a Peasant is more decorative, but also more clearly mystical, than Malevich's earlier Cubist works. The composition showing a head against a cross recreates that of a fifteenth-century icon well known to Russian viewers (plate 31a), in which the stylized head of a severe Christ appears centered against a cross. The presentation of the landscape in widely separated horizontal rows is a compositional stratagem that also borrows from icons, and one that would be recognized instantly by native viewers. The spirituality that Malevich associated with the color white, its reference to the cosmos and infinity in the white paintings, has here been transferred to the face of the figure. Now we see a distinctly unearthly and incorporeal peasant, who is related to the tiny flowering village in the distance as an exalted archetypal symbol of its suffering and redemption.

The work is painted on wood, which may have been a matter of necessity at the time, but which also reinforces its identity as a modern icon, as does the yellow-gold color of the nose of the peasant and the original painted gold frame.

Head of a Peasant was probably first exhibited in Malevich's 1929 retrospective at the Tretiakov Gallery in Moscow. It has been kept in the Russian Museum since shortly after the death of the artist.

Plate 31a. *Head of Christ*. Russian.
Fifteenth century

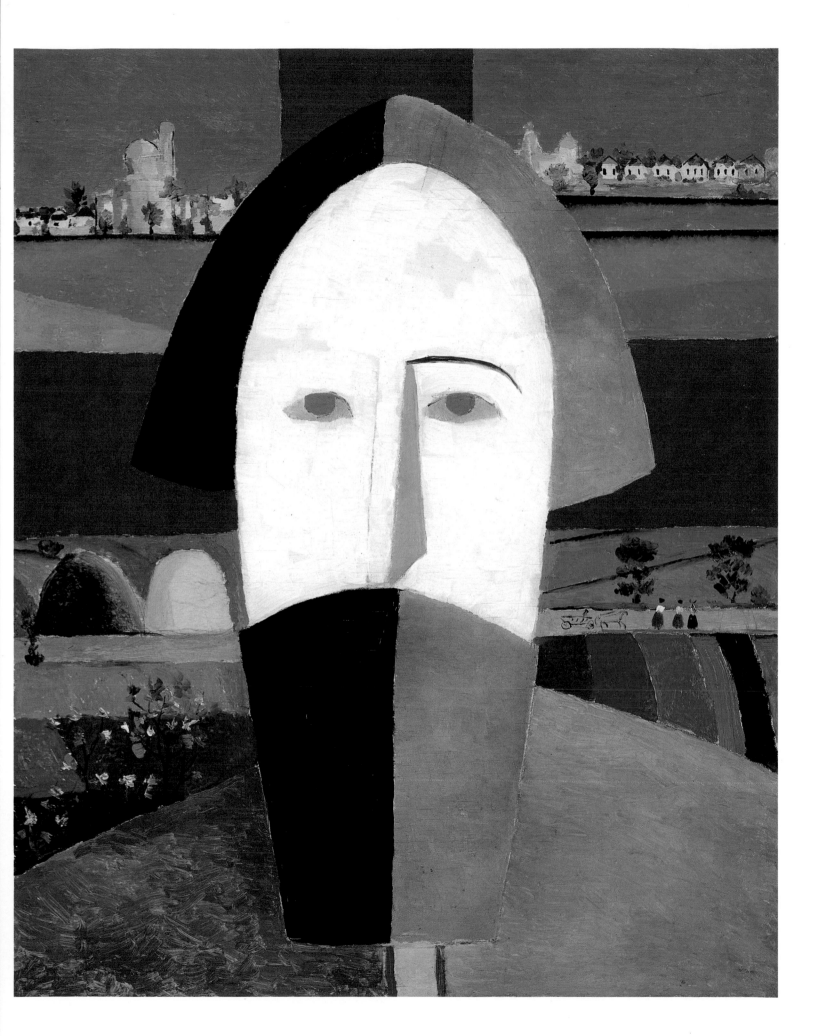

32. PEASANTS

c. 1928–29. Oil on canvas, 30½ × 34⅝" (77.5 × 88 cm).
Russian Museum, Saint Petersburg

In this surprisingly moving work Malevich adopts an expressionistic disfigurement as a stance of revolt. The simple brushy background and the naïve sketchiness of the elongated bodies affect us with the power of direct and unsophisticated truth. The peasants' lack of arms emphasizes their helplessness; the absence of other detail, their isolation. Here we have moved far from Suprematism, and references to the cosmic and the heroic.

The peasant subject of this work continues a theme that had occupied the artist for almost twenty years: man's unequal relationship with the universe. The period in which *Peasants* was painted, however, added a personal and a social dimension to the work: the situation of the peasantry in Russia and Ukraine was grim, and this picture could not have helped but strike a responsive chord in the contemporary viewer.

The bearded peasants occupy the entire height of the work and are presented facing the viewer in an arrangement familiar from icons of standing saints (plate 37a). The artist in this way compares the suffering peasantry with the saints of the church. But sympathy for the helpless victims of Stalin's collectivization in the late 1920s was dangerous, and in part to protect himself from questions about his loyalty to the Revolution, as well as to conceal the fact that much of his early work was still in the West, Malevich assigned this work to 1909.

Malevich's long identification of the artist with the figure of the peasant is especially poignant at this time. In the late 1920s he was in wide disrepute. The Leningrad Institute of Artistic Culture, which he had helped to found, and in which he had taught, had been forcibly closed, and he was the subject of severe and incessant criticism by the government, the press, and politically radical artists.

The painting has been in the Russian Museum since 1936.

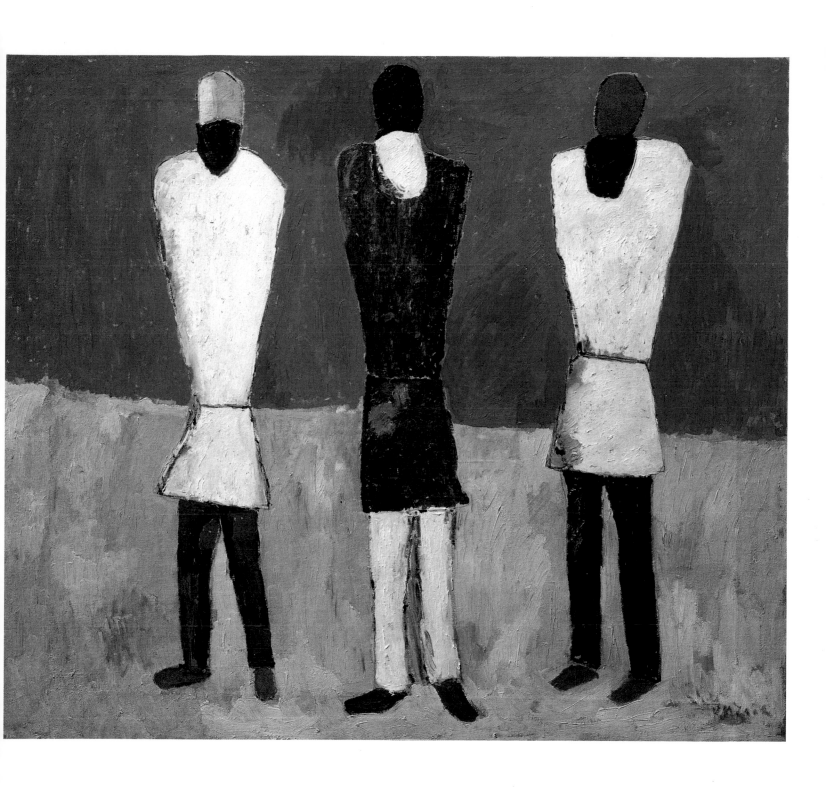

33. UNTITLED (MAN AND HORSE)

c. 1928–29. Oil on canvas, 22½ × 17 " (57 × 43 cm).
Musée National d'Art Moderne, Centre Georges Pompidou, Paris

Although it was obviously painted about the same time, *Man and Horse* is a much more dynamic picture than *Peasants* (plate 32). In this painting the vigorous animation of the brushstrokes and the outlining by means of unpainted canvas serve to reinforce the dynamic stance of a red-shirted vertical figure that occupies almost the entire height and width of the canvas. The peasant's active, off-balance pose is in striking contrast to the calm white horizontality of the innocently grazing horse behind him. A contemporary viewer would have been inclined to interpret such a scene as a peasant defending against the seizure of a farm animal for collectivization, and indeed Malevich undoubtedly had such an interpretation in mind when he painted this work.

Although small, *Man and Horse* is a major painting; it exhibits some of the Metaphysical tendencies that will be a major component of Malevich's work for the remainder of his career. The horse is an unusual subject for the artist, and it, as well as the stance of the figure, its diminutive head, and its lack of arms, are details that were probably borrowed from the work of de Chirico (plate 33a). Malevich here exploits the exaggerations of the peasant figure to suggest a heightened emotional state, and to convey the universality and nobility of the subject.

This work was probably shown in Malevich's 1929–30 retrospective. After the artist's death it was preserved in the collection of his assistant, the artist Anna Leporskaia, in Leningrad. In 1978 the painting went to the Musée National d'Art Moderne in Paris, where it has remained.

Plate 33a. Giorgio de Chirico.
The Faithful Wife. 1917. Pencil,
12⅝ × 8¾" (32 × 22 cm). Galleria
Nazionale d'Arte Moderna, Rome

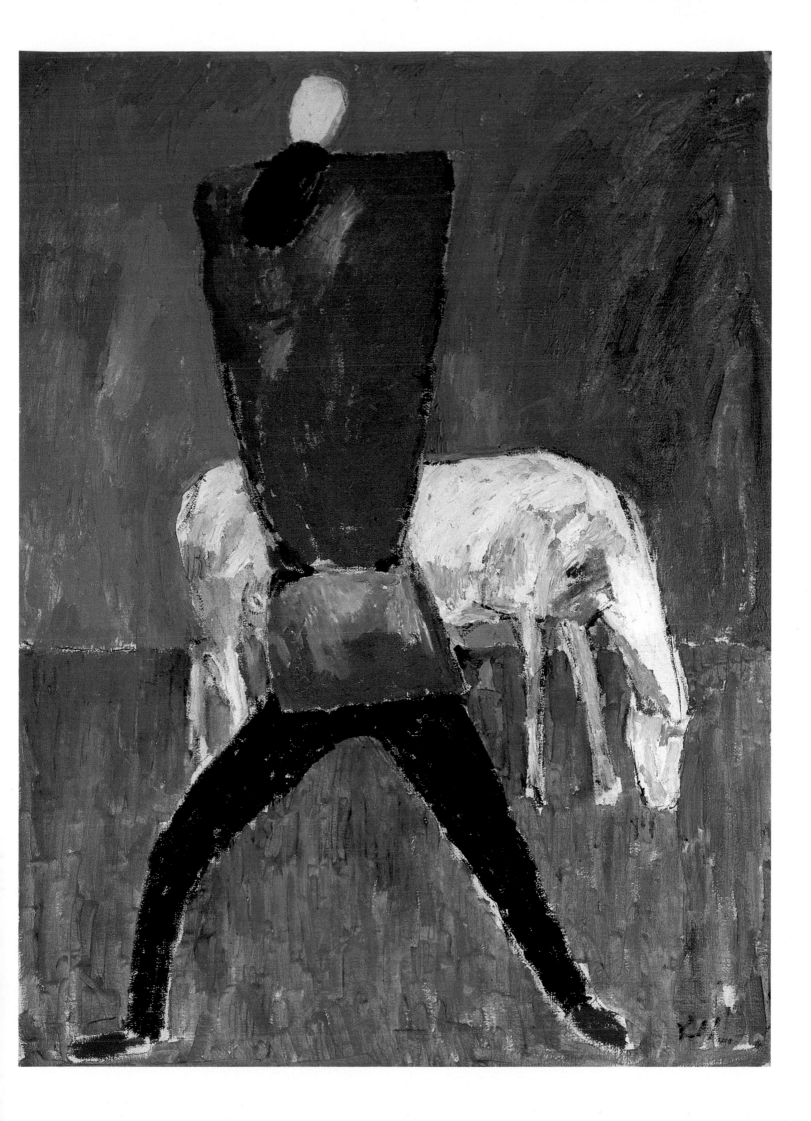

34. UNTITLED (MAN RUNNING)

c. 1928–30. Oil on canvas, 31⅛ × 25⅝" (79 × 65 cm).
Musée National d'Art Moderne, Centre Georges Pompidou, Paris

Man Running is Malevich's most anxiety-filled painting. Probably the work is unfinished, but even in this state it is powerful, and unique in its sense of alarm and desolation.

A large central man with black hands, feet, and face, wearing a green peasant's shirt and white trousers, runs left, his right arm extended straight in front of him. The upper two-thirds of the canvas is dominated by a deep blue sky, with outlines of clouds suggested by curvilinear traces of white. The landscape's foreground and background have been consolidated into discrete stripes of color. Most notable is Malevich's treatment of the figure's hair and beard, which seem to fly in advance of his moving head. Malevich worked especially on this strange occurrence; there is a careful drawing of the head (plate 34a), probably done in preparation for the painting, which illustrates the same effect in detail.

To the right of the picture, on the horizon behind the runner, are the roofed red and white rectangles of two buildings. A red and white sword hangs in the air between them. Farther to the left on the horizon, balancing the three objects on the right, is a tall black and red cross.

The composition and painterliness of this work are distinctly different from the motionless individual figures of about the same period. Here the viewer is presented with an explicit dualism—the red and the white buildings, the cross and the sword—and the manifest physical fright of the subject running between them. The double position of the head, the blowing hair and beard creating the semblance of a fiery ring around the face, make manifest an equivalent psychic panic.

It is not incidental that the peasant subject—for Malevich always a stand-in for the artist—runs from the sword and toward the cross. In Malevich's symbolic vocabulary the cross often stood for the church or religious belief, and the artist was a profound believer. But it is probably significant also that the figure runs not directly to the cross, but beyond it, toward some other place that remains beyond our view. Hand outstretched in a pose reminiscent of the gesture in icons that traditionally represents supplication and presentation, the man moves swiftly toward a vision uniquely his own. Even in this frightening and hallucinatory work there is a suggestion of an ultimate vision and sanctuary.

After Malevich's death this work was preserved in Leningrad in the collection of Malevich's assistant, the artist Anna Leporskaia. She transferred it in 1978 to the Musée National d'Art Moderne in Paris, where it has remained.

Plate 34a. *Man's Head.* c. 1928–30.
Graphite pencil on paper,
8½ × 7⅛" (21.4 × 18.2 cm).
Collection Lev Nussberg

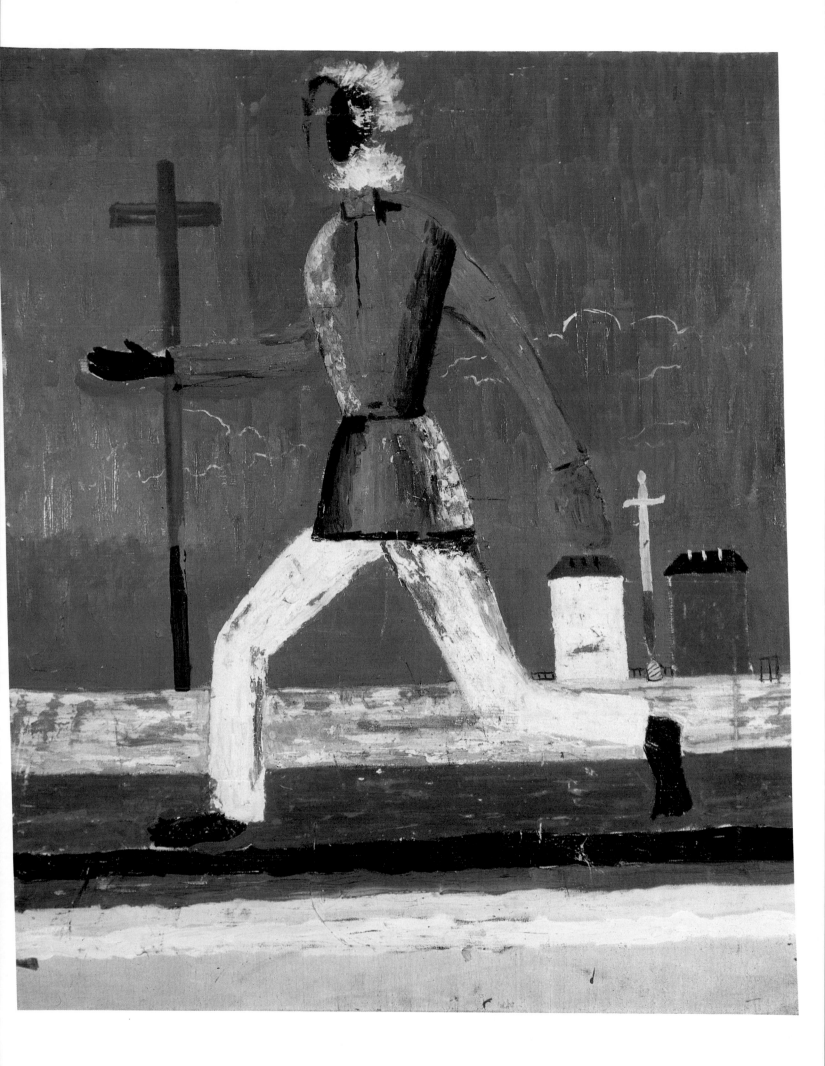

35. THE RED HOUSE

c. 1928–30. Oil on canvas, 24¾ × 21⅝" (63 × 55 cm).
Russian Museum, Saint Petersburg

By about 1928 or 1929 Malevich had developed several innovative styles of painting. This new work continued the themes devoted to the countryside and peasantry, but it cultivated forms and images that were much more abstract and symbolic.

In *The Red House*, an isolated rectangular building occupies the center of a colorful landscape. Both the earth and sky have been collapsed into bold painterly stripes of color. There is a challenging ambiguity about this structure; it confronts us so uncompromisingly and so mysteriously that it seems to demand attention. But the house is also familiar; we have seen it before—in the bright rectangles and squares of Suprematism that almost fifteen years earlier first floated between earth and sky.

Malevich came to the conclusion that the new Soviet art, since the Revolution the focus of so much public discussion, would be figurative, but that its images would be symbolic rather than realistic. In his new painting the artist endeavored to find a vocabulary of visual symbols that would be potent enough to initiate an entirely new style of Metaphysical painting. *The Red House* is one of a series of paintings of houses that explored their symbolic potential. The strict rectangular form of these structures is reminiscent of his Suprematist quadrangles, and the way they sit solidly between earth and sky is similar to the placement and solidity of his large peasant figures.

In his analysis of the history of artistic styles, Malevich included Surrealism as one of the last stages of modern art, and he was particularly interested in the works of the Italian Metaphysical painter Giorgio de Chirico. The motif of *The Red House* is drawn from de Chirico's *Red Tower* (plate 35a), which that artist used in a similar emblematic way. But Malevich is very far from de Chirico's interest in the retrospective and the antique. In this painting he has flattened de Chirico's deep perspective and simplified the image of the building to the point of abstract signification.

The Red House was shown at "Artists of the R.S.F.S.R. During the Last Fifteen Years," the compendious 1932 anniversary exhibition in Leningrad commemorating the Revolution. The work entered the Russian Museum shortly after Malevich's death, and has remained there. X rays show that *The Red House* was painted over a portrait of a man.

Plate 35a. Giorgio de Chirico.
The Red Tower. 1913. Oil on canvas,
28⅞ × 39⅝" (73.5 × 100.5 cm).
Peggy Guggenheim Foundation, Venice

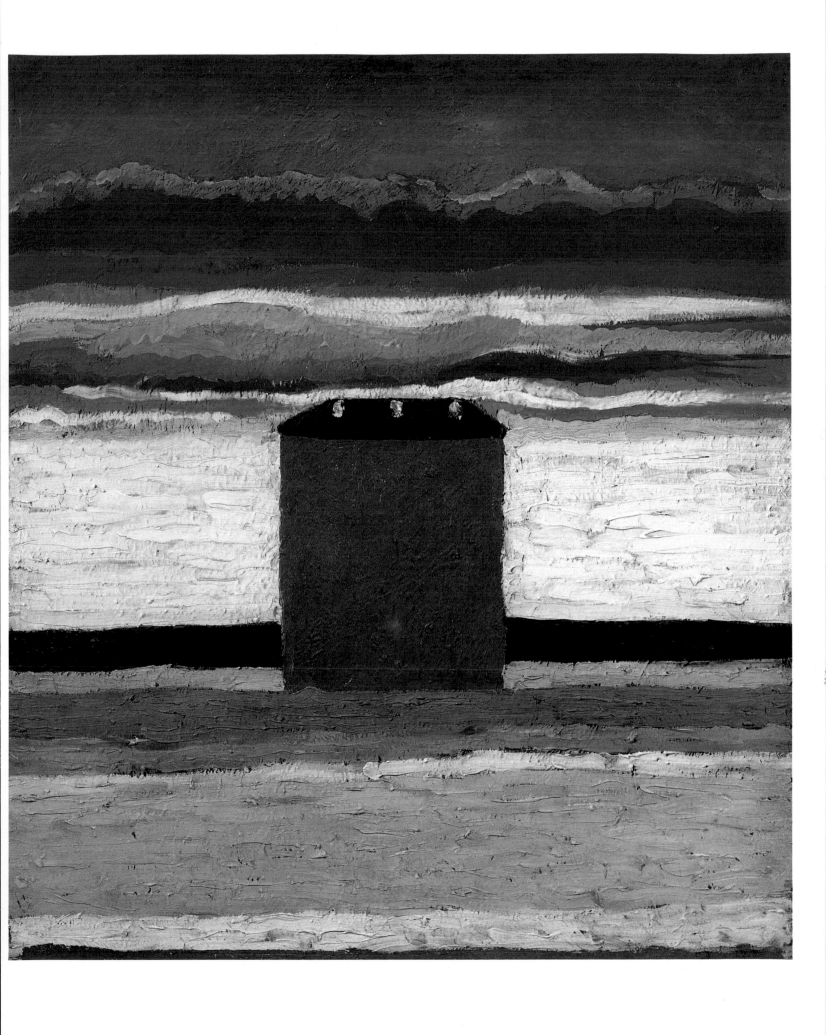

36. COMPLEX PREMONITION
(HALF FIGURE IN A YELLOW SHIRT)

c. 1930. Oil on canvas, 39 × 31⅛" (99 × 79 cm).
Russian Museum, Saint Petersburg

This is one of the most beautiful of the paintings in Malevich's new Metaphysical style. The picture conveys a nobility and a harmony with the world that is reminiscent of the 1916 and 1917 Suprematist works. A highly simplified and stylized peasant stands upright, arms at his side, wearing a golden yellow shirt tied at the waist with a narrow string. The three-quarter figure occupies the entire height of the canvas; his neck is long and straight; he wears a beard and holds his featureless head high against the sky. Behind him are wide widths of colored land, and to the left on the horizon sits the red rectangle of an emblematic house.

By suppressing particularizing details, including the features of the face, Malevich aspired to a universal, timeless image, one that might be identified with the past and the future, with sacred and profane art. In *Complex Premonition*, he conveys just enough detail to establish a certain realm of interpretation: the austere figure, the beard, the string around the waist suggest not only a peasant, but also a monk, a prophet, an ascetic, a heroic human sacrifice, the artist himself. On the back of the canvas he wrote: "The composition was composed of elements of the sensation of emptiness, solitude, the impasse of life." Into this simple scene the artist has compressed all his social and philosophical concerns: the relationship of human beings to the universe, their attachment to the earth, the mysteries of another dimension, the grave situation of the peasants, their identity with the artist and with all of humankind.

Contrary to his usual practice, Malevich has moved the figure out of the center and slightly to the right to make room for the red house. This composition draws on the Romantic convention of the tower in the distance, and has both Russian and Western precedents. In de Chirico's *Amelia (Portrait of Signora Bontempelli)* (1922), the red tower similarly lurks in mute significance in the distance behind the subject. A similar red house appears in *Untitled (Man Running)* (plate 34), as well as in *The Red House* (plate 35).

This painting has been in the Russian Museum since 1936.

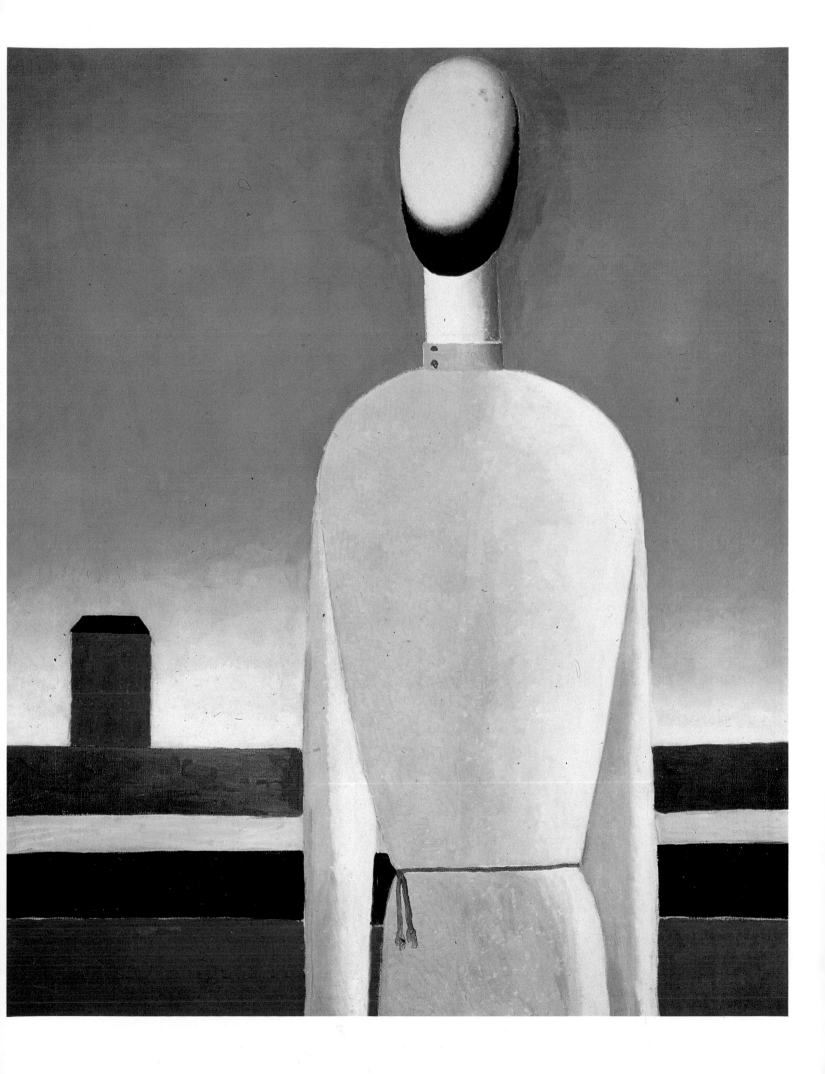

37. THE ATHLETES (SPORTSMEN)

c. 1930–32. Oil on canvas, 56 × 64⅝" (142 × 164 cm).
Russian Museum, Saint Petersburg

The Athletes is Malevich's largest known painting; clearly he thought it a major and fully realized work. The figure of the athlete had been popular with the Cubo-Futurists before the Great War, epitomizing their vision of the heroic man of the future, powerful, and in perfect control of mind and body. In this late *Athletes*, the subject retains the feeling of transfigured perfection, but to that Malevich has succeeded in joining both the cosmic associations of Suprematism and the spirituality of icons.

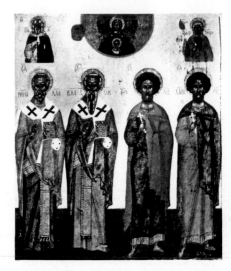

Plate 37a. *Selected Saints*

Four hieratic figures are lined up horizontally across the foreground. Except for the arrangement of the colors of their clothes, the figures are similar; their form, position, and height vary only in minor ways. The faces are featureless, but each is divided vertically in half into areas of white and one other color: red, blue, or black.

Although their stance is similar to that of the large figure in *Haymaking* (plate 30), and their arms are extended straight down at their sides as if they, too, were meant to be carrying something, they hold nothing. The symbolic implements of previous works have been removed, as has the entire scene of daily life that motivated, for example, the landscape in *Haymaking*. In *The Athletes*, Malevich has subtracted the specific content of his peasant series; he has simplified the figures and condensed the landscape into abstract bands of color. In a manner reminiscent of his creative process in the development of Suprematism, Malevich has here sought out the universal within the familiar and the mundane.

The Russian viewer would readily recognize that this deceptively simple composition is also a compelling condensation of spiritual and apocalyptic allusions drawn from icons. A typical genre of fifteenth- and sixteenth-century Russian painting is the "selected saints" icon, in which full-length figures of holy men and women are depicted across the width of the work (plate 37a). They stand motionless, in bright patterned garments, facing the viewer in a solemn rank. In Malevich's painting not only do the colors and compositional structure invoke the powerful associations of icons, but the shape and stance of the athletes' feet, lined up along a black line parallel to the lower edge of the canvas, imitate the placement of feet in icons. The colored bands that function as a landscape and a low horizon in the modern painting at the same time recreate the traditional horizontal bands of earth or carpet often seen along the lower edge of icons.

The Athletes also concerns the artist's own metaphysics, which was quite distinct from that of the established church. He has erased all particularizing detail in order to bring to the fore his vision of humanity's connection to the cosmos, a theme that dominated his last paintings. The removal of facial features and the lowering and flattening of the horizon graphically emphasize the figures' tenuous connection with the earth. Their feet on the colored ground, their heads in the infinite white heavens, their half-white heads—all express the dualistic nature of human beings and their evolving destiny. On the back of the canvas Malevich has written, "Suprematism in the shape of athletes." This is precisely it. Cosmic Suprematism has here emerged from its colored rectangles and taken on human form, but its contemplation of transcendent and universal evolution still prevails.

The painting was exhibited in Leningrad in 1932 at "Artists of the R.S.F.S.R. During the Last Fifteen Years." It was loaned by Malevich's family for safekeeping to the Russian Museum in 1936 and transferred to the museum's ownership in 1977.

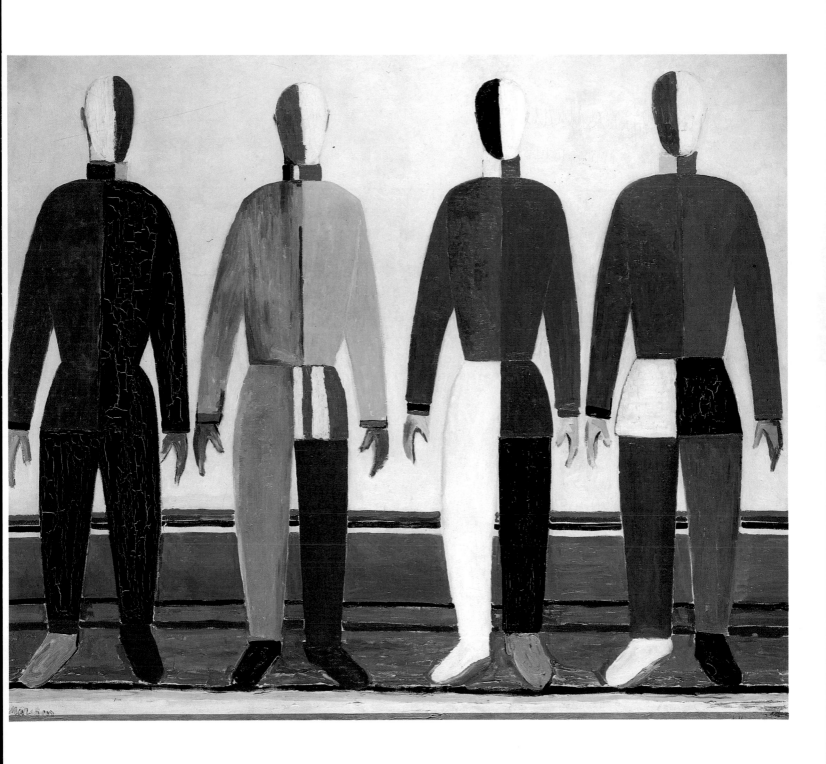

38. UNEMPLOYED GIRL

c. 1930. Oil on canvas, 31½ × 26" (80 × 66 cm).
Russian Museum, Saint Petersburg

In the late 1920s and early 1930s Malevich undertook an extensive study of Impressionism and Post-Impressionism, culminating in a long manuscript on this topic for a book he planned to call "Izologia" (Artology). In 1930 and 1931 he was also engaged in teaching art history at the Central House of the Arts in Leningrad. His late paintings in an Impressionist style are closely related to these historical studies. In an attempt to recreate and expand his own artistic past, to replace the early works left in the West, and to avoid questions of his ideological commitment, the artist assigned false early dates to these Impressionist works.

In *Unemployed Girl*, a reserved woman gazes skeptically at us and the world. The identity of this sturdy, self-contained sitter is uncertain, but she appears also in Malevich's *Flower Girl* (see fig. 31). The social specification of the subject in the title is unusual for the artist, and may have been a deliberate attempt to exemplify the class-based ideological content that he distinguished in certain Impressionist paintings. No doubt he also hoped it would prove advantageous to identify himself as an artist who had been socially conscious long before the November Revolution.

There are also elements in *Unemployed Girl* that we might associate with the actual biography of the artist: in 1930 and 1931, after having been expelled from the Institute of the History of Art, and spending time under arrest for the suspicious advocacy of modern styles, he was officially registered as unemployed. The artist was known also to wear hats and neckties similar to those of the painting's subject, and typically he faced the camera with the same sort of self-contained seriousness. Although this work may not, in fact, be a disguised self-portrait of the artist, at least the subject partakes of the artist's identity, and the painting conveys something of his unhappy situation and his current beleaguered frame of mind.

As in other works that feature a single large figure, Malevich has positioned the young woman in the center of the canvas, a location that is emphasized by the receding trees in the background, and especially by the empty space surrounding the top of the hat—a favorite device of this period. The horizontal elements noted as part of the landscape in *Haymaking* (plate 30) and *The Athletes* (plate 37) are here transformed into the slats of the bench and the fence across the width of the canvas, just at the height of the subject's face. The shadows that fall across the upper portion of the face emphasize and continue this "horizon."

Unemployed Girl has been in the Russian Museum since 1936, when it was loaned to the museum by the artist's family for safekeeping. For a comparison with a similar subject painted twenty years earlier see *On the Boulevard* (plate 5).

39. PORTRAIT OF THE ARTIST'S WIFE, NATALIA ANDREEVNA MANCHENKO

1933. Oil on canvas, 26⅝ × 22" (67.5 × 56 cm).
Russian Museum, Saint Petersburg

In the last two years of his life Malevich concentrated on painting portraits of himself, his friends, and his family. There were political reasons for this: by the early 1930s, class-based criticism had become vicious and even dangerous in Russia, and portraits, among the most neutral of subjects, were resistant to easy ideological analyses.

But Malevich's pictures are not primarily concerned with the most obvious task of portraiture, that is, with reproducing the sitter's likeness. True to the direction of his previous artistic interests, the artist continued through portraiture to represent the metaphysical modes he understood as inherent in human life.

Painted against a featureless ground, Malevich's third wife, Natalia Andreevna Manchenko, is shown in bright fantastical clothing which defies easy categorization. She wears an ocher bodice, yellow belt, and red peplum. Her blue sleeves are trimmed at the cuff with red, black, yellow, and white stripes, and the garment's neck closes in a red and black Suprematist effect. She wears a reddish hat banded in yellow and cream. The total effect of this outfit would be lighthearted, were it not for the formality and Elizabethan coolness of the subject.

Portrait of the Artist's Wife is strangely allegorical, full of import. The turned figure and the gesture of her right hand repeat a characteristic pose of the saints and angels depicted on the deesis row of an iconostasis, or icon screen, of a Russian Orthodox church. The gold-colored band of her hat is reminiscent of a halo. (In icons such a gesture is an expression of supplication and presentation, and bodies are turned to address a central and front-facing Christ.)

In addition to the deesis icons, the most immediate inspiration for this work is probably Holbein's *Portrait of Jane Seymour* (1536). Malevich himself made the association of Holbein's work and icons when he included them both as examples of "color painting" on the teaching charts he brought with him to Warsaw and Berlin in 1927.

The colorful clothing is, indeed, of more than decorative significance here. In his previous work, Malevich's peasants were not yet completely in the objectless world; they occupied an intermediate stage. We saw their heads against the sky, but their feet were still rooted in the landscape. Malevich's subject here is no longer separate; the figure itself has been invested with signs of a higher existence. It wears the colors of Suprematism and the objectless world; to Malevich's thinking, this colorful clothing gives evidence of the subject's psychic evolution and the state of her consciousness.

The beginnings of such a merging of human beings with the universe could be detected in *The Athletes* (plate 37), but in this small work the integration of the "here" and "there" is so complete and so profound that it no longer has to be represented by means of blank faces or simplified figures. The universal landscape lives in the oddity, color, and formality of the woman's costume, and in her distant gaze and gestured silence.

As if to remind the viewer of the genesis of this work, Malevich has signed it in the lower left with a Suprematist square. *Portrait of the Artist's Wife* went to the Russian Museum from the artist in 1934, shortly after it was painted.

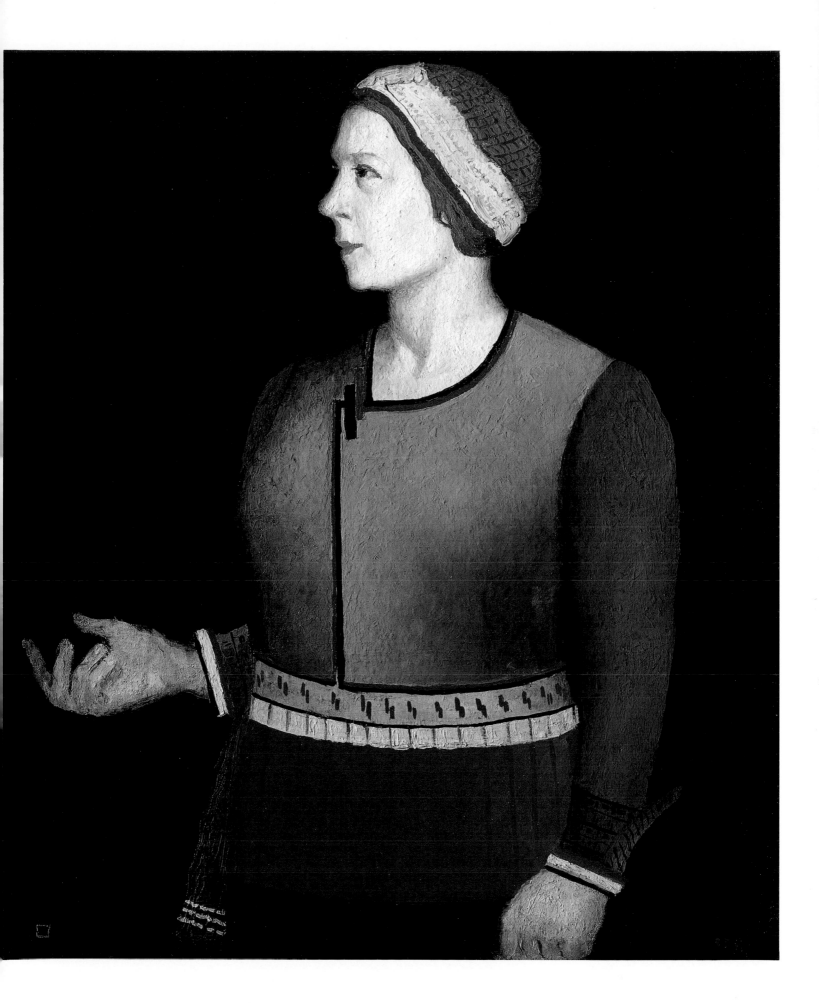

40. THE ARTIST (SELF-PORTRAIT)

1933. Oil on canvas, 28¾ × 26" (73 × 66 cm).
Russian Museum, Saint Petersburg

In the last years of his life Malevich sought to endow his Metaphysical art with the character of age and endurance. The iconography of a number of his portraits evokes Italian and North European painting of the fifteenth and sixteenth centuries: Dürer, Holbein, Cranach. *The Artist* is in the tradition of self-portraits in the guise of an assumed persona. In such paintings artists see themselves, and their identity as artists, as intimately related to the nature of the assumed personality. For this work Malevich apparently looked closely at Dürer's *Self-Portrait* (1500), which depicts the artist as Christ.

Malevich's image is, of course, also evocative of the Christ of Russian icons, the frontal countenance placed at the center of every iconostasis. But Malevich draws back from repeating Christ's pose too literally; here he has discreetly turned the head slightly, and like Dürer, has altered the position of the right hand, which traditionally forms a gesture of blessing in depictions of Christ. In *The Artist* the hand is, nevertheless, a direct quotation of an iconic gesture of presentation.

The style of Malevich's self-portrait deliberately reaches back into history and ahead to a distant future, to that "kingdom of the beautiful into which life wishes to come." The Suprematist colors of the clothing are a sign of that future, and of an inner transformation that has taken place within the subject of the painting. Malevich shows us the artist as seer and prophet, possessed of a timeless and transcendent vision. But at the same time, in the strong, warm face he finally insists on the artist's essential humanity, on his role as a teacher, and as an inspired but flesh and blood intermediary between heaven and earth. By entitling the work *The Artist*, rather than "Self-Portrait," Malevich emphasizes the universality of his characterization.

The painting is signed with a Suprematist black square at the lower right. At Malevich's death in 1935 it was hung above his bier as he lay in state; it entered the Russian Museum collection immediately thereafter.

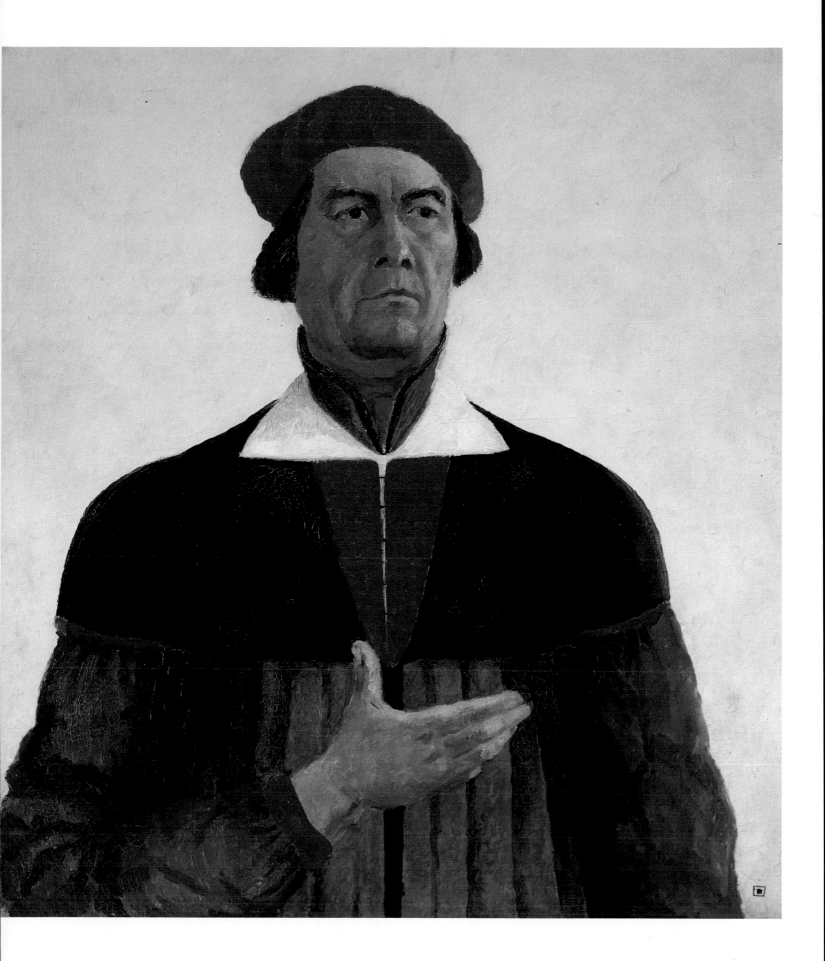

TEXT NOTES

1. "Glavy iz avtobiografii khudozhnika." In N. Khardzhiev, K. Malevich, M. Matiushin, *K istorii russkogo avangarda* (Stockholm: Hylaea, 1976), 107.
2. Moskovskii khudozhestvennyi teatr, *Anatema* (Moscow: Iu. Lepkovskogo, 1910).
3. K. Mokler, *Impressionizm, ego istoriia, ego estetika, ego mastera*, trans. F. I. Rerberg (Moscow, 1908, 1909).
4. A somewhat different translation is available in B. Livshits, *The One and a Half-eyed Archer*, trans., introd., annotated John E. Bowlt (Newtonville, MA: Oriental Research Partners, 1977), 163.
5. A. Fevralskii, *Pervaia sovetskaia pesa: "Misteriia-buff" V. Maiakovskogo* (Moscow, 1971), 69–70.
6. Bengt Jangfeldt, ed. and trans. *Iakobson-Budetlianin: Sbornik materialov* (Stockholm: Almqvist and Wiksell International, 1992), 24.
7. K. Malevich, *The World as Non-Objectivity*, ed. Troels Andersen, trans. Xenia Glowacki-Prus and Edmund T. Little (Copenhagen: Borgen, 1976).
8. Quoted from A. Shatskikh, "K. Malevich v Vitebske," *Iskusstvo*, 11, 1988: 39.
9. Malevich is referring here to the poet Vladimir Mayakovsky's suicide on April 14, 1930; "the incident is closed" is a quotation from his suicide note.
10. Letters from April 26 and May 28, 1930. Kazimir Malevich, *Pisma k Shutko* (Eisk: Otdel zhivopisi i grafiki Eiskogo istoriko-kraevedcheskogo muzeia, 1992).
11. The similarities between Malevich's and Pimonenko's *Flower Girl* were first pointed out by Irina Vakar in a paper given at the Russian Museum in December 1988.
12. Entry from January 12, 1933, in diary kept by Malevich's student Konstantin Rozhdestvensky. Personal communication.
13. M. L. Lazarev, *David Shterenberg* (Moscow: Galaktika, 1992), 205.

PHOTOGRAPH CREDITS

The author and publisher wish to thank the libraries, museums, galleries, and private collectors named in the picture captions for permitting the reproduction of works of art in their collections and for supplying the necessary photographs. Photographs from other sources are gratefully acknowledged here, with their respective page numbers:

Author's collection: 12, 16 (bottom), 22, 39 (bottom), 42 (bottom), 43, 60, 90, 108; Klaus Hurrgimalla, Frankfurt: 23 (top), 28 (bottom), 33, 42 (top); Stedelijk Museum, Amsterdam: Frontispiece